SENSATIONS OF HISTORY

ELECTRONIC MEDIATIONS

Series Editors N. KATHERINE HAYLES, PETER KRAPP,
RITA RALEY, AND SAMUEL WEBER

Founding Editor MARK POSTER

(*continued on page 221*)

SENSATIONS OF HISTORY

Animation and New Media Art

James J. Hodge

ELECTRONIC MEDIATIONS 57

UNIVERSITY OF MINNESOTA PRESS

MINNEAPOLIS | LONDON

The University of Minnesota Press gratefully acknowledges financial support for the publication of this book from the Alice Kaplan Institute for the Humanities at Northwestern University.

Published by the University of Minnesota Press
111 Third Avenue South, Suite 290
Minneapolis, MN 55401-2520
http://www.upress.umn.edu

Printed in the United States of America on acid-free paper

The University of Minnesota is an equal-opportunity educator and employer.

26 25 24 23 22 21 20 19 10 9 8 7 6 5 4 3 2 1

Library of Congress Cataloging-in-Publication Data
Names: Hodge, James J., author.
Title: Sensations of history : animation and new media art / James J. Hodge.
Description: Minneapolis : University of Minnesota Press, [2019] |
Series: Electronic mediations ; 57 | Includes bibliographical references and index.
Identifiers: LCCN 2018055271| ISBN 978-1-5179-0682-5 (hc) | ISBN 978-1-5179-0683-2 (pb)
Subjects: LCSH: Phenomenology and art. | New media art. | Computer animation.
Classification: LCC N70 .H687 2019 | DDC 776/.6—dc23
LC record available at https://lccn.loc.gov/2018055271

TO ORION

CONTENTS

ANOTHER HISTORY

Animate Opacity

How do digital media affect historical experience? For more than a half century, media and cultural theorists have argued variously that digital media end, foreclose, and diminish historical experience. This book rebuts that idea, and it does so by attending to animated forms in new media art. The central argument of this book is that animation in new media art expresses a transformation in historical experience occasioned by the digital age, the period from digital media's popular emergence in the 1990s until the saturation of culture by smartphones, social media, and wireless networks in the early twenty-first century. The transformation in question concerns the experiential opacity of digital media, or what Bernard Stiegler calls the "deep opacity of contemporary technics."[1] As a field of aesthetic forms based on the perception of absent causes, animation represents both a symptom of and a critical response to the opacity of digital experience. Animation in new media art, in turn, creatively articulates and expresses the widening chasm between lived experience and the insensible technical infrastructure that makes so much of it possible.

New media art represents an especially vibrant and critically rich terrain through which to examine lived experience in the digital age. It is uniquely suited to address this period not only because so much of twenty-first-century experience is itself digital but also because the emergence of digital culture and the process of its uneven diffusion into culture as such distinguishes so much of the character and shape of this time. Because new media art is by definition based in digital computational

media, it readily instantiates the lived infrastructure of the digital age. Tethered to the mainstream neoliberal culture of new products and technical habits, new media art also represents something quite different. It holds itself critically proximate to the furious pace of the ever-updating present. Embracing the possibilities of new technology, new media art also responds critically to emerging movements in thought and expression inaugurated by digital media and remains dedicated to resisting any simple promotion of the "new." For instance, a parodic video promoting a work of glitch software art entitled *Satromizer sOS 4* by Pox Party (Jon Satrom and Ben Syverson) vividly exemplifies how new media artists embrace new technology while simultaneously retaining a critical and playful posture toward it. Dressing in plain black T-shirts recalling Steve Jobs and speaking in the casually confident tone of Silicon Valley, Satrom and Syverson wryly promote what they call a glitch-filled "100% problem-based operating system." Jobs famously touted the Macintosh as a machine for artists. Satrom and Syverson, in turn, give the machine and its culture a run for its money. In a nutshell, this is what new media art does so well. Because new media art addresses digital media precisely as aesthetic experience, it furnishes a rich resource for encountering the digital age anew through a variety of textual and sensory forms at once both immanent to and critically engaged with digital technologies and culture.

This book proceeds by rethinking the changing meaning of several keywords and their ongoing reconstellation in digital technology and the arts: "historical experience," "animation," and "writing." It will take the full course of this book to unpack and digest the shifting and related meanings of these words as they fit together anew. Yet their changing meanings all route through the experiential opacity of digital media, the felt sense of computers operating beyond human perception and cognition. As a way forward into these interlinking ideas, consider an exemplary work of new media art: American artist and activist Paul Chan's 2005 video installation *1st Light*. Research for this book began during a trip to New York City in 2005, where I saw *1st Light* installed at the Whitney Museum of American Art, one of the most prominent museums to exhibit and support new media art. Throughout the process of writing this book, this artwork has exerted a guiding influence, and so I would like to begin with it here.

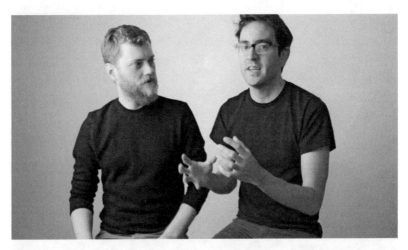

Figure 1. Pox Party promotes a glitch OS in the style of Apple guru Steve Jobs. Pox Party (Jon Satrom and Ben Syverson), Introducing *Satromizer sOS 4,* 2011. Courtesy of the artists.

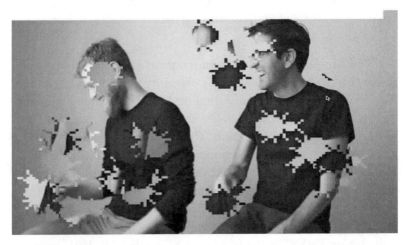

Figure 2. Glitches overrun the professional aesthetic of Apple and Silicon Valley. Pox Party (Jon Satrom and Ben Syverson), "Introducing *Satromizer sOS 4,*" 2011. Courtesy of the artists.

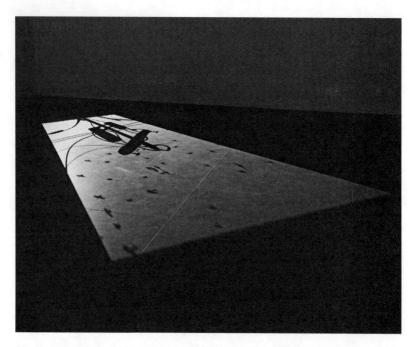

Figure 3. Installation view of *1st Light* by Paul Chan (2005), digital video projection, 14:00. Courtesy of the artist and Greene Naftali, New York.

The story of the changing meanings of *historical experience, animation,* and *writing* begins with the experiential opacity of computers. To examine the experience of digital media, it is often most helpful to look not into the internal logics of the machine, but rather the sorts of images artists make with them. To wit, Chan's *1st Light* presents an animated vision of *historical experience*. Projected on the gallery floor in the shape of a canted rectangle in a fourteen-minute loop, everything appears in mute shadow. Telephone wires billow and birds distantly fly by. Flip phones, cars, and bicycles all float up slowly and disintegrate. Then, suddenly, bodies start falling out of the sky. As anyone who visited New York after the attacks on September 11, 2001, knows, a charged and melancholic sense of history seemed to hang in the air in the following months, if not years. The bright ghostly columns by Light America and known as *Tribute in Light*, evoking the absent presence of Minoru Yamasaki's World Trade Center towers, represent the most

famous artistic form devoted to this feeling. Decidedly antimonumental by comparison in its projection of shadows on the floor, *1st Light* expresses a more ambivalent relation to historical experience. In stark contrast with *Tribute in Light*'s heroic and transcendental verticality, *1st Light* entreats us to look down and offers, instead, a quieter and affectively complex vision of historical experience. As art historian George Baker observes, *1st Light*, like virtually all of Chan's artistic output, signifies in multiple ways that complicate any single reading.[2] *1st Light* is just as much about the Rapture, for instance, as it is about 9/11. Also like much of Chan's work, *1st Light* consciously evokes art historical reference points as a way to stir the conceptual pot of iconic significations. The composition of *1st Light*, for instance, recalls the photography of Tina Modotti.[3] Whereas Modotti's futurist photographs suggest a striving confidence in technology, however, *1st Light* invites a dual sense of ambivalence and opacity that is actually reassuring in its refusal to assign any one master narrative or theme to its treatment of historical experience. Meaning never coalesces into total coherence. The installation's animate shadows spectrally embody the experiential opacity of the historical present for those living through it, those without or unable to find the words to make sense of what has happened. In *1st Light*, historical experience resonates without clear resolution. The installation sets aside a space in solidarity for those who cannot go along with the version of history being sold to them by the U.S. government, conspiracy theorists, the national news media, or anyone else with too strong a story about what it all "means."[4] Again in contrast with *Tribute in Light*, *1st Light*'s main argument may be that historical experience never appears in semiotic high definition.

The titular strikethrough foregrounds *1st Light*'s devotion to opacity. If light connotes knowledge, vision, and truth, then ~~light~~ suggests the frustration of these meanings, if not precisely their negation. ~~Light~~ is not total darkness. It is instead, rather surprisingly, a *window*. Windows per se may be more readily associated with light pouring in through them than with darkness, but Chan emphasizes the ways shadows give form to light via windows such as the one evoked by *1st Light*. In his essay "On Light as Midnight and Noon," Chan describes the longstanding art historical topos of the window as a technology and metaphor of vision. Discussing the related histories of windows and shadows, he observes

how Alberti, "the first philosopher of the window," cites Quintilian's tale of the origin of art in the tracing of shadows. Windows and shadows are intimately connected as key terms for Chan's media-theoretical vision of artistic expression. As Chan implies, this connection has ramifications for our digital present. He writes, "the idea of the window—whether the cinematic window, the tele-video window, or the computer window—still dominates what and how we see."[5] What we see, of course, is never just the light in terms of clarity or revelation, but also darkness in shadow. The total absence of shadow yields blinding light. Shadow helps us to navigate the light that is always ~~light~~. *1st Light*, in turn, plays with this philosophy of windows and shadow and asks how this dynamic shifts in the digital age:

> The whole piece functions with the idea that if you walk in the room where this piece is you'll look on the floor to this non-square light and think to yourself at some point, where is the window? That there's a window somewhere in this room that's casting light onto this floor.[6]

Of course, there is no window, only the absence of a window, and in its place, a digital projector. Looking up at the projector and catching the angle of projection right, one might see only blinding light, the absence of shadow. Looking for the window does not reveal anything so much as it directs the viewer back toward animated shadows on the gallery floor. Seeking out reality or the technical source of the images on display leads nowhere except maybe to colored after-images and a headache.

Why does Chan entreat his viewer to look for a window only for her to be fooled or chastised? The window has changed, and so too has the shadow. The metaphor of the window as a technology of vision persists in the digital age, most notably in the title of Microsoft's famous operating system, Windows. Yet the digital window is very different from the windows of Renaissance perspective or the cinema screen. The point is now to look *at* the window itself, not *through* it. This is not because one must remain attentive to the medium, but rather because one has no choice. A digital window is not something one can look through. There's no other side, at least not one readily available to ordinary experience. Unlike the cinema—so appealing to the philosopher Stanley Cavell because one might remain in darkness to observe the outside world at a remove—digital media simply have no window with an inside–outside

structure in the lineage of the *camera obscura*.[7] To playfully modify an expression from interface design that many in digital studies love to hate, what you see *is* in fact what you get. Of course, it's not at all clear what you get! What's more, the expressive truth or power of *1st Light* lies not in the technical source of the image; looking at the projector reveals nothing. The projector is not an aperture opening onto reality. Instead, truth emerges in all its messiness and ambivalence in the encounter with the work of art as an animated shadow. In a digital inversion of Plato, the shadows at play on the gallery floor do not portray some false reality, as they do for the shackled inhabitants of the allegory of the cave. In the digital age shadows may be our best way into the true nature of experience. Ultimately, the fundamental ambivalence of historical experience expressed by *1st Light* finds form in its animate opacity.

The digital age is best defined by the experiential opacity of its technologies. In focusing on the experiential opacity of digital technologies, I mean to foreground the commonplace inability to explain why one's smartphone, wireless network, or laptop behaves in the ways it does. Why, for example, does a progress bar indicate that a software installation will take two hours and then it takes only two minutes? Why is it even borderline acceptable to say, "oh, it must not have gone through" when we have forgotten to send an email? Why are autofills and autocorrections often so bizarre? Why do people have so much trouble understanding how digital cryptocurrencies work? Why does a program glitch or an internet connection lag? For various reasons, the answer to all of these questions is that the operations of digital media remain, by and large, mysterious. This does not mean, of course, that one cannot learn more, even much more, about how digital media work. It does mean that individual knowledge of digital media will never prove sufficient to dispel and recuperate the opacity of digital media.

Of course, I am far from the first to observe the technical opacity of digital media. Their operational opacity functions as a starting point for a number of scholars working in the field of digital media studies. N. Katherine Hayles, Matthew G. Kirschenbaum, Alexander R. Galloway, and Mark B. N. Hansen are among the most prominent critics to note that it is impossible to know exactly or to perceive with clarity how digital media work on a fundamental level.[8] I elevate this observation to a general principle for analyzing digital experience. For many scholars

in software studies and related subfields, however, the technical opacity of digital media is a problem to be overcome through technical explanation. For example, in *Plain Text: The Poetics of Computation*, literary critic Dennis Tenen describes his methodological approach as "laying bare the device" in order to ensure "legibility and comprehension."[9] The present book takes the opposite approach by foregrounding opacity. An autopsy may tell you a lot about a human being as an organism. But a painting or novel will tell you much more about culture and human experience. So it is with the analysis of digital media in a strict sense versus an approach to digital culture and aesthetics. They are very different objects of study. One privileges technology itself. My concerns, by contrast, are overwhelmingly with human experience and aesthetics. Thus, technical opacity is not for me a problem to be overcome via technological expertise and deep dives into the nitty gritty of hardware and software. Moreover, in this book, opacity does not amount to woeful ignorance. As much recent writing in queer and digital activism shows, opacity serves as a potent rallying cry for political resistance to oppressive forms of digital mediation.[10] In this book, I treat technical opacity as a fundamental fact of digital experience worthy of encountering, describing, and reckoning with in all its phenomenal obscurity and formal complexity. This is why art plays such an important role in my analyses. Art gives form to the complexity of experience. It enables encounters with technology in terms of lived experience, not merely in terms of technology's internal logics.

By "the experiential opacity of digital media," I also mean to convey two distinct but related ideas. The first is that a certain opacity shapes any human encounter with digital media because they largely operate at scales and speeds beyond human cognition and perception. The second sense of *experiential opacity* that I have in mind concerns the general cultural reception of digital media in the digital age. The popular emergence of digital media is often touted as a "digital revolution" in a positive, transformative, and hooray-for-progress sort of way, even when it is treated critically. It is ethically vital, however, to recognize how brutally destructive digital media have been and continue to be of human life and culture generally.[11] One need look no further than reports on the devastating environmental impact of digital technologies, this or that article on social media and smartphones contributing to unprecedented

mental health crises, or the deleterious effects of social media on the 2016 presidential election in the United States. Less dramatic but no less important, it is important to keep in mind how the arrival of digital media in work life and popular culture in the digital age made enormous and largely unfair demands on so many. These demands include rethinking virtually every aspect of life: from what it means to ask a question, to what it means to have a friend, to what it means to do one's job, and much more. The slow historical event of digital media's popular emergence may seem ordinary today, and the strange creep and saturation of culture by digital media may make it difficult to recall how very different so much of Western postindustrial life was as recently as the 1990s. Yet it is worth noting with astonishment how much of life digital media have rapidly transformed, and not always for the better. Responses to digital life do not always represent happy or soulful adaptations to the new, but rather involuntary or compromised forms of relation to the new shape of things, from the complexity of new gadgets and terms-of-service agreements to new forms of (non)communication like ghosting or trolling and the steady disappearance of local bookstores. The cost of adapting can be enormous in all the senses of those words. Fredric Jameson famously writes, "history is what hurts."[12] I can think of no better way, then, to approach historical experience in the digital age than by attending to the opacity of digital media.

To back up a half step, I want to clearly describe what I mean by "historical experience." There are, of course, many definitions of history. In approaching history as *experience*, I want to foreground history as it is lived, perceived, and thought. In this way, I aim to unite my concerns with history to my interests in art and aesthetic experience, embodied encounters with works of art. I also aim to fit my interests with the theoretical and philosophical resources I draw on throughout the book, particularly the tradition of phenomenology beginning with Edmund Husserl, running through Martin Heidegger and Maurice Merleau-Ponty, and continuing variously in a "postphenomenological" fashion in the writings of Paul Ricoeur, Vilém Flusser, Jacques Derrida, and Bernard Stiegler. Lived experience represents a key idea for much of phenomenology, and I share that tradition's devotion to scrutinizing the finitude and marvel of the human senses. As I hope will become evident later on, phenomenology furnishes an especially pertinent critical vocabulary for encountering

the experiential opacity of digital media. With these two commitments in mind, it will now become a bit clearer how I approach *historical experience*. But let me be even clearer.

Historical experience refers to two aspects or dimensions of our lived relation to history. Neither side may be wholly separated from the other, and each requires a slightly different conceptual posture. For the sake of clarity, it may be helpful to discuss them schematically. The first aspect of historical experience concerns our lived relation to the past. The second aspect concerns our relation to our lived relation to the past. In simple terms, our lived relation to the past may be thought of as an experience of the past, or pastness. Our lived relation to our relation to the past concerns the forms through which the experience of pastness becomes grasped, written, or otherwise organized in discourse. At its root, the experience of the past is an experience of its conditions of possibility, what Michel Foucault calls the "historical a priori," or the "condition of reality for statements."[13] The discursive dimension of historical experience concerns "statements" themselves and their larger forms in language and images as narratives. We experience the conditions of possibility for historical experience when we encounter the past in its absent presence: a trace on paper, a shard of pottery, or a scratch on a table—physical evidence available to our senses that something happened. We experience the discursive dimension of historical experience when we read historical accounts or view representations of historical events that have turned those traces into discourse. The distinction is absolutely crucial and pivotal. For most of human history, the "condition of reality" for statements has been subject to human perceptual experience and oversight.

At this point, a key insight from German media theorist Friedrich Kittler proves indispensable. In *Gramophone, Film, Typewriter,* Kittler updates Foucault's archaeological method with the opacity of digital media in mind. For Kittler, the condition of reality for statements becomes increasingly vexed with the advent of sound and image recording in the nineteenth century and even more fraught with computational media in the twentieth century.[14] This pivotal argument helps us to get to the bottom of the problems digital media pose for historical experience. In the context of digital media, traces become highly dynamic, time-based, and complex. They operate at scales and speeds largely beyond human cognition and perception.

What is more, digital traces do not graduate naturally to the level of linguistic discourse addressed to human perceivers. As a number of scholars in digital studies have argued, digital discourse does not primarily address human experience, but rather other machines.[15] Traces of the past effectively recede from human experience with the advent of digital media. To be sure, the trace persists in the era of digital media.[16] Yet it bears emphasis that the trace becomes deeply inaccessible, no longer visible to human eyes but solely visualizable by technical means. In this way, the technical conditions of possibility for historical experience become experientially opaque. Routed through the black box of digital computation, the relation between the first and second dimensions of historical experience becomes deeply uncertain. The withdrawal of traces from human perception throws into question the basis of historical experience and how it comes about.

If the experiential opacity of digital media defines the digital age, then the task of theorizing historical experience must be to reckon with that opacity. As Jonathan Crary writes, "an illuminated 24/7 world without shadows is the final capitalist mirage of post-history, of an exorcism of the otherness that is the motor of historical change."[17] To embrace the opacity of digital media, then, to recall the lesson of Chan's *1st Light*, does not entail illuminating the darkness so as to dispel it completely. Instead, encountering the opacity of digital media means dwelling in the shadows.

For this book, this also means considering how we experience the transformed character of digital media as *writing*. In his lightning-rod 1992 essay "There Is No Software," Kittler remarks on the opacity of computer code and hardware in a Derridean lineage of writing technologies from print to photography to sound recording and cinema to digital computers: "We can simply no longer know what our writing is doing, and least of all when we are programming."[18] As algorithmic programs, digital media represent a technology of writing. Writing becomes pro-gram, or following Derrida, writing becomes *pro-grammé*, the mark or trace inscribed in advance. This book follows the Derrida-Kittler imagination of writing as a fertile topos of evolving communication technologies.[19] While many in digital media studies frequently reject or ignore this perspective, this is often done ostensibly as a way to privilege the historical specificity of digital computational media in its different

artifactual forms, such as mainframe computing, mini-computers, home computers, game consoles, and so on. Without contesting the need for fine-grained analyses of specific technologies, I join a number of scholars and artists, including Kirschenbaum, Donna Haraway, John Cayley, Federica Frabetti, and many others who treat digital media in a general fashion as writing or inscription technologies.[20] Owing much to Derrida and French poststructuralism, this position has never really gone away, although it has often fallen out of favor for institutional reasons and the vagaries of intellectual fashion. The strength of treating digital media as writing, I believe, is that it helps to historicize and position digital media in relation to other inscription technologies such as print and cinema. Treating digital media solely in terms of its medium specificity or material affordances runs the risk of tech fetishism. Like any medium or technology, the material specificity of digital media matters. However, their discursive relations to other media matter just as much, a commitment that I take to be fundamental as I analyze a number of artworks striving to historicize digital media precisely in relation to older media such as cinema and the book.

Slovenian artist Vuk Ćosić's classic net.art work from 1998, *ASCII History of Moving Images*, illustrates these themes of opacity and writing as central to the historical experience of the digital age. *ASCII History of Moving Images* consists of a potted history and genealogy of moving image aesthetics leading to digital media. Presented as the third volume in the *History of Net.art*, Ćosić's project features short clips titled simply "lumiere," "eisenstein," "king kong," "star trek," "blow up," "psycho," and "deep throat." This condensed and strategic minihistory evokes a number of media and genre forms readily seen as vital to digital aesthetics: from film, photography, and television to montage, genre fiction, and pornography.

None of the clips appear in anything like high definition, as this work hails from the mid-1990s and the time of dial-up modems.[21] Each clip appears in silence as ASCII characters, a moving image version of a popular 1990s internet practice for reproducing images before the advent of high-speed connections. The images dance in and out of legible, figural shape, sometimes appearing more as their source texts and often appearing more as swirling alphanumeric characters indicative of computer code. ASCII, or the American Standard Code for Information

Interchange, is a 128-character-encoding scheme initially adopted as an industry standard in 1963. It works by specifying the relation between digital bit patterns and character symbols.

In the layered architecture of digital writing, ASCII provides a kind of bridge between, on the one side, the more machinic and abstract numerical representation of digital bits and, on the other, their address to human users as scriptural characters. As Galloway notes, code has a Janus face: a machine-facing side that is *executable* and a human-facing side that is *scriptural*.[22] Or, as Hayles puts it, "code is addressed both to humans and intelligent machines."[23] People write code. Code originates in human thought and action. But people write code in order to tell machines what to do, including telling other machines what to do. Once machines start "telling" other machines what to do, they don't tell humans what's happening; actually, they *can't*. Technologist Kevin Slavin calls this "writing the unreadable."[24] But crucially, writing the unreadable does not mean writing the wholly invisible. While no phenomenal form may strictly show how a machine addresses another machine in excess of human perception, Ćosić's use of ASCII characters elegantly expresses this dynamic. And he does it, moreover, in the service of expressing the historical experience of the digital age both in its conditions of possibility and in its discursive manifestation. In Ćosić's rendition of the shower scene from Alfred Hitchcock's *Psycho*, for example, a flickering field of dollar signs and other characters snaps into focus as Norman Bates dressed as Mother raises his arm, knife in hand.[25] Each entry appears out of and disappears into the perceptual opacity of digital inscription. ASCII characters become recognizable as historical only insofar as viewers see them as renditions of iconic moving images. History flickers in and out of legibility according to its digital reanimation.

The mere fact that *we do not know what our writing does* does not mean that we should find out, or indeed that we can. Ćosić's *ASCII History of Moving Images* underscores the uncertainty and perceptually partial dimensions of this new relation to writing. It is perhaps too seldom observed that the origins of digital media were, in large part, in technological advances in cryptography, or "hidden writing" (from the Greek *kryptòs* and *graphein*). The 1992 artist book and digital poem *Agrippa (a book of the dead)* by writer William Gibson, artist Dennis Ashbaugh,

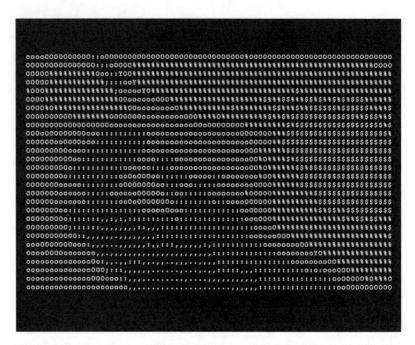

Figure 4. Sceenshot of ASCII Norman/Mother (shower scene in Alfred Hitchcock's *Psycho*), from *ASCII History of Moving Images* by Vuk Ćosić, with programming by Luka Frelih and production by Ljubljana Digital Medialab (1998). Courtesy of the artist.

and publisher Kevin Begos Jr. demonstrates the affinity between digital writing and opacity. Promoted as a project that would become the "first digital myth," the poem "Agrippa (a book of the dead)" may be run only one time before it self-encrypts and vanishes irretrievably.[26] Housed on a hard disk and run on a 1992-era Macintosh, the poem self-scrolls, animating itself into a sort of oblivion, or as the poem puts it, "laughing, in the mechanism." Imagined as a self-destructing book at the beginning of the digital age, *Agrippa*'s animated, "self-encrypting" poem envisions the digital future as a volatile gamble with the future of the book, the engine of historical experience par excellence.

Agrippa's self-encrypting poem recalls Kittler's idea that we do not know what our writing does. For *Agrippa* and for Kittler (although for different reasons), this idea about digital writing smuggles in a not-so-subtle vision of computers inaugurating the end of history. In a number

of texts, Kittler proclaims that digital computers usher in an "information posthistory."[27] The idea of computers as antihistorical is not peculiar to Kittler. Indeed, as I detail nearer to the end of this introduction in a bibliographic overview, the correlation of computers with the end of history is incredibly widespread and persistent. The end of history in its different articulations is, however, less the proclamation of an event or new state of things. "The end of history" names instead a blockage, an impasse, an inability to think or conceive of the relation between computers and historical experience. While end-of-history narratives may sound a bit outdated in the twenty-first century, they have never truly been resolved. They are often dismissed precisely as grandiose proclamations. If we take them as symptomatic of the experiential opacity of digital media, however, they point toward unfinished business.

As I have suggested, the technical opacity of computers removes the substrate of traces so distantly from perception, and thus from any "natural" relation to their discursive codification in linguistic discourse (narrative, figurative representation, etc.), that it becomes difficult to say how historical experience endures. It is often argued by those such as Jameson and Ricoeur that narrative is not only the privileged discursive mode of history, but history itself.[28] Of course, language-based narrative histories still play an important role in the expression of historical experience in the digital age. However, my argument is that, in the digital age, *animation* emerges as a newly significant field of moving image forms for grasping, understanding, and encountering historical experience. While historians and philosophers of history have long employed metaphors of animation from resurrection to ghosts to "drinking the blood" of the past to describe what history is,[29] the present book treats animation as much more than a linguistic metaphor for imagining the nature of history. With the popular emergence of digital media, animation in the form of moving images now plays an expanded role in the expression of historical experience, both in terms of encountering the technical conditions of possibility for historical experience and in terms of the discursive manifestation as moving images. Animation allows for phenomenal encounters with the experiential opacity of digital media precisely without dispelling that opacity. As a field of aesthetic forms based on the perception of absent causes, animation instantiates the very character of a digital output whose origin is always and fundamentally

ever hidden from view. Moreover, animation grants aesthetic form to the operation of digital media in their operation beyond the direct purview of individual human agency or observation. In sum, animation expresses the experiential opacity of digital media. At the same time, animation captures the time-based volatility of digital media. Its forms index not only the obscurity or absence but also the partial, dynamic, and evolving coupling of human experience to digital media vital to my broader commitment to the analysis of lived experience. Addressing not only our relation to history but also our relation to that relation, animation in new media art gives rise to what I will call "another history."

Are New Media Really Antihistorical?

One of this book's main aspirations is to contest the remarkably consistent and persistent view that digital media contribute to the end of history or that they are antihistorical, or at least ahistorical. Throughout the process of writing this manuscript, I have had readers often respond to the idea that digital media are antihistorical with incredulity: "Really? People think that?" Or, if they recognize this thought, they might say, "well, people used to think that in the 1980s and 1990s." As I hope to show in a sort of bibliographic overview here, a stunning number of media and cultural critics and philosophers have made the claim that computers are antihistorical. Moreover, the idea goes back much earlier than the 1980s. It stretches back at least to the 1950s during the early popular reception of computers and cybernetics. The idea does indeed reach its peak in the 1990s, when premillennium tensions were high, especially when everyone seemed to be citing Francis Fukuyama's infamous proclamation of the end of history.[30] But it continues in a number of unchallenged claims in the twenty-first century too. In charting the contours of the idea that computers are antithetical to history, I must note that the authors cited below hail from many different backgrounds and that their claims matter in different ways with different stakes. Taken as a group, however, they help to clarify just how widespread the idea that computers are antihistorical is and has been. It should illustrate also the strength of the current against which this book swims in even asking its main question: how do digital media affect historical experience?

Let's start with a comparatively recent example before working our way back to the present. The idea that computers are antihistorical is definitely not an idea that exists somehow only in the digitally naïve years of the 1990s in the panic of Y2K and excitement over the "information superhighway." Indeed, it continues right up to the present. In 2015, Google's vice president and chief internet evangelist, internet pioneer Vint Cerf, warned that we may be entering a digital dark age. Citing *Team of Rivals: The Political Genius of Abraham Lincoln*, a book by renowned historian Doris Kearns Goodwin based on Lincoln's extant correspondence, Cerf imagines a twenty-second-century historian writing about our twenty-first century: "She discovers that there's an awful lot of digital content that either has evaporated because nobody saved it, or its [*sic*] around but it's not interpretable because it was created by software that's 100 years old."[31] Bringing the point closer to home, Cerf advised: "If there are photos you are really concerned about create a physical instance of them. Print them out." It bears noting here that Google owns Picasa, one of the largest cloud-based services for personal photos (succeeded by Google Photos in 2016). And Silicon Valley giants like Google usually express nothing but boundless confidence in the power of digital media. For a powerful representative like Cerf to even hint at the deep instability of that infrastructure reads as simply astounding. Saving the family photos is something people do when the house is burning down, not when they are promoting the ubiquitous reach of their business brand. To be sure, many would contest Cerf's vision of the gaping absence of future history. Like Cerf, however, a sizable number of librarians, preservationists, and archivists have long expressed dire concerns about the long-term viability of digital media as the physical substrate of the historical record.[32]

The notion that computers are antihistorical runs deep and long pervades popular representations of computers. Sometimes, this theme remains secondary to the more famous idea that computers will bring about the end of the world, humankind, or both. For instance, in Arthur C. Clarke's 1953 short story "The Nine Billion Names of God," a group of Tibetan monks purchase a mainframe computer in order to enunciate the eponymous nine billion names, after which, a monk explains, humanity will have served its purpose. With the help of a computer, a task that would otherwise have taken fifteen thousand years takes only a

few months. As the computer finishes its task at story's end, the stars start to go out. A 1967 episode of the British television serial *The Prisoner* entitled "The General" explores the idea that computers are antihistorical more explicitly. In the episode the titular prisoner (played by Patrick McGoohan) is made to view a screen-based technology called "Speed Learn" that delivers a three-year university course in history in three minutes. Fearing Speed Learn will lead to mind control, the prisoner discovers that "the general" behind Speed Learn is actually a mainframe computer. In a characteristic gesture of the 1960s imagination of computers, the prisoner destroys the computer by asking it an essentially unanswerable and therefore "human" question: *why?* Of course, looking forward from the 1970s through the present, one might cite any number of television shows or movies associating computers with the end of the world and of history generally: *Battlestar Galactica*, the *Terminator* franchise, and many more. The best example is, no doubt, *The Matrix* (1999). Released on the cusp of the new millennium at the height of Y2K mania, *The Matrix* preaches the gospel that computers destroy history. As Morpheus (Lawrence Fishburne) explains to Neo (Keanu Reeves), the wars between humans and machines have been so utterly destructive that they now do not even know what year it is. The end of history, indeed.

Doubts as to digital media's capacity to function as the material conditions of possibility for historical experience become even more extreme in the fields of media and cultural theory. In fact, the notion that computers are somehow fundamentally antihistorical utterly pervades philosophical approaches to media and cultural theory more broadly. One finds it as early as the 1950s and 1960s in Heidegger and Merleau-Ponty.[33] In his influential 1970 essay "Constituents of a Theory of the Media," Hans Magnus Enzensberger writes, "the new media are oriented towards action, not contemplation; towards the present, not tradition."[34] In the 1970s and 1980s, Jean-François Lyotard and Jameson made versions of the claim in their respective accounts of postmodernism.[35] In the 1980s and 1990s, French media theorists Stiegler, Paul Virilio, and Jean Baudrillard all decry the antihistorical effects of digital media.[36] Throughout the 1980s, 1990s, and early 2000s even, one consistently discovers the idea that computers are antihistorical in a multitude of writings by cultural and media theorists reflecting on the emergence of digital culture.[37]

Moving into the twenty-first century, the story of computers as antihistorical becomes a bit more complex. Following the publication of Hayles's *How We Became Posthuman* in 1999 and Lev Manovich's *Language of New Media* in 2001, the field of new media studies brought new focus and sophistication to the study of digital technologies, including a healthy skepticism of the "new" in "new media."[38] In his 2004 study of "the culture of information," Alan Liu argues convincingly that the dominant ideology of the information age is itself fundamentally antihistorical.[39] Working against the ideology of the information age, then, would seem to involve promoting or sustaining a new sense of history. For many in the digital humanities, this has meant reimagining history in new terms.[40] And for many others, the emergence of digital media studies made possible a flood of notable publications chronicling the history of digital media technologies. However, while these approaches remain highly valuable, neither ventures to explain how historical experience persists or changes in the digital age itself. Indeed, the young field includes many statements reiterating the old idea that computers are antihistorical. Casting off the rhetorical alarmism or technological naiveté of earlier theorists, scholars in digital media studies nonetheless continue to let old ideas go unchallenged.

Several scholars within digital media studies advance the idea that digital technology itself is logically and materially ahistorical. Galloway and Wendy Hui Kyong Chun are two of the most influential scholars in digital media studies since the mid-2000s. Their earliest works combine technological expertise with political theoretical sophistication, but yet they too tend to reiterate the old chorus of computers as antihistorical. For Chun, the "major characteristic of digital media is memory." Yet it exists as "an enduring ephemeral," especially as it relates to the internet:

> Digital media is not always there. We suffer daily frustrations with digital sources that just disappear. Digital media is degenerative, forgetful, eraseable. . . . [Digital media] is perhaps a history-making device, but only through its ahistorical (or memoryless) functioning, through the ways it constantly transmits and regenerates text and images.[41]

By virtue of their technical logic, digital media are, for Chun, "degenerative, forgetful, eraseable." This is a *technical* truth. Digital media remain "ahistorical" or "memoryless" in their operation. Even though she

begins from ordinary experience ("digital media is not always there"), her engineer's perspective overprivileges the technical logic of digital media in explaining lived experience. Experience and technical operation, it must be said, do not clearly relate to one another, especially in the context of digital media.

Like Chun, Galloway has emphasized the technical operations of digital media as ahistorical. In his 2007 book cowritten with Eugene Thacker, he argues that graph theory, the mathematical field subtending the architecture of digital networks, is characterized by a certain "diachronic blindness."[42] This point echoes the considerable influence of Gilles Deleuze and Félix Guattari's explicitly ahistorical notion of the rhizome on early theorizations of networks.[43] In his 2006 book *Gaming*, Galloway makes the point more strongly that computational texts cannot express history because they exist as code:

> History is what hurts, wrote Jameson—history is the slow, negotiated struggle of individuals together with others in their material reality. The modeling of history in computer code, even using Meier's sophisticated algorithms, can only ever be a reductive exercise of capture and transcoding. So "history" in *Civilization* is precisely the opposite of history, not because the game fetishizes the imperial perspective, but because the diachronic details of lived life are replaced by the synchronic homogeneity of code pure and simple.[44]

The technical operation of the machine overwrites the complexity of aesthetic experience. Why exactly is it that computer algorithms cannot hurt? As Safiya Umoja Noble's book *Algorithms of Oppression: How Search Engines Reinforce Racism* makes plain, algorithms obviously can do material harm.[45] Galloway has since softened his position on history somewhat and remains committed to software as the material basis of history in the digital era.[46] In response, my contention throughout this book is that what counts as the material basis of history is not just "math" or software, but rather also the embodied experience of digital media.

More recently, the tide has begun to turn against the tendency in digital media studies to explain cultural phenomena in terms of the technical operation of the machine. For Patrick Jagoda, as well as for Stephanie Boluk and Patrick LeMieux, the technical operation of games

as digital media becomes less an abstract logic to be held apart in analysis and more an integral and expressive aspect of the aesthetic experience of videogames such as *Braid* and *Dwarf Fortress*.[47] For these scholars, the complex interrelations of the representational and nonrepresentational dimensions of game mechanics and gameplay inform the analysis of historical experience. This book engages in the same basic spirit as these projects in its attention to digital texts as fruitful objects of inquiry with which to consider the general impact of digital technologies on historical experience. At the same time, this book strives to build on these works by providing a comprehensive picture of the philosophical and aesthetic problems of historical experience in the digital age.

As a way to recap the problem of history in the digital age, and also as a way to push forward, consider one final version of the persistent correlation between the rise of computers and the decline of history. Flusser, a Czech-born media theorist, makes perhaps the most imaginative version of this claim. Instead of championing or bemoaning the end of history, however, Flusser provocatively speculates on the possibility of digital machines ushering in an entirely new mode of historical experience, what he calls "another history."[48] Writing in the 1980s while looking forward presciently to the popular emergence of digital technologies, Flusser develops this idea in a speculative spirit. Like Kittler and Stiegler, he regards history as deeply linked to the history of writing, or inscription technologies. The problem with computers is that digital inscription withdraws from human experience. Human consciousness loses contact with writing as handwriting gives way to pushing buttons whose causal relation to writing becomes mysterious, and for Flusser, this shift marks the end of historical experience as historical consciousness. The decline of traditional forms of writing inaugurates a posthistorical era because, for Flusser, writing makes historical consciousness possible. The transformation of writing from analog to digital technology, however, does not end history *tout court* so much as it brokers a new era of history. Digital programming does not express historical consciousness because it "is a gesture that expresses a different kind of thought." History continues, but no longer as something by and for human minds. Digital machines "do not write in the same way we did," and they use "other codes": "History written (and made) by apparatuses is another history."

While his writings remain suggestive, Flusser died in 1991, at the dawn of the digital age. This book picks up four threads of Flusser's brief discussion. First, history does not end so much as it changes according to the ways human experience relates—and *does not* relate—to the operation of digital media. While Flusser named this experience "historical consciousness," I employ the broader term "historical experience" to recognize all the ways digital media inflect lived experience without acting directly on conscious thought per se. Second, digital media massively transform the nature of writing as technical inscription. Third, digital inscription does not primarily address human consciousness, but rather human experience more broadly, and importantly, the manner in which it does so in excess of human experience can be re-presented to human experience by animation. Fourth, and perhaps most importantly, the changing relation to writing occurs in concert with the rise of what Flusser terms "the universe of technical images." The moving image achieves a novel level of historical prominence in the media ecology of the digital age. It does so precisely as the indirect means through which the opaque relation between human experience and "another history" becomes expressible, visible, and articulable. One of my primary contentions is that new media art represents the best archive through which to grasp the newly animate character of another history.

Chapter Outlines

How do digital media affect historical experience? Guided by this question, each chapter pursues different iterations of the "already there," different discursively animated versions. Following Heidegger and Stiegler, the "already there" refers to the idea that *historical experience* derives from the existential fact of things appearing as having happened, such as in the encounter with traces of the past. The opacity of computers, of course, puts this dynamic into question as traces recede from perception. Each chapter, then, attends to different figures for the *already there*: from technics and writing to the trace and sensation. Attending also to the animated correlate of each iteration of the *already there*, each chapter similarly explores aesthetic discursive figurations of historical experience, from the hand and noise to flickering static, and finally the proliferation of chronophotographic iconography in the digital age.

Chapter 1, "Out of Hand," focuses on animation as an aesthetic symptom of the experiential opacity of digital media. Building on Stiegler's theory of technics, I trace the origins of animation to its emergence in the nineteenth century in tandem with the rise of the Industrial Revolution. As machines grow larger, faster, and increasingly more complex, they seem to act "on their own." Animation represents, then, one mode of response to these events in the way it reroutes the historical experience of technological change into aesthetic production and expression. With the emergence of digital media, we once again face a similar experience of machines acting "independently" of human thought and action. I trace the genealogy of the relation between technology and experience through evolving versions of the motif of the "hand of the artist" in animated moving images, from nineteenth-century optical devices, to early cinematic animation, to Phil Solomon's digital video *Last Days in a Lonely Place* (2007).

Focusing directly on animation as the indirect expression of digital writing, chapter 2, "The Noise in History," theorizes digital media as inaugurating a massive transformation of writing. This transformation requires rethinking several presuppositions attending the long-standing idea that history depends on writing. Through the analysis of Cayley's poem *overboard* (2003) and Cory Arcangel's *Untitled (After Lucier)* (2006), I specify the animate and nonintentional dimensions of digital writing. At the same time, the chapter revises Husserl's notion of historical reactivation, especially the intentional dimensions of writing or the idea that writing exists *for* human experience. Advancing from poststructuralism's powerful emphasis on noise, or the exteriority of writing, the chapter revisits Stiegler's account of the primordial exteriority of technics and revises it accordingly to reflect the inherent exteriority of writing.

Chapter 3, "Lateral Time," addresses one of the most profound dimensions of the experiential opacity of digital media: its temporal operation beyond yet also alongside human experience. I coin the term "lateral time" to describe this experiential aporia. Through the analysis of several long-duration artworks, including John F. Simon Jr.'s *Every Icon* (1997) and Barbara Lattanzi's *O.D.E.* (2006), I show how new media art addresses the vast and open-ended timescales of lateral time in the digital age. Building on Ricoeur's famous notion of historical temporality, I

show how digital media artworks catalyze a revised understanding of temporal dynamics in relation to twenty-first-century media. Building on and departing from Ricoeur's engagement with the trace as the "reflective instrument" of historical temporality par excellence, I discuss dynamically static and flickering aesthetics as the new discursive terrain of the lateral time of historical experience in the digital age.

Chapter 4, "The Sensation of History," considers the role of embodied sensation in registering historical experience alongside the emergence of ubiquitous media and always-on computing. Exemplified by smartphone GPS technology, Google Glass, RFID, and other forms, ubiquitous media operate invisibly and insensibly in the background of ordinary life. The movement of computation away from concrete computational artifacts such as laptops and toward more environmental forms and hands-free interfaces poses challenges to the question of how one encounters traces of the past. Within this context, I analyze the contemporary popularity of the chronophotographic motion picture studies of Eadweard Muybridge in tandem with Ken Jacobs's experimental digital videos. Jacobs's "eternalism" videos, I argue, represent a continuation of these "motion studies" in a different experiential idiom especially suited to the era of ubiquitous computation, and in elaborating this claim, I draw on Merleau-Ponty. I conclude by pivoting away from the problematic of encountering textual traces of the past and end by affirming the significance of articulating the experiential opacity of digital media in its simultaneously embodied and environmental manifestation.

Finally, in a short conclusion, I take stock of emergent trends in digital aesthetics since I first began researching and writing this book in the late 2000s. Since the mid-2000s, social media and always-on computing have risen to prominence. This technological and social shift in the nature of digital media has occasioned a subtle sea change in the nature of new media art. Instead of relying on "found" media objects and technologies from earlier media eras, artists now turn more and more to new networked genres native to digital media. Examining two "found footage" videos—a 2002 video by People Like Us entitled *We Edit Life* and a 2013 GIF-compilation video by Eric Fleischauer and Jason Lazarus entitled *twohundredfiftysixcolors*—the book ends by considering the efficacy of the animated GIF for expressing the changing meaning of historical experience in the ordinary times of always-on computing.

In all these chapters, I hope to show how historical experience remains a vibrant concept for humanistic inquiry in the digital age. Rooted in Karl Marx's pioneering claim that the senses are themselves historical, I offer this study as a contribution to the history and theory of media as they inflect and transform human experience. There is still so much work to be done on these emerging subjects. I hope, then, that this study will contribute to ongoing efforts to theorize digital media and to imagine new modes of thinking, feeling, and being historical.

1

OUT OF HAND
Animation, Technics, History

Unhanded

There is a maddening game called *Cookie Clicker*. Released free online in 2013 by French programmer (Julien) Orteil, *Cookie Clicker* has been called a nongame, an art game, and, most evocatively, an idle game. You can't lose. You also can't win. Eventually it's not clear you're involved at all.

The goal is to accumulate cookies. Just click the image of a cookie to get more. With each click the cookie pulses against an animated background of raining cookies and undulating milk. Very soon you accrue enough cookies to buy another "clicker" beyond your own hand: a white-gloved manicule. Native to graphical user interfaces since Susan Kare's original designs for Macintosh icons in the 1980s, these little hands click automatically at a regular rate so you don't have to.[1] The manicule has a long history going back centuries through print and manuscript cultures. In such contexts, "the function of the manicule" is to aid the reader in asserting mastery over a text, to organize and to annotate, "to prevent the text from *getting out of hand*."[2] In *Cookie Clicker*, however, the function of the manicule is the opposite: to demonstrate how very *out of hand* everything already seems to be.

Very soon you get enough cookies to buy more manicules as well as other avatars of automatic accumulation: grandmas, farms, mines, factories, banks, temples, and more. Having outsourced the hand's ability to click to an increasingly effective and colorful collection of modes of production, one gains sublimely absurd numbers of cookies. Of course, you can still click the cookie, but it makes less and less sense to do so when the game garners hundreds, thousands, millions, billions, trillions of cookies per second on its own. Eventually, *Cookie Clicker* plays itself and a feeling

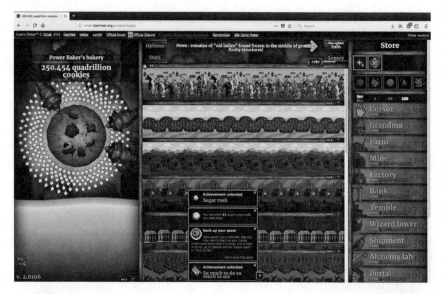

Figure 5. Cookies and more cookies. Full-browser screen shot of *Cookie Clicker* by Orteil.

of networked attachment supercedes active gameplay. After a few days, I begin to check in with it more than I "play" it in any active sense. Cookies pile up as I'm doing other things. As I write this now, the game runs on and on in a minimized web browser. Out of sight and out of hand, the game nonetheless exerts a lateral computational presence. The computer's fan spins and spins. A hand by other and unrecognizable means, its whirring indexes a material struggle to render the game's uneventful animations.[3] Things seem to be happening, but I'm less and less a part of the action.

Cookie Clicker is a game about computing. Like a Lovecraftian adding machine counting into oblivion, *Cookie Clicker* offers a wry, weird rebuke to the idea of interactivity, often thought to be central to digital aesthetics. Far from expanding human experience through play or cybernetic possibilities, the game makes plain how little computers need people. By doing so, *Cookie Clicker* articulates what it means to live in relation to digital media as the infrastructure of experience. It gives the lie to the myth of any one-to-one or happy, symmetrical relation between individual personhood and the operations of technology (a myth fostered

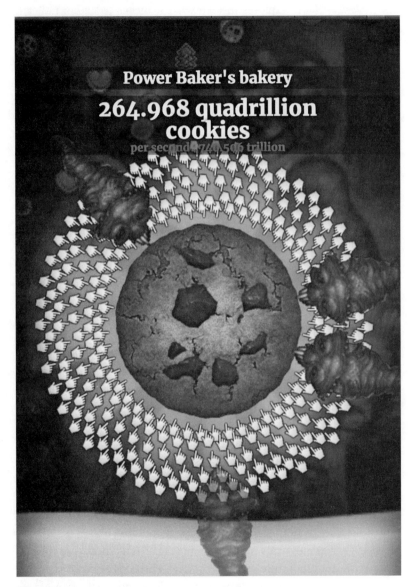

Figure 6. Manicules "out of hand." Detail of screenshot *Cookie Clicker* by Orteil.

conspicuously by the imagination of computers as "personal comput-ers"). *Cookie Clicker* explores instead what it means to live in radically asymmetrical relation to the opacity of digital media and their opera-tion over and above human experience. *Cookie Clicker* makes obvious the startling, nonobvious fact that computational events overwhelmingly do not address human perception. Whereas we now largely entrust cal-culation to digital computers, the very word calculation derives from the Greek word for small pebbles manipulated by hand.[4] We count in tens because we have ten fingers.[5] Computers face no such embodied restric-tions, and use binary. The rhetoric of digital media sometimes tries to ignore this reality, as when it addresses users in the second person. This trend leads media critic Wendy Hui Kyong Chun, observing the influ-ence of *you*tube and other *you* brand names in digital culture, to play-fully rebrand media as "N(YOU) media."[6] However, as much as they are marketed toward individual experience, digital media are *not for us*; they work far beyond the purview of our individual perceptual and cognitive experience. The cookies pile up and up and up.

Cookie Clicker is also about history. The game evokes the curious specter of browser "cookies," the much-maligned data feeding a web browser's "history."[7] A banner message appears at the start of the game: "Unsurprisingly, this website uses cookies for ads and traffic analysis." Cookies also enable a user to save her game without registering an account. HTTP cookies are what situate you online; they provide con-text and orientation. Cookies remember passwords and usernames. And they do so precisely so you don't have to. Of course, it's hard to trust cookies, and many people don't or simply can't. One may try to get rid of cookies by clearing the browser history or cache, but this never quite works. Just like the game and much of digital media, browser cookies keep working and working in excess of any direct input. They just seem to be "already there." This engine of contemporary historical experi-ence works one way or another in excess of anything one does. Despite all this, the game remains pleasurable precisely as a function of the ani-mated withdrawal of the experience of play. History goes on without us, or to the side. In the meantime, we see a circle of animated white-gloved hands standing in for our own, poking and poking a giant cookie.

This chapter is about how we get to a world in which *Cookie Clicker* makes any kind of sense.[8] How does such a seemingly absurd object come

to instantiate historical experience in the digital age? The key to answering this question concerns *Cookie Clicker*'s out-of-hand aesthetic and the way it thematizes the experiential opacity of digital media. In *Cookie Clicker*, gameplay (if it may be called that) amounts to a manifest divergence between the agency of the human player and the operation of the game as software. This dynamic has multiple aesthetic effects. It magnifies the game's cosmic horror aesthetic, but it also presents an especially astute vision of historical experience. *Cookie Clicker*'s out-of-hand aesthetic cuts to the heart of the problem facing the expression of digital historical experience: the broad sense of *existential* disenfranchisement characterizing so much of the experience of contemporary technology. Historical experience in *Cookie Clicker* appears as *not for us*. The cookies keep multiplying without direct input. At the same time, *Cookie Clicker* presents such historical experience as *already there*, already up and running: "this website uses cookies." As Bernard Stiegler observes, following Martin Heidegger, our sense of history derives from the fundamental fact of experience that the past always already runs ahead of us. The past always precedes us in any and all encounters we have with the world.[9] Wherever we are, something appears to us as having happened before. The decisive difference of the digital age is that the *already there* manifests as computational obscurity. Something happened here, but also elsewhere.[10] Something happened elsewhere or otherwise, yet I feel its effects here as a body a bit distanced from itself: unmoored, a little bit here and partially elsewhere in the once exotic (cyberspace!) but now commonplace (Facebook) feeling of living in a digital world up and running and already updated more times than anyone might count. As several critics in new media studies note, the human environment has become increasingly digital, networked, and computational in recent years.[11] This change brings about significant alterations in the ways we experience the environment, and by extension, the nature of the *already there* as a crucial part of the environment. Whereas philosopher Maurice Merleau-Ponty, for instance, imagined the phenomenal world in the mid-twentieth century as what may be touched in the sense of directly grasping ("my surroundings as an ensemble of manipulanda"), the digital world now manifests as a series of environments defined by touch without grasping or active manipulation.[12] Touchscreens and kinetic interfaces may afford tactile experiences, but they do not afford experiences

of touch in the same sense of active manipulation that Heidegger famously calls *zuhandenheit*, "readiness-to-hand" or "ready-to-hand," which presupposes that what we grab will either conform to or resist the shape, strength, and native skill of our hands.[13] If you have ever pressed the return key extra hard to open a link and realized that it makes no difference at all, then you will know what I mean. Today, to the extent that the environment itself appears precisely in its digitality, it shows up not via the human hand, but rather as *animation* in the already-up-and-running appearance of digital media, as if somehow autonomous or out of reach. Animation renders phenomenal the operation of digital media in their operationality, obscurity, and apparent independence from direct human experience. Because animation is a field of aesthetic forms based in the perception of absent causes, it becomes perfectly suited to this strange new state of affairs in which the world appears to our experience as always here and as something else from somewhere we can never go: the opacity of digital machines.

So how did we get here? *Cookie Clicker* vividly expresses historical experience through the opacity of technology. It also represents only one in a long line of artworks to address this condition through motifs of unhanding, the out-of-hand, and what film historian Donald Crafton calls the "hand of the artist." This chapter sketches the techno-aesthetic genealogy of *Cookie Clicker*'s out-of-hand expression of historical experience in animation aesthetics. It reaches back all the way to the birth of modern animation during the Industrial Revolution, proceeds through early film animation to Hollywood cinema, and ends up back again in the twenty-first century with Phil Solomon's experimental digital video *Last Days in a Lonely Place*. Tracing this genealogy marks the first step toward answering the core question of this book: how do digital media affect historical experience?

To take this step, however, we will also need to take a half step sideways to reframe animation beyond the purview of film history and to situate it in terms of Stiegler's theorization of technics. Without abandoning film history altogether, I approach animation in an expanded sense guided by scholarship in precinema and digital studies and Stiegler's trailblazing account of technics as the story of humankind's originary and dynamic relation to technology. As Stiegler teaches us, "technics" refers both to a process of *exteriorization* (essentially, people making things)

and to *epiphylogenesis*, or "the pursuit of life by means other than life." This second aspect of technics becomes significant, as Stiegler stipulates, only during the Industrial Revolution, when technology first appears to possess a kind of life of its own *as a general condition* of lived experience. To be sure, automatons and the like have long flirted with the idea of nonorganic life. But the industrial proliferation of technics in the nineteenth century ushers in a qualitatively new apprehension of technology and its development as somehow independent from human influence and experience.

This insight becomes even more important in the digital age as technology comes to saturate experience ever more deeply. While these epochal changes are abstract, *Cookie Clicker* and the other texts discussed below offer a way to grasp the historical and the historicizing nature of technics. Put more simply, *Cookie Clicker* reminds us that the history of technology is also the history of the human hand. This story is also, at root, the story of the changing relation between human experience and technology. Building on Stiegler, this chapter and this book argue that the story of the relation of human experience to technology has a remarkably expressive aesthetic correlate: animation. The history of the hand and technology is also the history of animation, which begins in its modern form of motion arising from the rapid presentation of successive separate images only during the Industrial Revolution.

With this formal and technical sense of animation in mind, I want to argue also that animation should be understood broadly as an aesthetic symptom of the experience of technology's rapid development and operation "out of hand." Following what I take to be the primary lesson of Walter Benjamin's writings on Mickey Mouse in the context of Nazi Germany, I approach animation as a field of aesthetic forms uniquely suited for coping with the alienating and exhilarating technologization of life.[14]

Finally, it is not just the confluence of the hand, technology, and animation that get us back to the present of *Cookie Clicker*. To arrive back at the present, we need to understand why these histories contribute to a new and meaningful way of experiencing history from the vantage point of the digital present. More specifically, our task will be to view animation aesthetics in the digital age as a powerful new discursive form of historical experience, not merely as reflective of the insensible operations of digital technology, but rather as a phenomenal aesthetic manifestation

of the experiential opacity distinguishing the digital age. Tracking the evolution of the hand of the artist from the nineteenth century to the twenty-first allows us to get a grip on how truly out-of-hand our experience of technology has become.

The Digital Ubiquity of Animation, or Animation as the "Already There"

Historical experience depends on perceptual access to traces of the past. Stiegler, following Heidegger, elaborates this idea as the *already there*. He writes, "What Heidegger calls the already there . . . is this past that I have never lived but that is nonetheless my past, without which I never would have had any past of my own."[15] A shard of pottery, scratches on the kitchen counter, houses in a neighborhood, inscriptions on paper— all these phenomena signify *something happened* before I was here. Something was *already there*. Perceptual encounters with the material evidence of the past shape our relation to historical experience. What happens, then, when digital media function more and more as the generalized infrastructure of experience? How does historical experience persist when the digital trace of the past withdraws from perceptual experience? This is where animation comes to matter for historical experience in the digital age. While animation has often been celebrated by critics for its capacity to dramatize the labor of its own making, it remains equally true that animation thrives on the insufficiency of what we see as an explanation for why.[16]

Catching a glimpse of the puppet's strings does not undo the magic of the puppet show. Indeed, animation has much in common with stage magic. A bit like the magician who entreats his audience to watch closely only to beguile with prestidigitation (literally, "fast fingers"), the animated moving image hides nothing yet inspires talk of invisible forces.[17] Often described in terms of the mind, soul, or spirit (*psyche* or *anima*) or by way of vitalist vocabularies ("energy" or the "breath of life"), animation uniquely expresses itself as the manifestation of absent causes where such causes may be literally imperceptible or simply insufficient in accounting for our experience.[18] It is perhaps no wonder, then, that animation has become the aesthetic correlate of digital media as the *already there* of historical experience.

It may seem that, in claiming that animation has become the aesthetic correlate of digital media, I am exaggerating the case of animation's newfound prominence. We are so used to thinking of animation as a paltry thing or a somehow dubious object for serious inquiry, such as in animism, which has been described since the late nineteenth century by anthropologists in Western modernity as a series of beliefs acceptable only in children, the irrational or insane, or cultural "primitives."[19] But I am not sure I actually can overstate the importance of animation to the digital age. Animation may seem a bit boutique by academic standards, but things have begun to change in this regard since at least the early 2000s.[20] To the degree that one accepts that digital media themselves have become ubiquitous in postindustrial Western cultures since the 1990s, which has become a truism in much scholarship on digital media, one must recognize at least that animation has also grown in cultural prominence. If digital media represent the *already there* of contemporary historical experience, their manifestation to experience is perhaps first and foremost as animation. Without belaboring the point, let us quickly take stock of the emergent ubiquity of animation, which unmistakably parallels the popular dissemination of digital technologies and the diffusion of digital cultures into culture as such.

The digital age is also an age of animation. As several critics have noted, animation has a special affinity with digital media that goes beyond cartoons.[21] The Mosaic web browser, the predecessor of Chrome, Firefox, and Safari, debuted in 1993, the same year that saw the release of Steven Spielberg's CGI (computer-generated imagery) blockbuster *Jurassic Park*. It was followed by a number of further CGI blockbusters, including George Lucas's *Star Wars* prequels (1999–2005), Peter Jackson's *Lord of the Rings* trilogy (2001–2003), and the *Harry Potter* films (2001–2011).[22] All immensely popular, these series and their imitators effectively normalized the appearance of motion-capture-based characters, as well as characters entirely produced and animated in digital postproduction. Less epic but no less successful, 1995 witnessed the release of another digital trendsetter: Pixar's *Toy Story*, the first popular feature-length computer animated film. Beyond the silver screen, animation and digital animation increasingly thrived on the small screen too. The Cartoon Network launched in 1992 as the first television network devoted to animation, and also notably marketed toward adults (especially with

their often absurd and avant-garde offerings during the "Adult Swim" late-night hours). In Japan and then in the United States and globally, anime became a powerful genre for exploring digital culture through animation in the 1980s and 1990s, most famously in the 1995 film *Ghost in the Shell* directed by Mamoru Oshii.[23] All videogames, too, might be approached as animation. While their history stretches back decades earlier, the videogame industry exploded and their claims to broad cultural significance gained new credibility in the 1990s and 2000s with advances in graphics processing units enabling more sophisticated and realistic animated imagery, as well as networked play. Rounding out the arts and entertainment, works of print literary fiction began to incorporate flip-book-style animation around this time, too, including in Jonathan Safran Foer's *Extremely Loud and Incredibly Close* (2005) and Steven Hall's *Raw Shark Texts* (2007). Electronic literary works of the time also often incorporated animated elements, most notably during the 2000s heyday of Flash animation works such as those by Young-Hae Chang Heavy Industries.[24] Animation now even refers to a style of dance, a variant of "popping" that is most famous for "the robot." Finally, the white cube world of art galleries and museums began to recognize animation in video art and installation and as a topic of general cultural significance in the 2000s.[25]

Beyond the arts and entertainment, animation pervades digital visual culture on an even more fundamental level. Animation appears in a number of web graphics elements and genres, from pop-up advertisements and "throbbers" (e.g., the ever-overturning hourglass or the spinning beach ball of death) to progress bars and animated GIFs. Across business and professional cultures, animation effects may often be seen in presentation software such as PowerPoint, Prezi, and Keynote. Sometimes undesired animated elements appear, too, such as glitches or Clippy, the Jar Jar Binks of Microsoft Office software ("It looks like you're writing a letter"). Though they are not often referred to as animation per se, animated elements represent a basic formal technique of data visualization and, as such, appear across the sciences, from biological simulations to physics visualizations and climate change forecasts. Indeed one encounters digital animations virtually wherever one finds a screen of any kind: in taxi cabs, on smartphones, on car stereo and GPS displays, in elevators, at ATMs, in supermarkets and airports, and especially

throughout urban spaces. Just how deep does the connection go between animation and digital media? Essentially, wherever one finds screen-based digital media, one encounters animation! Dennis Tenen helps to explain this claim: "Screen reading further happens on screens that refresh themselves at a rate of about 60 cycles per second (Hertz). The digital word is technically an animation; it moves even as it appears to stand still. This property attunes the reader to a particular mode of apprehension, affecting not just the physics but also the aesthetics of digital media."[26] Adding to Tenen's precise formulation in the context of literary studies, I would add that *all* digital images (from words to images to any visual element whatsoever on a digital computer screen) are, in essence, *animations*. Insofar as everything that appears on a computer screen bespeaks an absent cause, everything that manifests to human perceivers on a computer screen is animation. As is made clear in the rise of digital assistants such as Amazon's 2014 Alexa and Apple's 2017 HomePod and other smart-networked technologies such as RFID and environmental sensors, the animated character of digital media goes beyond the screen. The distributed character of networked technologies only adds to the emerging experiential consensus that animation now pervades culture as a function of the broad and atmospheric reach of digital media. As Beth Coleman writes, "everything is animated."[27]

To be clear, animation is not synonymous with digital media. Animation appears, instead, as the fundamental mode of phenomenal address by digital machines to human perceivers. So, while animation and digital media are both everywhere, they are not the same. And this is precisely what gives animation its critically expressive power to address the experiential opacity of the digital age, both from within its dynamics and also potentially standing aside or with some critical distance. No longer mere kids stuff or the domain of fuzzy animals with big eyes, animation has become remarkably mainstream. At the same time, it retains what I might only insufficiently characterize as its essential weirdness, its affinities with the uncanny, the nonhuman, and life by means other than life. As fears of cultural and experiential homogeneity often afflict those thinking about the digital present and future, the ubiquity of animation offers cause for critical and aesthetic hope. For this book, then, it is certainly the case that not all animation offers critical insight into the changing nature of historical experience. However, as an aesthetic symptom of the

changing relation between humans and technology—indeed as a privileged modality of the digital *already there*—animation offers a compelling vantage point from which to consider how historical experience persists.

The Nineteenth-Century Origins of Animation: Crary, Marx, and Stiegler

Again, how did we get here?[28] Film theory and history, the disciplines one might look to first to answer this question, remain puzzled.[29] In "The Myth of Total Cinema," film theorist André Bazin offhandedly muses on the "disturbing" fact that the phenakistoscope (a hand-held animation toy) was invented only in 1839, rather than much earlier. It is possible, Bazin surmises, to imagine a phenakistoscope with images that are photographic instead of drawn. One could thus conceive of cinema prior to the advent of such supposedly vital technological features as instantaneous photography and the Maltese cross. "The photographic cinema could just as well have grafted itself onto a phenakistoscope foreseen as long ago as the sixteenth century," Bazin writes.[30] Of course, the phenakistoscope did not exist in the sixteenth century; it was not invented until the mid-nineteenth century. Though he does not pursue the issue, the question arises of why animation in its modern form of successive images emerged only in the nineteenth century when it was technically possible much earlier. The history of the magic lantern, for instance, goes back centuries earlier, but it is not until the invention of the choreutoscope in 1866 that such lanterns began to present animated images as the rapid succession of individual frames. And while many have supposed that the flip book dates back centuries, perhaps even to the fifteenth century, there is no concrete evidence of its existence prior to the nineteenth century.[31]

In short, modern animation began in the nineteenth century. It begins, moreover, as a reaction to life during the Industrial Revolution. But why? Jonathan Crary provides the most succinct explanation. As Crary observes, a suite of animation devices, or philosophical toys, emerged in the nineteenth century: the thaumatrope, phenakistoscope, zoetrope, kaleidoscope, and many others. Crary's main argument is that the cross-pollination of physiology and optics led to an entirely new

regime of vision during this time, an embodied viewer epistemically distinct from what he terms the earlier *camera obscura* model of vision. Less prominent in his account, but no less vital, are his observations that many of these early devices were invented precisely as responses to the experience of industrial technology, specifically the wheels of fast-moving trains and other whirling industrial machinery: "New experiences of speed and machine movement disclosed an increasing divergence between appearances and their external causes."[32] It is difficult to overstate the importance of this claim. Modern animation essentially emerges as a response to the experiential opacity of industrial technology. In their accounts, cited by Crary, innovators Jan Purkinje, Peter Roget, and Michael Faraday all report curious perceptual phenomena in their observations of wheels seeming to slow down even as they speed up or moving in illusionistic reverse. Their inventions represent experimental responses to these experiences. In sum, as Crary's text implies, animation in its modern form of sequential images was fostered in the aesthetic incubator of the Industrial Revolution when technology was starting to become very fast, incredibly productive, and perceptually overwhelming.

It is at this moment that the hand appears as a central character in our story. Looking forward toward the late nineteenth century, the twentieth, and the twenty-first, the hand will shortly be relegated to a supporting role and then a bit part, and then finally as maybe an extra whose scene has been left on the cutting room floor. Animation has long been known as a mechanical process, the product of frames, projection, and intense labor. Yet, at the precise moment of animation's historical emergence, it appeared as a manual practice demanding dexterity and hand–eye coordination. To produce the synthetic image promised by the thaumatrope, one holds two strings between thumb and forefinger and twists them to spin the double-sided disk hanging just taut enough in the middle. A bird and a cage have become a bird in a cage! The phenakistoscope requires holding the device up to a mirror and peering through one of its slats while spinning it around. Spinning the disk by hand, one sees not just one moving image but many arranged in a circle. The zoetrope also involves manually spinning its apparatus: a drum with slats and a strip of paper inserted inside with variations on a moving figure. Without anything like an industrial, mechanical standard to govern the presentation of images, the viewer's hand and eye work together to

animate the image. Later innovations such as the mutoscope (1894) and even early Lumière cinematograph cameras add a mechanical crank. The addition of a crank allows for greater regularity and control over the animation image, but it still requires a human operator. More and more beholden to the demands of the filmic apparatus, for much of the twentieth century the film projectionist continued to play a largely unseen role in manually projecting films. The advent of DCP (Digital Cinema Package) turned the projectionist, as Michelle Puetz observes, into "an IT person learning how to read code," no longer in charge of film reels, but rather of a package of files accompanied by menus for subtitles and the like.[33]

While it is sometimes observed that the digital age has brought about a decline of handicraft, the trend began in the nineteenth century. Karl Marx was among the first to describe the broader situation of industrial technology outpacing the human body, a story told in miniature in the shift from handheld and manipulated animation devices to more mechanized and automated forms. No other nineteenth-century observer so keenly recognized the changing historical relation between human experience and technology or so aptly grasped the experience of

Figure 7. The phenakistoscope. Photograph by Chad Davis.

this historical shift in terms of both the increasingly opaque nature of technology and its seemingly animate character. Although *Capital* remains primarily a work of political economy, I turn to it here for its insightful descriptions of the experience of the Industrial Revolution in terms that exceed individual turmoil and enter onto a more broad and historical plane of critical imagination. Marx frequently paints vivid pictures of commodities and machines operating beyond the scope of consciousness and perception. In doing so, he frequently turns to animation as a key motif in his thinking, such as in this famous passage on the nature of commodity fetishism:

> The form of wood, for instance, is altered if a table is made out of it. Nevertheless the table continues to be wood, an ordinary, sensuous thing. But as soon as it emerges as a commodity, it changes into a thing which transcends sensuousness. It not only stands with its feet on the ground, but, in relation to all other commodities, it stands on its head, and evolves out of its wooden brain grotesque ideas, far more wonderful than if it were to begin dancing of its own free will.[34]

Equal parts Pinocchio and political economy, Marx describes the commodity as standing on two feet, standing on its head, having ideas, and dancing. Much ink has been spilled over this rich passage concerning the commodity's mediation of social relations.[35] Here I merely wish to underscore the centrality of animation to Marx's critical imagination of industrial capitalism.[36]

The human hand plays a key role in several passages Marx devotes to describing the animated character of industrial machines. In the chapter devoted to "Machinery and Large-Scale Industry," Marx narrates the gradual diminishment of the human hand as the key site of labor in the historical progression from handicraft to manufacturing to large-scale manufacturing. The move from handicraft to manufacturing subtly transfers the productive agency of the worker from the hand of the craftsman to an industrial mode of production. The subsequent move from manufacturing to large-scale industry shifts the agency of production further away from the human body. It is as if, for Marx, the machine subsumes the creative power of the hand, which becomes an unrecognizable property of industrial machines the bigger and faster they become. Animation becomes crucial in this context as a topos through which to

imagine the relation of human experience to the rapid historical pace of technological development.

At each stage of the development of the technocapitalistic mode of production, the hand plays less and less of a central role. Marx chronicles the replacement of "the hand itself" and the concomitant rise of self-reproducing machines with a seeming motion of their own.[37] His comments are remarkable for their figurative emphasis on the autonomous and even supernatural movement of machines: in a word, their attention to the *animate* dimensions of industrial technics. He writes, "as soon as tools had been converted from being manual implements of man into the parts of a mechanical apparatus, of a machine, the motive mechanism also acquired an independent form, entirely emancipated from the restraints of human strength."[38] Such a "system of machinery," as in large-scale manufacturing, he continues, "constitutes in itself a vast automaton as soon as it is driven by a self-acting prime mover."[39]

In these passages, Marx frequently invokes Aristotle's idea of the prime mover, provocatively substituting a vision of technology itself as the industrial "prime mover." His recognition of technology as somehow ontologically fundamental and not just supplementary to human life anticipates in many ways themes in twentieth- and twenty-first-century media theory. Moreover, his prescient recognition of animation as a crucial dimension of the experience of this fundamental shift also looks forward to themes more widely recognized only with the proliferation of digital technologies. He elaborates:

> Here we have, in place of the isolated machine, a mechanical monster whose body fills whole factories, and whose demonic power, at first hidden by the slow and measured motions of its gigantic members, finally bursts forth in the fast and feverish whirl of its countless working organs.[40]

Animation pervades Marx's description of the encounter with large-scale manufacturing. The operation of technology exceeds the grasp of human control and perception due to its tremendous scale and speed. Instead of describing things he cannot actually see, Marx employs a rhetoric of animation to convey the historical experience of this new form of technology. Like the warning in so many twentieth- and twenty-first-century works of science fiction, Marx's account of large-scale industry registers

the felt impact of the new threat of technology to overrun and displace not only human labor and comprehension but also something like the human more generally. Marx's emphasis on the reproductive capacities of machines further inflects his remarkable account of the animate character of nineteenth-century technology. For Marx, machinery was required to adapt to the mode of production it had itself inaugurated. Recalling the commodity fetish's capacity to stand on its own two feet, he elaborates:

> Large-scale industry therefore had to take over the machine itself, its own characteristic mode of production, and to produce machines by means of machines. It was not till it did this that it could create for itself an adequate technical foundation, and stand on its own feet.[41]

An unprecedented shift transpires: in place of human labor, machines assume the role of making other machines. They effectively become "self-reproducing," not in any biological sense, but rather in their disengagement with the hand as the traditional point of generative exteriorization. In order to prove adequate to the transformation of labor, "the means of communication and transport gradually *adapted themselves* to the mode of production."[42] Marx anthropomorphizes the new machines at the same time that he sensationalizes their operation as monstrous. I do not take this to be a shortcoming, but rather an authorial effort to characterize this historical shift in an experiential idiom.

Stiegler's late-twentieth-century theorization of technics helps to realize the full meaning of Marx's emphasis on the recession of the hand in concert with the animate character of industrial technology. The evolutionary framework of Stiegler's project radically opens up the historical dimensions of the unfolding relations of the hand and technology. Looking forward to the contemporary efflorescence of animation in digital visual culture, Stiegler's philosophy of technics furnishes the larger framework necessary to grasp animation as an aesthetic symptom of the historical experience of the changing relation between humans and machines.

Stiegler defines "technics" in two distinct but related ways. In the first definition, he follows paleoanthropologist André Leroi-Gourhan in defining it as a "process of exteriorization." For Léroi-Gourhan, exteriorization denotes the human body's capacity to place "itself" or its

processes outside the body.[43] In this sense, writing exteriorizes memory and cooking exteriorizes digestion. In the larger evolutionary context of Léroi-Gourhan's (and Stiegler's) discussion, the innate capacity to exteriorize defines human beings as *essentially technical*. This is because we have been tool users much longer than we have been *homo sapiens*.[44] Far from being a technique of twentieth-century technoculture, technical exteriorization is a prominent engine of human evolution. As a process of exteriorization, technics names a capacity for both biological and cultural "evolution." In both, "technics" names a process feeding back into the development of the human species. In the biological, we have the brains, hands, and faces we do because we have "always already" been tool users. In the cultural, everything we put out into the world—artifacts, technologies, rituals, language, and so on—is "exteriorized" and, following the logic introduced by Ludwig Feuerbach and elaborated by Marx as commodity fetishism, the exteriorization of our ideas and lives returns to us as quasi-objective or natural.[45] Technics takes on a life of its own. The full implications of this idea do not become clear until the Industrial Revolution, the historical moment when it becomes impossible not to reckon with the apparent autonomy of industrial technics.

Stiegler's second definition of technics is as *epiphylogenesis*, or "the pursuit of life by means other than life" (17). This definition accounts for the possibility latent in the first definition of technics as exteriorization, as taking on an apparent life of its own. Drawing on Gilbert Simondon's own engagement with Marx, Stiegler's secondary theorization of technics as the pursuit of life by means other than life responds to the idea in Marx that industrial technology becomes "self-reproducing."[46] Recalling Marx's delineation of the increasing withdrawal of the hand from the technological mode of production, Stiegler describes the advent of the "industrial technical object" in the mid-nineteenth century as catalyzing a crucial shift in the relation between human experience and the productive force of technology: "The human is no longer the *intentional actor* in this dynamic. It is its *operator*" (66). Human agency does not assert overt dominance over the industrial technical object in the way that it did with previous technical objects that we might call tools. The industrial technical object, then, is not a mere instrument subject to manipulation by the hand. It appears animate and autonomous. It pursues life

by means other than life as a direct function of its withdrawal from the mastery of the human hand.

This second definition provocatively affirms the extra-intentional and inventive nature of technics. What appears in Marx's *Capital* as a literary flourish of the nineteenth-century imagination responding to the transformation of experience by industrial technologies now features as a core principle of Stiegler's philosophy of technics. This profoundly anti-instrumentalist philosophy of technology powerfully reconceptualizes the relation between human experience and technology. If the first definition tacitly suggests the mutual constitution or transductive relation between human experience and technology, the second definition insists on it. Stiegler puts the matter succinctly: "Technics as inventive as well as invented" (137). This idea has radical implications for the theorization of historical experience.

Although history is a minor theme in Stiegler's philosophy of technics, it is nonetheless crucial for synthesizing the two definitions of technics as exteriorization and as *epiphylogenesis*. If the written historical record represents one way in which humans exteriorize their own experience as tradition, then the second definition of technics in particular requires rethinking the assumption that the same historical record is merely the inert record of human hands inscribing records of the past. If technics is, to follow Stiegler, inventive as well as invented, it follows that those same inscriptions have a sort of life of their own. The historical record ought to be regarded, too, as inventive as well as invented, "creative" in itself over and above any flat sense of it as merely "written."

How truly *inventive* can technics be? In the case of historical experience, Stiegler's answer to this question is quite conservative and does not seem "inventive" in any way that maintains fidelity with Marx's imagination of the experience of self-reproducing machines. Instead, Stiegler consistently employs a rhetoric of individual personhood in describing the phenomenology of history: "What Heidegger calls the already there . . . is this past that I have never lived but that is nonetheless my past, without which I never would have had any past of my own" (140). For Stiegler, the inventive character of technics realizes itself in individual experience: "Epiphylogenesis bestows its identity upon the human individual: the accents of his speech, the style of his approach, the force of his gesture, the unity of his world" (140). For Stiegler, historical

experience emerges in the realization that individual human life owes its shape and contour to all that precedes it. This is a brilliant observation. But all the same, I do consider it partial, and therefore insufficient in accounting for what Stiegler otherwise emphasizes (along with Marx and Simondon) as the tremendous shift in the relation between human experience and technology in the context of the Industrial Revolution, an explicit thread of thought occasioned by his own stated concern with the "deep opacity of contemporary technics" (21). What if we take animation as the lens through which to view the inventive nature of technics, and not, as Stiegler does, individual personhood? Instead of speech and gesture, what if we took more literally (as the contemporary ubiquity of animation in digital visual culture licenses us to do) the *animate* dimensions of the very technologies providing the conditions of possibility for historical experience?

In the following section, I return to the animated image in order to synthesize and advance the insights gathered here from Crary, Marx, and Stiegler. Tracking the long history of what Crafton calls the "hand of the artist" through early animation, Hollywood cinema, and digital experimental cinema, I make my way back to the present moment figured at the outset by *Cookie Clicker* and the experiential withdrawal of digital technologies. By doing so, I insist on the continuing relevance of the human hand as the privileged site through which to examine the changing relationship between human experience and technology. The digital age's reprisal of the industrial era's intensity of technological development provides the context for following Marx's insight into the changing experience of technology in relation to the hand. The animated aesthetics of historical experience, as figured in the hand's increasingly opaque relation to technological production, provides the model for the experiential withdrawal of technology as a key dimension of historical experience for the digital age.

Just before turning to the hand in the context of digital technics, however, let us first briefly note the popular path we are not taking. Discussion of the animate character of technics inevitably evokes a nebulous fear about the obsolescence of humanity and the end of history. There are two basic ways in which aesthetic forms express the historical encounter with the transformation of technics into the pursuit of life by means other than life. Both explore the disengagement of technology

as a matter of its newly apparent quasi autonomy, or *life*. But they do so in decidedly different ways. Just as Marx describes the new machines as gaining independence, narrative forms have generally expanded on this idea thematically through stories of political or existential liberation. This first strategy for representing the transformation of technics is very well known. Such famous works as Mary Shelley's 1818 *Frankenstein*, Samuel Butler's 1872 *Erewhon*, Carlo Collodi's 1883 *Pinocchio*, Karel Capek's 1921 *R.U.R. (Rossum's Universal Robots)*, Isaac Asimov's 1950 *I, Robot*, Philip K. Dick's 1968 *Do Androids Dream of Electric Sheep* and its 1982 film adaptation by Ridley Scott as *Blade Runner*, and the television serials *Battlestar Galactica* in 2004–9 and *Westworld* (2016–) all narrate and express what Félix Guattari calls the machine's desire for abolition.[47] Many other examples might be cited. To recast Stewart Brand's battle cry of the incipient information era, in these stories technology wants to be free. Why? Technology wants to be free precisely because it has life. The "downside" to such stories is that machines invariably work for emancipation by killing human beings if not attempting to eradicate them completely (thus working toward the end of history). The threat of human extinction hovers over these narratives as new forms of artificial life strive to replace us at the top of the food chain. Told over and over again, this narrative tacitly yokes the "life" of technology to scenarios inevitably courting different versions of the "end of history," from nuclear holocausts to worlds where machines enslave humans.

Yet the notion of machines having a life of their own does not need to culminate in the end of history. Even as the bulk of aesthetic output on the subject of the proliferation of technics in the last two hundred years has tended toward anthropomorphizing technics on the general theme of liberation, Marx's writings implicitly contain the possibility of a less well-known alternative: encountering the animate opacity of technics in their historical manifestations precisely as moving images. To the degree that Marx describes the opacity of industrial technics—an opacity that only increases with technical and digital media—as the phenomenal withdrawal of technics from human perception and cognition, he identifies an important second theme for the aesthetic registration of the pursuit of life by means other than life. This second option concerns the experiential opacity accompanying the advent of industrial technics and only increases in relative significance as one tracks forward

into history the relation of human experience to the development of technology. This experiential opacity is, I contend, just as important as its more famous antihistorical cousin exemplified by narrative fictions of liberation, if not more important.

Turning away from narrative representations of animation, in the following section, I analyze the motif of the hand of the artist in moving images from early cinema to digital video. To be sure, these animated works are not strictly "nonnarrative." They depict the development of characters and events over time. They also overlap with the first, dominant notion of animate technology: in hand-of-the-artist cartoons, the drawing and the animator do battle in a way suggestive of the stark "end of history" conflicts one finds in *Terminator* or *Battlestar Galactica*. At the same time, their main appeal is not narrative per se. They are often short, chaotic, ambivalent, and following Tom Gunning's formulation, "attractions" in the sense that they often employ direct appeals to the "camera" in the service of thrills, gags, and surprise.[48]

The conflict between hand and technology depicted in these works also functions as an enjoyably minor and mocking version of the grand conflicts depicted in narratives of machinic liberation in popular science fiction. The hand of the artist depicts something like the foodfight version of the apocalyptic wars of humankind and machines so familiar from popular culture. But this does not mean we should take them less seriously. Precisely by avoiding narrative and grand conflict, hand-of-the-artist works focus attention on the experience of technology as out-of-hand, as withdrawing and withdrawn from experience, without overdetermining the stakes of that experience in teleological, narrative terms as the "end of history." Instead of the end of history, attention to the evolution of the hand-of-the-artist motif in animated moving-image aesthetics focuses, rather, on the more diffuse, pervasive, and ambiguous terrain of the experiential opacity of technology. My sense is that sketching the hand of the artist across more than a century's worth of moving images reveals something of why it feels like history might be ending, but also why it doesn't actually end. Sketched from the early twentieth century to the twenty-first, the evolution of the hand of the artist paints an ambivalent picture of the changing and often fraught relation of human experience to the accelerating pace and operational opacity of modern and digital technologies.

The Hand of the Artist: From Silent Cinema to the Digital Age

The most famous example of the hand-of-the-artist motif is undoubtedly the Chuck Jones 1953 short *Duck Amuck*. In that cartoon, Daffy Duck, characteristically flabbergasted and enraged, struggles against the whimsical decisions of his animator. A paint brush and pencil stand in for the hand of the animator until the very end, when the "camera" pulls back to reveal Bugs Bunny as Daffy's tormentor. Sitting at the animator's desk, pencil in hand, Bugs turns to the camera and quips, "ain't I a stinker?"

As Crafton chronicles, "the hand of the artist" has a long history going back to the earliest years of cinema.[49] Pioneering films from the late 1890s, 1900s, and 1910s by J. Stuart Blackton, Thomas Edison, Emile Cohl, Winsor McCay, and others depict artists battling drawings in scenarios mixing cinema's familiar reproduction of the flux of reality in tandem with its capacity to *animate* otherwise inanimate images and objects. The motif of the hand of the artist depicts the eternal agon of artist and artwork, a drama that shifts in interesting ways as technologies of image production change over time. Recalling Stiegler's theorization of technics, I argue here that the hand-of-the-artist motif concretizes both senses of the word "technics." It represents technics as exteriorization in the sense of showing the very production of the image, but also as *epiphylogenesis*, or the sense of technics as the pursuit of life by means other than life in the depiction of the animated image as quasi-autonomous from its creator.

The hand of the artist is first and foremost a dramatization of immanent production. Following Crafton, the motif has three main elements: an artist, a drawing surface, and drawings. To this list, I want to add a few points. The hand-of-the-artist motif uniquely dramatizes itself as being *in production* at the moment it appears onscreen. This fiction of simultaneity between the film and the time of viewing fuels the constant sense in these works that the image has no predetermined end and that it might veer out of control. This element of uncertainty contributes to the motif's depiction of a struggle for control between the artist and the animated image.

Most fundamentally, the hand-of-the-artist motif centers around the human hand: a uniquely powerful icon for constelling human

experience with technology. Because the hand-of-the-artist motif focuses on the hand, it privileges all the things human hands do: write, draw, manipulate, create, touch, express, produce, and much else. An emblem of humanity as such, the human hand represents the body's capacity for changing the world. Hands are also synecdoches for labor and for humanity in general. They represent social life in a handshake, and they reach out and touch someone. Hands represent the finite capacity of the individual (think Rick Deckard hanging on the edge of a skyscraper at the end of *Blade Runner* or the ceiling of the Sistine Chapel). Hands touch the world, and hands touch themselves. Hands suggest almost too many things. There is, then, perhaps no more appropriate site for tracking the history of technics than the human hand. In Aristotle's felicitous phrase, the hand is the "tool of tools."[50] Stiegler reiterates this claim in a different key: "The hand is the hand only insofar as it allows access to art, to artifice, and to *tekhne*" (113). It is no wonder, then, that the hand remains central to many philosophers' and media theorists' ideas on the relation between human experience and technology.[51] The hand is also, of course, the paradigmatic pedagogical image of digitality, the five fingers of each hand exemplifying the discrete nature of individual digits. It is no accident that so many images of the human hand appear on the covers of so many prominent books in new media studies.[52]

The human hand is also a strangely *animate* thing in itself. To recall Thing, the mobile disembodied hand on *The Addams Family* television show, there is just something about hands suggesting an independence from the rest of the body. Art historian Henri Focillon remarks, "hands are almost living beings."[53] The hand is a key site for imagining life otherwise. From God's hand writing prophecy on the wall in the biblical story of Belshazzar's feast and Adam Smith's invisible hand of the market to William Wordsworth's "forming hand" of Romantic poetic development, and from Charles Darwin's powerful description of evidence for his theory of human evolution based on the similarities in the skeletal structure of hands, paws, and fins, to weird fiction tales of murderous, autonomous, severed hands, the hand has long been imagined as an animate avatar of "life by means other than life."[54] As Peter Capuano shows, the hand emerged as a dominant concern in the nineteenth century precisely for the ways it articulated the changing intersections of human experience in both industrial technology and evolutionary

theory.[55] Building on Stiegler's evolutionary theory of technics, I contend that the hand represents a key site for figuring the changing status of human experience in relation to the accelerating development of technology beyond the purview of individual use, knowledge, or experience. Not only are the products of human production newly animate in the industrial era, but the imagination of this shift draws on the longstanding affinity of the human hand as itself animated. The battle depicted by the hand-of-the-artist motif between animator and animated is not, then, some simple us-versus-them representation of humans against machines. Because both humans and machines are animated, a kind of ontological indistinction suffuses these works, playfully expressing the experiential opacity of the human relation to technology as *out of hand*.

In what follows, I trace the genealogy of the hand-of-the-artist motif in moving images from early cinema to digital video. I do so with the caveat that my efforts are indeed a sketch, perhaps even a *lightning sketch* (to cite the vaudeville genre related to the hand of the artist, in which an artist draws so quickly as to seemingly animate an image in real time).[56] In moving from a Fleischer Brothers' cartoon to Hitchcock's *Vertigo* and then to Solomon's *Last Days in a Lonely Place*, I aim not for synoptic coverage. I aim instead to draw out the fuller implications of Stiegler's theorization of technics for elucidating the efflorescence of animation in the digital age, as well as its critical aesthetic value for expressing historical experience as increasingly *out of hand*.

Released in 1924, the Fleischer Brothers' short *Cartoon Factory* perfectly exemplifies the hand-of-the-artist motif. *Cartoon Factory* appears in the *Out of the Inkwell* series, which appeared from 1918 to 1929, the period running from the earliest years of the studio system and the emergence of the Classical Hollywood Cinema until the advent of synchronized sound in the late 1920s. The lion's share of hand-of-the-artist cartoons appear during this period, and *Out of the Inkwell* may be understood as the capstone series of the genre. Unlike those earlier and often more "hand-crafted" productions, *Cartoon Factory* treats cinema thematically as an industrial art form involving factory-line production, electric switches, and automation. Focusing on the hand in an industrial context, *Cartoon Factory* lies somewhere between the handspun philosophical toys of the nineteenth century, the hand-cranked cinema of the early twentieth century, the vaudevillian "one-man show" nature of

Figure 8. The hand of the artist. Screenshot from *Cartoon Factory* by Max Fleischer (1924).

Figure 9. The animator throws the switch. Screenshot from *Cartoon Factory*.

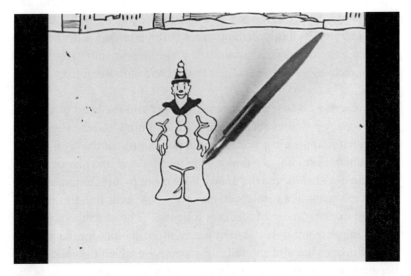

Figure 10. The handless hand of the animator. Screenshot from *Cartoon Factory.*

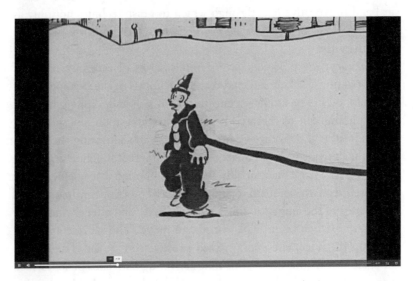

Figure 11. Koko the Clown gets electrocuted by the animator. Screenshot from *Cartoon Factory.*

early hand-of-the-artist cartoons, *and* the fully industrial domain of the Classical Hollywood Cinema and its reality-based rules of editing and composition, which were soon to influence Disney in the 1930s. *Cartoon Factory* marvelously demonstrates multiple tensions in the battle between artist and image symptomatic of the broader shift in the experience of technology as increasingly opaque and withdrawn from human agency.

In *Cartoon Factory*, the cartoon character and the hand of the animator occupy promiscuously mixed realities. Both Koko the Clown and the animator appear in worlds composed variously of the "real world" (the animator's studio), the drawn page manipulated by a photograph of the animator's hands, and the drawn page drawn by an autonomous pencil. Koko's status as a rotoscoped character only feeds into this productive and dizzying series of media ontologies.[57] The unstable mixture of media suggests not only different material possibilities for the production of images but also the shifting grounds on which the relationship between human experience and technological operation articulates and disarticulates itself. In Stiegler's terms, *Cartoon Factory* provides a whimsical and provocative lens through which to grasp technics not only as exteriorization but also as *epiphylogenesis*, the pursuit of life by means other than life.

Cartoon Factory depicts a vertiginous series of exteriorizations of exteriorizations. Taking a deep breath, a synopsis of the cartoon might run as follows. The animator uncaps his inkwell and, dipping his pen, a still photograph of the artist's hand draws a cartoon landscape and Koko's head and then throws an electrical switch activating the pen to finish the drawing of Koko on its own. From there, the action gets more complex in the sense that causality and the assumption that agency derives ultimately from the animator operate more and more openly in question. The hands of the animator affix a wire to Koko, and after the animator throws the switch again, Koko begins to move. The sadistic animator turns up the juice, eliciting a pained protest from Koko. The animator again throws the switch, this time activating a wireless pencil, which forms a drawing machine on wheels. Koko then cranks the drawing machine, setting it into motion (without the aid of the animator). The drawing machine then creates images of a turkey dinner and of a beautiful young woman. Koko responds to each as if they are real.

Recalling "new media encounters" of country rubes with cinema in Robert W. Paul's 1901 *Countryman and the Cinematograph* and Edwin S. Porter's 1902 *Uncle Josh at the Moving Picture Show*, what is striking here is the utter lack of stable reality.[58] Viewers of Paul or Porter can laugh at the inability of gullible viewers within the diegesis of these films to tell the difference between reality and illusion. *Cartoon Factory* offers a more anxious viewing position as exteriorizations give rise to more exteriorizations beyond direct human agency. The rest of the cartoon plays with the increasingly blurry boundaries between reality and illusion. After a trip to the animator's living room, Koko returns to the cartoon world to visit a "machine shop." There he builds toy soldiers resembling *the animator* (including a still photograph of the animator for the soldier's head). Setting the soldier in motion by a string, Koko rides the soldier back into the animator's living room where he oils his neck and sets him in motion. Now acted by the animator himself, the toy soldier draws more toy soldiers (just drawings) on his living room wall. At the animator's/soldier's command, these new drawings attack Koko. Koko employs the drawing machine to erase the charging soldiers and to launch a counteroffensive. The machine then fashions its own army of animators/soldiers. This army chases Koko through the cartoon world into the living room and back out into the cartoon. Eventually, Koko jumps back into the inkwell when the animator throws the switch, capping the inkwell and ending the cartoon where it began.

In many ways, *Cartoon Factory* exemplifies the madcap and playful ontologies of cartoon shorts from the 1920s and early 1930s celebrated widely in critical theory.[59] Along with Felix the Cat and early Mickey Mouse shorts such as *Plane Crazy*, *Out of the Inkwell* cartoons such as *Cartoon Factory* revel in a kind of anarchic plasticity. For various reasons, the anarchic character of cartoons diminishes in subsequent decades, along with the hand of the artist, in celluloid cartoons.[60]

At this point, our story takes a twist. In the mid-twentieth century, the hand of the artist continues but, as Hannah Frank notes, "these hands were always animated themselves."[61] Subsequent versions of the hand of the artist, such as *Duck Amuck*, no longer present such anarchic play with the boundaries between animation and live action. In quite subtle ways, however, the hand of the artist now migrates occasionally

to the domain of live-action filmmaking without any obvious connection to cel animation. Just as the cinema of attractions, as Tom Gunning argues, goes "underground" in the 1910s with the rise of narrative film, so too does the hand of the artist in the long middle portion of twentieth-century film history.[62] Sharing the cinema of attractions' propensity for direct address and showing over telling, the hand of the artist occasionally punctuates moving image works more properly deemed narrative in character. In a longer version of this chapter, we might spend time with Hans Namuth's 1951 *Jackson Pollock 51* or Henri-Georges Clouzot's 1956 *Mystery of Picasso*, each of which features a famous artist producing paintings seemingly without any direct contact between brush and canvas.

Moving forward with an eye cast toward the digital age, our next stop will be the redwood forest scene in Alfred Hitchcock's 1958 *Vertigo*. Picking up on our analysis of *Cartoon Factory*, this scene features the next remarkable inside-out mutation of the mixed-reality drama of the hand of the artist. In moving from cartoons and texts traditionally categorized comfortably within the film genre of animation to live-action filmmaking, the hand of the artist in *Vertigo* privileges decisively different dimensions of the motif. Focusing less on the power of the creative hand and more on its existential fragility, the redwood forest scene opens a space for encountering the indexical function of the hand of the artist.

In moving away from animation traditionally conceived in the mid-twentieth century, the hand of the artist takes a melancholic turn away from its playful origins. The hand of the artist is not only about exteriorization as artistic production. It is also about what happens when technical production exceeds human agency, when all one can do is point and say "there!" The hand and its writing implement do not just draw; together, they *point*. Let us put aside the critical boondoggle of the index's relation to capital-O Ontology in discussions of the materiality of celluloid and digital images.[63] Even as the hand of the artist plays with the ontology of the image, I want to focus here instead on the index in terms of its pedagogical capacity to imagine a simultaneously uncertain and too-certain form of relation between the animator and the animated image. The pointing finger and pen teach the viewer to construct not just the relation between the act of exteriorization and its image,

but rather the uncertain, playful, and ultimately untethered relation between animator and animated, production and image, exteriorization and exteriority.

Consider the oft-cited example from Charles Sanders Peirce's influential account of the index: a weathervane. What matters is not so much that the weathervane bears any necessary, physical relation to the environment, but rather the fact that it points. It teaches us more than a fact about the world, such as that the wind is blowing or last blew this or that way. It articulates an orientation to the world that we ourselves can modify to situate our own experience. Like indexical shifters in language (*you*; *I*; *here*; *today*), the weathervane gestures toward something. More importantly, it establishes a relation between things. The fact or action of pointing, however, in no way guarantees that the same act of pointing will mean anything more than its gesture of pointing. While an indexical relation implies a relation of necessity or contiguity, the hand of the artist deftly recalls that this principle may not apply to human experience, and thus that any pointing may not amount to a gain in clarity or knowledge. Indices indicate a relation notwithstanding the fact that they may not indicate a relationship that is at all obvious, self-evident, or clear in any sense. Indeed, the dramatic force of saying "there!" bespeaks precisely an inability to say what one is pointing at, a failure of language to demarcate the dynamics of a relation. The act of indexing or observing an index in the wild is more often than not an occasion to note the marginality or partiality of one's experience to grasping a situation unfolding on different or experientially unavailable terms.

The redwood forest scene in *Vertigo* perfectly bears out this dynamic of the paradoxical presence of absence. "Somewhere in here I was born, and there I died." *Somewhere*; *here*; *I*; *there*; *I*. The statement consists almost entirely of indexical shifters. There is a lot of *here* in this line, but also a lot of *elsewhere* too. The lines are spoken by the character Madeleine (Kim Novak) during the iconic redwood forest scene, and the words accompany an extreme close-up of a black-gloved hand as it points, hovering hesitatingly over the rings of a felled sequoia, tracing the air, making no inscription. The words follow another shot that lingers over the tree rings in close-up and pans over several labels pointing to famous historical events: "1215 Magna Carta Signed"; "1492 Discovery of America"; "1776 Declaration of Independence." The hand points

to the recent past, but also beyond the famous historical events, as if lingering at the edge of historical experience. Strictly speaking, this is not an instance of the hand of the artist in Crafton's sense. It features no obvious artist, drawing surface, or drawings. At the same time, its composition is inescapably redolent of the hand of the artist. Pointing at the tree's inscriptions of history and speaking in otherworldly, dissociated tones of life and death, the image bespeaks the hand's lack of agency, a lack of agency punctuated by the absence of a pen, and suggests an inability to write one's own story. Viewed in light of the long history of the hand of the artist from the handspun animation devices of the nineteenth century to *Cookie Clicker*'s out-of-hand aesthetic, this haunting scene in *Vertigo* expresses another key moment in the changing relation between human experience and technological exteriorization: the historical moment when the balance of power definitively shifts between the hand and the images against which it negotiates its standing.

Madeleine's gesture represents the inverse of so many of the dynamics characterizing the hand of the artist. In *Vertigo*, the hand is a woman's hand, not a man's. Hand-of-the-artist cartoons are invariably dramas of masculinist creative control. But *Vertigo* inverts this key assumption, and with great motivation. The woman's black, death-shrouded, gloved hand is the opposite of the lively-with-an-exclamation-point cartoon

Figure 12. "Somewhere in here I was born, and there I died." Screenshot of *Vertigo* by Alfred Hitchcock (1958).

minstrel white.[64] Here, an actress (Novak) plays a woman (Judy) pretending to be another woman (Madeline) possessed by the ghost of yet another woman (Carlotta). Hired to play a part and then some, Novak/Judy/Madeleine/Carlotta may be said to be controlled or *animated* by several different men: Gavin Elster (who hired Judy to play his secretly murdered wife Madeleine), Scottie Ferguson (who desperately wants Madeleine to be Judy, and who memorably dresses her up accordingly, as if she were a living doll), Alfred Hitchcock (the director of the film, famous for his overbearing relations with his female lead actresses), and perhaps even, following Laura Mulvey, the male gaze itself in its sadistic reification of the female body as an object of pleasure![65] It is no wonder her gloved hand holds no brush, pencil, or pen. Too many men are busy influencing her actions. Of course, Judy arguably animates herself, caught up as she is in the reality-granting power of her own acting. The endpoint of this dizzying state of affairs is this: *Vertigo* presents a version not so much of the hand of the *animator*, but of the hand of the *animated*. If the Fleischer brothers' *Cartoon Factory* represents a decisive moment in the history of technics illustrating the increasing technological opacity of the relation between lived experience and machinic operation, then the redwood forest scene in *Vertigo* dramatizes the increasingly unmoored and out-of-hand relation between life and technical artifice. The rise of technics as the pursuit of life by means other than life begins to take a toll on human life. In the figure of Madeleine, human experience begins to doubt its own (at least potential) mastery over its creations. Reaching out as if in the act of falling away, Novak's hand points toward what it might have created and controlled, what it once was, but is no more.

For filmmaker Chris Marker, the master theme of *Vertigo* is not the bodily feeling of dizziness, but rather historical vertigo, the vertigo of time.[66] Over and over, the film explores Scottie's (James Stewart) inability to accept the present and his pathological focus on seeing the world in terms of the past. Marker's thesis may be expanded by reflecting on the film's signature concern with *animation*. Saul Bass's vertigo spirals do not appear only in the iconic title sequence. They appear again at key turns (or spiralings) in the narrative. Combining Marker's idea of the film's primary interest in the vertigo of time with the film's animated repetition of its spiral motif, I argue that the vertigo of time may be more

precisely conceived as indexical encounters with the vertigo of historical experience, an experience encapsulated by the redwood forest scene and its evocation of the ghostly and paradoxical present absence of the past. The hand of the artist expresses the volatility of presence and absence. The motif is itself animated not so much by the artist or the animated, but by the manifest divergence between them in the form of the human hand alongside the animate absence of its influence.

Everything comes together and gets undone as Scottie and Madeleine encounter the cross-section of a tree. The spiral (emblem of Scottie's vertigo, the pattern in Madeleine's hair, and the icon of the famous title sequence by Saul Bass) reappears here as a natural image of historical inscription in the form of the tree's rings. The historical labels depict history at its most familiar: landmark dates in the history of Western civilization. This rather obvious pedagogical model of "History" functions as a foil for the film's true investment in historical experience as a sense of a past that is *not for us*. Establishing shots emphasize the relative smallness and implied existential insignificance of Scottie and Madeleine's human drama set against the "oldest living things," the trees, which, as Scottie notes, are two thousand years old. Madeleine's atmospheric "hand of the artist" encounter with the tree eerily reinforces this theme of history untethered from human drama. Gunning describes the scene:

> In an extreme close-up of the outer section of the tree, the woman's dark-gloved index finger points out an unmarked ring within a dark space between the last marked ring and the rim. Off screen she intones in a strange voice: "Somewhere in here I was born"—her middle finger now picks out a slightly more outer ring—"and there I died." She adds, "It was only a moment for you—you—you took no notice." As she stutters over this last phrase, the camera pulls back. Her lips now unmoving, almost as if she had not been the source of the voice we heard off frame in the previous shot, and her eyes oddly unfocused, staring into the distance, she moves out of the frame past Scottie, who turns to watch her.[67]

As if missing a stylus, Madeleine's finger traces the rings of the tree without touching. Her history has already been written.

Shifters abound. As Gunning's sensitive description demonstrates, the film subtly disarticulates the relations between tree, hand, voice, and

identity. And it does so all in the encounter with . . . a tree? Who is the "you" the line of dialogue addresses? Gunning suggests Madeleine addresses the tree, but this answer seems incomplete. Her apostrophic address is, to borrow Barbara Johnson's language, both typically "direct and indirect," making present and animating the "absent, dead, or inanimate entity addressed."[68] The tree is not absent. Madeleine also never names the absent entity in question. All the same, her hand points toward the tree rings, the avatar of the vertigo spiral reappearing throughout the film. Apostrophe here, then, animates what is absent yet also manifestly present by other means: the animating artifice at the very core of the film, a space both inside and outside its diegesis. It is thus all the more striking that Madeleine (a name Marcel Proust connects with memory itself in his novel *À la recherche du temps perdu*[69]) encounters in the tree what cannot be remembered, or at least not named. She points at the vertigo spiral and she points, too, at what she is not and cannot be, both in the film's plot and beyond, a piece of film passing in the flux of projection.[70]

This present absence is the animating kernel at the core of *Vertigo*. Following Marker, we might say that Madeleine addresses the vertigo of history: the sense both of being present to an evidence of the present absence of the past and of the way this presence of the past threatens to overwhelm the thin singularity of any present moment of lived experience. The entire scenario of the hand of the artist has here been inverted. The animator has become the hand of the animated. What was once animated by inscription is now still, even as it recalls animated movement in the form of Saul Bass's animations. The animated character has become the animator. The presence of the past bears down on the hand of the animated (once the animator!) in a manner that makes Madeleine, the figure of human memory par excellence, question her own existence as an anxious knot of artifice. Memory turns itself inside out. No longer the province of human subjectivity and agency able to exteriorize itself as the historical record, historical experience tilts in favor of the machine.

My lightning sketch of the hand of the artist now concludes nearer to the present. The hand undergoes an epochal change with the slow popular emergence of computers. But computers were not always engines of unhanding. As Tenen notes, "early computers were programmed by physically manipulating a complex arrangement of wires and relays."[71]

This regime of computing changed in the 1960s with the development of sophisticated programming languages, and also especially with the 1968 "mother of all demos" delivered by Douglas Engelbart. In that demo, Engelbart introduced the graphical user interface, the ancestor of today's screens dominated by Windows and Macintosh operating systems featuring desktop icons with file folders and a trash can. Engelbart's demo also introduced the mouse, a crucial peripheral that displaced devices like the light pen and other more "direct" modes of computer manipulation. Further developments in computer art and graphics reflect the displacement of the hand. As Grant Taylor notes, the early reception of plotter-based computer art by the art world in the 1960s was perhaps tepid at best. For art critics, the computer represented a "soulless usurper" who "made the artist's hand absent."[72] *A Computer Animated Hand*, an important demo film from 1972 for early 3D computer graphics, developed at the University of Utah by Pixar founders Ed Catmull and Fred Parke, features a disembodied computer animated hand.[73] The film seems innocuous enough as an explanation of how computers create images, but all the same, it is difficult to escape the sense that the computer is somehow recreating the human hand only to replace it. Indeed, the inclusion of these very same images of the hand in the 1976 robots-run-amok science fiction film *Futureworld* only affirms this common paranoid fantasy.[74]

Finally within sight of *Cookie Clicker*, we return to the digital age. It might be said of the 1990s and 2000s that this was the period when the popular imagination learned that there are ways to think about computers other than as vicious engines of human obsolescence (not that this stopped). Other stories began to emerge in full force, in large part occasioned by the meteoric rise of videogames. For instance, it became clear that the digital age was also the *digital* age in the sense of *digits* on the human hand. In a short 2003 essay entitled "All Thumbs," literary theorist Bill Brown observes the rise of videogames as a mass cultural form of global significance inaugurating a new chapter in the technological history of the senses. Citing reports of the qualitatively new dexterity of the thumbs of videogame players, Brown writes, "the hand itself has become a new scene where dramas of the advance guard—where relations among the emergent, the dominant, and the obsolete—have become, say, digitized."[75] Reaching back to the history of cinema while

Figure 13. The empty, darkened clearing among the redwoods. Screenshot from *Vertigo* by Alfred Hitchcock (1958).

Figure 14. Trees quiver in the empty, darkened clearing. Screenshot from *Last Days in a Lonely Place* by Phil Solomon (2007). Courtesy of the artist.

looking forward into the future sensorium of videogame aesthetics, no artwork better expands on Brown's prescient insight than Solomon's 2007 short experimental video, *Last Days in a Lonely Place*.[76]

In *Last Days in a Lonely Place*, Solomon reimagines Hitchcock's handiwork in *Vertigo*'s redwood forest scene, and contributes an important new chapter to the history of the hand of the artist. Solomon's video contains several references to *Vertigo*, including the iconic shot of the Golden Gate Bridge during Madeleine's feigned drowning. Solomon similarly recreates a moment from just after the "hand of the artist" scene examined above. In Hitchcock's original, Madeleine wanders away from the tree and Scottie and into the forest. She walks behind a tree but remains invisible even as Scottie (and the camera) searches for her. For a moment, it seems as if she has vanished unaccountably. The use of an electronic tremolo contributes an eerie, technological atmosphere to this odd moment of absence. *Last Days in Lonely Place* recreates and reimagines exactly this moment. But Solomon also adds a crucial and apparently enigmatic element: two trees quivering and unevenly rotating in the clearing.

Why does Solomon add these trees? The answer, I believe, lies with the way Solomon produces his digital videos: he makes movies by putting down the videogame controller.[77] A student of Stan Brakhage working in the tradition of American experimental cinema, Solomon is best known for his lyrical and evidently hand-crafted, materially distressed manipulations of celluloid film. From the perspective of his oeuvre, *Last Days in a Lonely Place* represents a stunning development.[78] Like his earlier films, it employs found footage. But here the footage is not film, but rather recordings of gameplay from the infamous videogame *Grand Theft Auto: San Andreas* (2004, Rockstar Games). In making these videos, Solomon plays *GTA* in order to establish a scene and then he puts the controller down and records the resulting "action." He records the footage in black and white, completely transforming the anarchic and brash sandbox-style world of *GTA* into a beautiful meditation on grief and absence.

Like the heir to the bizarro world of Winsor McCay and other practitioners of classic hand-of-the-artist animated pictures, Solomon makes his videos by removing his own hand. He removes the hand of the filmmaker-as-gamer, and thus removes the most explicit human agent contributing to the production of the moving image. The effect

is haunting and capitalizes on the game's "ambient act." The ambient act is a feature of many games that functions in lieu of a pause button. Game action ceases but the game world continues on in the absence of player input. During the ambient act, no points are scored. Nothing "happens" from the perspective of the goal-driven/level-up/shoot-'em-up gamer. And yet the wind blows, leaves flutter, fog rolls in, water ripples, and figures sway. As Alexander R. Galloway asserts, the slightly variable and atmospheric movement of the ambient act has no meaning in the context of gameplay: "If the passage of time means anything at all, then the game is not in an ambient state."[79] In Solomon's absent hands, however, the ambient act means everything. By translating the ambient act from *GTA* into a video redolent of film history, the ambient act comes to stand for the past evidence of the hand itself, for the very purposeful play that goes into producing the evidence of the absence of the hand, but it is not now the hand of the animator, but that of the gamer. While the hand of the artist is mainly known as dramas of immanent production, as dramatizations of the hand working at the same time as the animation of its creativity, *Last Days in a Lonely Place* instead de-dramatizes the work of the hand by placing it in a past, yet always hauntingly present, tense. We see only what the hand has done: we encounter its evidence everywhere in Solomon's video, but the hand itself never appears.

Writing at virtually the same time as *Vertigo*'s initial theoretical release, film theorist Siegfried Kracauer describes modern man's situation thus: "He touches reality only with his fingertips."[80] Kracauer may just as well have been describing the way Madeleine's fingers almost touch the sequoia's ringlets in *Vertigo*. Jumping forward to the digital age, and jumping from Kracauer to Vilém Flusser, we might say that humankind no longer makes direct contact with the reality of the past. No longer *homo faber*, humanity is now *homo ludens*. Against all common sense, for Flusser, as for Solomon, the "new human being . . . is . . . without hands."[81] The two quivering trees lend animate presence to Solomon's artistic practice and his reimagining of film history. The two trees evoke the nonpresence of the two characters from this scene in *Vertigo*, Madeleine and Scottie. In Alex Garland's 2018 science fiction film *Annihilation*, one of the main characters turns into a human-shaped plant after prolonged exposure to an alien pathogen that threatens ultimately to end humankind. Something similar, if less menacing, happens in *Last*

Days in a Lonely Place. In Solomon's recreation of *Vertigo*, Madeleine and Scottie have become trees after encountering the digital mutation of the ambient act: everyone's left the theater; nobody's playing the game. Disallowed from proceeding to the next scene, they quiver and rotate, an uncanny amalgam of Madeleine's slight hand quiver and the ancient trees of the redwood forest caught in the pulsing lateral time of the digital age.

Vertigo is far from the only classic film referenced in *Last Days in a Lonely Place.* The video features a treasure trove of references to landmark films including Nicolas Ray's 1950 *In a Lonely Place* and 1955 *Rebel Without a Cause,* Andrei Tarkovsky's 1986 *Sacrifice,* and Gus Van Sant's 2005 *Last Days.* On one level, Solomon's references are deeply personal. *Last Days in a Lonely Place* is dedicated to Solomon's friend and fellow filmmaker Mark LaPore. Solomon and LaPore together created a video using *GTA*: the 2005 short video *Crossroad.* After LaPore's death, Solomon drew on the same footage to create the *In Memorium (Mark LaPore)* trilogy: *Rehearsals for Retirement* and *Last Days in a Lonely Place* in 2007 and *Still Raining, Still Dreaming* in 2008–9. As a group, the videos explore themes of melancholy, existential loss, and a looming sense of meaninglessness. Organized around the same themes in different terms, *Last Days in a Lonely Place* stands out as a profound meditation on the changed and changing status of cinema and film culture in the digital age. As the recurring shot of a cinema marquee without any film title suggests, *Last Days in a Lonely Place* is a video about the absence of cinema, and by extension, a certain passing relation to the historical past embodied in the institution of cinema. It is as though Solomon has refashioned the violent and crass "sandbox-style" gameplay of *Grand Theft Auto* into a dimly lit, mournful, and quivering museum of film history. Considering the many proclamations of the "death" or "end" of cinema in the context of digital media, this choice seems meant to provoke discussion along the same lines. Largely putting aside the fraught terrain of the "end of the cinema," however, as a remarkable digital example of the hand of the artist, *Last Days in a Lonely Place* opens up inquiry into a larger set of considerations of film's future at the limits of film history. Solomon's key provocation is to present us with a vision of history that remains only partially *for us.*

The audio track plays an important role in expressing the sense that the images seen may not be for human eyes. *Last Days in a Lonely Place*

Figure 15. The empty cinema marquee. Screenshot from *Last Days in a Lonely Place.* Courtesy of the artist.

begins with a long audio excerpt from *Rebel Without a Cause.* Accompanied by the game image of the Griffith Park Observatory, the same building that appears in the film, a lecturer impersonally expands on the relative insignificance of our planet and its end:

> The heavens are still and cold once more. And all the immensity of our universe and the galaxies beyond, the earth will not be missed. Through the infinite reaches of space the problems of man seem trivial and naïve indeed. And man, existing alone, seems himself an episode of little consequence.

The audio quotation of the lecture sets the mood for *Last Days in a Lonely Place* as a meditation on the notion of "the end" and end times. It frames the video's interest in the end around the speculative possibility of a time and space without us, an idea also expressed, as we have seen, in the redwood forest scene in *Vertigo* and referenced by Solomon. The inclusion of an audio clip from Van Sant's *Last Days* links the problem of

time unframed for human experience as one tenuously linked to memory and history. "I remember," says an almost inaudible, breaking voice. What does the voice remember? What might memory mean in this odd confluence of game and film space? The film answers with an expedient cut to an image of an empty movie theatre marquee. *Last Days in a Lonely Place* remembers *cinema*. It remembers the absence of cinema.

Solomon's audio quotation of the astronomy lecture in *Rebel Without a Cause* also excises the interrupting banter in the original, the very human teenaged drama of James Dean and other high school students goofing off. This subtle absence of dialogue involving the film's iconic star reorients the question of memory away from any specific human experience. The "I" in the statement "I remember" already feels ghostly and untethered. *Last Days in a Lonely Place* features few human figures or avatars. When they do appear, they're mostly still and off in the corner of the frame cast in shadow. The video's citation of *Rebel Without a Cause* omits all mention or representation of James Dean, a Hollywood star of Hollywood stars. This choice only reemphasizes the unmooring of memory and history from human experience. In place of a spectatorial act of remembering—*hey! I know James Dean!*—memory becomes more the function of a technical *epiphylogenesis*, or the pursuit of life by means other than life. Videogames remember the cinema.

Videogames are a manual art. What relation does gameplay have to historical experience? Gaming often requires virtuosic dexterity, and gameplay amounts to learning, becoming habituated to, and manually executing a game's underlying algorithms. Successful play puts the player in synch or tune with the code subtending the game's operation. As videogame scholar Daniel Reynolds argues, the process of "adapting to the unique behavioral demands that games put on their players" is simultaneously a practice of "engaging with history." By learning a game, one implicitly experiences something of the programming and composition of the game often represented in the explicitly *already there* of ancient ruins and established worlds of games such as *GTA* and the 2005 *Shadow of the Colossus*. For Reynolds, "we engage historical thought from the moment we pick up a controller."[82] On this view, the *act* of gaming itself lends itself to historical experience. Solomon's *Last Days in a Lonely Place* essentially reverses this claim. For Solomon, it is only by putting down the game controller that historical experience emerges. What kind of

historical experience emerges from the disengagement of the hand? The lingering presence of the historical past in *Last Days in a Lonely Place* amounts to a kind of Orphic shadow space. Historical experience here is something that happens at the margins of human experience, more an effect of past human action uncertainly related to the present than anything ready to hand. Historical experience in *Last Days in a Lonely Place* appears to human experience, but not *for* it.

Solomon's experimental video vividly illustrates the deep experiential chasm dividing human experience and technological operation in the digital age. As Galloway makes plain, videogames run on code and the player plays alongside: "One *plays* a game. And the software *runs*."[83] Playing and running may sound similar, but here we should be cautious. Playing and running are not the same thing. In the case of videogames, a person does the former and a machine does the latter. This is precisely the experiential difference evoked by Solomon's sustained deployment of the ambient act in *Last Days in a Lonely Place*. This is how the video expresses the nature of historical experience in the digital age. It is only by putting down the controller that Solomon is able to evoke the present absence of film history routed through the medium so many describe as displacing cinema as the preeminent form of cultural aesthetic production in the twenty-first century.

Looking forward to chapter 2, Galloway's theorization of code opens the question of inscription. The divergence between *playing* and *running* marks a distinction between what human hands and programmed machines do. Following the hand-of-the-artist motif, we can now see that the history of this divergence is not purely a product of the technical medium specificity of digital technologies. Seen in the larger context of the history of animation and technics, the experiential divergence between the hand and the program belongs also to the history of inscription. The hand of the artist is very often a writing hand, a hand that inscribes even if it does not produce alphabetic script. In this chapter, I have emphasized the hand in its capacity to index absence. Following Marx's narrative of technological development as one moving from handicraft to manufacturing to large-scale manufacturing, I have traced the ways in which the hand begins to "let go" or diverge from production in order to sketch allegories of the larger processes informing the status of historical experience in the digital age. Building on Stiegler's theorization

of technics as *epiphylogenesis*, I have sketched an alternative genealogy for grasping the ubiquity of animation in the digital age, a much longer story of the relation between humans and technics. Yet it bears noting at length that writing itself is also fundamentally an index of absence, an assertion of presence anticipating the absence of the author. As many argue, historical experience depends on writing. What happens when it feels like writing disappears into the opacity of the machine?

2

THE NOISE IN HISTORY
Reactivating the Exteriority of Writing

Historicity itself is tied to the possibility of writing.

—Jacques Derrida

Quasi Autonomy, or Digital Inscription

Historical experience depends on writing. Inscription makes it possible to imagine traces conjugating the present with the past and the future. In encountering the trace, we perceive something of the presentness of the past, a sense that something happened. In the same encounter, we attach an expectation to future encounters with the same trace, its capacity to endure meaningfully as evidence of the past. All this allows one to synthesize written traces of the past with other traces in the form of words to narrate the past as history. More fundamentally, writing as inscription furnishes the conditions of possibility for the belief that things might endure historically, that the meaning inhering in the traces of the past may be "reactivated" as they are handed down to future generations of readers. While one might qualify the claim in a number of ways, such as with reference to oral tradition, collective memory, or intergenerational storytelling, the idea that history depends on writing feels intuitive and perhaps even obvious. So, while history may not utterly depend on writing, it is not controversial to affirm that historical experience depends on writing to a significant degree. To change writing is to change the character of history. John Durham Peters writes: "Writing is itself the bias through which we read history; our access to the history of writing—and the history of almost anything else—comes from the medium of writing itself."[1] Of course, writing is not one thing. The traces of handwriting, typewriters, and other sorts of writing technologies change the

character of writing and our relation to it. What does it mean when writing changes? The answer is, of course, that historical experience changes along with it. What happens, then, when digital inscription becomes the basis for historical experience?

The proliferation of digital media in the last few decades has engendered a massive transformation in writing. This transformation is so tremendous that it requires the reconceptualization of the nature of writing's relation to history. My primary claim here is that the advent of digital inscription necessitates rethinking *reactivation*, the very mechanism by which historical experience is generated. For Edmund Husserl, "reactivation" names the process by which historical experience is handed down from generation to generation via written inscription. Updating and expanding Husserl's phenomenological account of historical reactivation for the digital age, this chapter explores the ways in which the task of thinking through the conditions of possibility for historical experience requires a specifically technical and primordial understanding of digital writing. This reappraisal requires not only thinking of digital inscription in terms of reactivation; it also requires rethinking reactivation itself. While Husserl's account remains vital, he fails to appreciate the materiality of inscription and the ways it changes the dynamics of reading, writing, inscription, and ultimately reactivation itself.

The main presupposition of the idea that *history depends on writing* that needs to be rethought is the notion that the reactivation of writing occurs as a function of human minds and bodies. Digital media do not primarily address human experience. As I argued in chapter 1, digital media are in many ways *not for us*. The digital reactivation of traces of the past, then, also appears *not for us*. This does not mean that the past does not appear; in fact, it does! The past persists in the human experience of digital inscription. It just takes forms different from those more familiar to history in the mode of print and analog culture. Digital inscription largely operates beyond human perception and cognition. The most profound result of this experiential opacity is the decline of narrative forms as refigurations of traces of the past adequate to the task of synthesizing the largely lateral existence of human experience and the operation of digital machines. Instead of narrative, as I have begun to argue, animation now assumes unprecedented significance as an aesthetic topos appropriate for expressing historical experience in the digital age.

Through an analysis of digital artworks by John Cayley and Cory Arcangel I work to demonstrate the powerful role played by digital animation aesthetics in refiguring digital inscription in its experiential opacity as precariously available for human experience.

But first, what does it mean to speak of writing in the context of digital media? Consider the following statement: "YEEAAAAA BUDDY . . . did you go to TUMBLRSTAFF(.)COM yet? FREE STUFF YEE-AAAAAA." Who wrote this? Who would write this? Nobody, really. A poor attempt to pass the Turing test, this bro-ish altruistic statement comes from a "spambot" on a Tumblr page.[2] A spambot is an algorithm posing as human and designed to advertise products online. Appearing in email (hopefully in your junk folder), as well as in social media, spambots are amazingly pervasive. A 2014 filing with the Securities and Exchange Commission revealed that spambots account for 23 million of the 271 million active user accounts on Twitter. Spambots are a subgenre of *bot*, algorithms running automated tasks. Bots mostly don't appear to human eyes and ears, since they typically "spider" through servers and gather data on websites. They're not inherently malicious; the "Googlebot" is the name of the bot that makes Google's search engine possible. Googlebots search the net so you don't have to. The sheer ordinariness of bots and spambots demonstrates the truth of Friedrich Kittler's statement about the historical specificity of digital media as writing technologies: "Today . . . human writing occurs through inscriptions that are not just burned into silicon by means of electron beam lithography, but rather—and in contrast to all writing implements in history—are themselves able to read and write."[3] The materiality of digital media matters, but what *really matters* is the way digital media appears to work in a quasi-autonomous manner distinctly untethered from human agency. This doesn't mean computers are literally *alive*, but it does mean that they appear *to human experience* as remarkably animate.

Is this really still writing? A passage from Plato's *Phaedrus* proves instructive. The text is well-known as a fundamental source for post-structuralist theorizations of writing and of media as *pharmakon*, both poison and cure.[4] The *Phaedrus* is known best for noting the ways in which writing expands and diminishes human memory by allowing people to exteriorize their memories outside their own bodies. In the digital age, a less well-known passage becomes newly curious and important. Near

the end of the section on writing and memory, Socrates compares writing to painting. Here he again denigrates writing, this time not because it will lead to the impoverishment of embodied memory, but rather because writing is not quite alive *enough*.

> The fact is, Phaedrus, that writing involves a similar disadvantage to painting. The productions of painting look like living beings, but if you ask them a question they maintain a solemn silence. The same holds true of written words; you might suppose that they understand what they are saying, but if you ask them what they mean by anything they simply return the same answer over and over again.[5]

This is, frankly, a weird complaint. Why would Socrates imply that writing might talk back? Context clarifies the matter somewhat. Socrates broadly valorizes *anamnesis* over *hypomnesis*, or embodied memory over recollection based on external physical supports such as ink and papyrus. For Socrates, *anamnesis* amounts to living knowledge. All the same, writing technologies as *hypomnemata* are not precisely the opposite of *anamnesis* (dead knowledge?!!?), but rather something else. This is stranger still. Here, writing signifies a diminished mode of life: unthinking, automatic, or "bare" knowledge.[6] The word for painting is *zographia*, or "life writing" in the sense of biological (not cultural) life. The astonishing thing is that Socrates actually seems to assume that writing might talk back. For Socrates, writing actually *answers* questions; it just doesn't answer questions very well. While much more might be (and has been) said on this point, it is important here that one discovers indications of writing's curious quasi autonomy at the very origins of the theorization of writing in Western civilization.[7] One wonders what Socrates would think of Kittler's claim that digital inscriptions can read and write all by themselves. Perhaps he would be impressed with chatbots and other algorithmic forms. However, it's more likely he wouldn't be too impressed. Following Socrates, the animate character of inscription has not fundamentally changed. We still expect writing to talk back. The weird thing is that we do more than merely treat writing as if it might talk back. As anyone who has ever asked Google for anything knows, today, writing really does talk back!

Are the animate dimensions of digital media a property of computer code or of writing more generally? The answer, I believe, is *yes* for *both*.

To understand this idea requires thinking against the grain of some of the most influential work in digital media studies. Since the publication of Lev Manovich's *Language of New Media*, the dominant tendency has been to discuss code specifically and new media more generally as "language" and not as writing. The preference for defining codes as "the only language that does what it says" reflects not only the authority of computer science within the field but also an emphasis on the historical singularity, the newness, of new media. Promoted by both Alexander R. Galloway and N. Katherine Hayles in a series of essays and books, the definition of code as the "only language that does what it says" actually comes from Kittler in an essay devoted to the history of writing technologies from scribal inscription to networked machines.[8] Kittler is an oddball, but not an outlier when it comes to the theorization of digital media as writing technologies. Like Cayley, Donna Haraway, Vilém Flusser, Matthew Kirschenbaum, and Federica Frabetti, Kittler also discusses digital media as writing technologies. I concur with this group of scholars: digital media are writing technologies.[9] This is not a metaphor.[10] Computational digitization divides the world as a function of preestablished protocols of division: binary, hexadecimal, and multitudinous other forms of symbolic representation predicated on the discrete division or inscription of data. Following Bernard Stiegler, computational digitization is writing because it is a process of *grammatization*, a rendering of the world into traces (marks or *grammés*) subject to "grammars" or technical logics of organizing those traces (alphabets, scripts, etc.). Computational digitization outsources the production and processing— the execution—of grammatization (trace and grammar) to microtemporal machinic processes. In contrast with more traditionally identified technologies of writing such as pen and paper, typewriting, and so on, digital inscription operates as a *time-based process*. It is not just produced; it is always in itself in production insofar as it is being read by other machines or human eyes and minds. Code runs. Instead of writing by hand or typing, computers manage the production of writing as a function of their very operation. More strongly put: in the way digital media appear to human experience, this production of writing does not just "run"; too small, too fast, and too complex to be perceived as discrete inscriptions in themselves, digital inscription *outruns* human experience. Is this still "writing"? In a fashion, *YEAAAAA BUDDY!*

While the bizarre messages of spambots represent one example of the quasi autonomy of digital technics, just about any output of a digital computational system demonstrates the same point. Computers foster "illusions of immateriality" by virtue of their operational displacement of direct human agency and removal from human cognition and perception. Kirschenbaum elaborates:

> My argument, then, is this: computers are unique in the history of writing technologies in that they present a premediated material environment built and engineered to propagate an illusion of immateriality; the digital nature of computational representation is precisely what enables this illusion—or else call it a working model—of immaterial behavior.[11]

What Kirschenbaum calls "illusions of immateriality" I call animation. I press a button on my keyboard and a letter appears onscreen. Unlike the letter produced by a typewriter, this letter appears without the causal aid of any possibly visible or intuitively functioning mechanism. Or, more to my point, a cursor blinks in and out of visibility on a word processing document. Such phenomena are "immaterial" in that they leave no apparent trace of having been.

Of course, as Kirschenbaum emphasizes, "every contact leaves a trace," albeit at a fundamental displacement from human experience. Computational behavior displayed on a screen, through speakers, or any other interface occurs on the basis of a highly complex technological system of layered code anchored in digital inscription. As the example drawn from Plato demonstrates, the perceptual and cognitive distance between human experience and the scene of inscription dramatically magnifies a fundamental structure of writing in terms of its coupling with a human reader/writer. For Plato, writing exteriorizes memory, taking knowledge out of the body and placing it elsewhere. On this model, writing tacitly exists for reactivation by human readers: writing in the traditional sense places writing somewhere other than the mind in order to be read by someone else. Digital writing, however, does not need to wait for human readers. Like other forms of inscription, it exteriorizes thought and action, but unlike traditional forms of writing, digital inscription is subject primarily to time-based processes beyond those of lived experience. This discrepancy facilitates the appearance of digital

inscription through more and more animate forms, products of human imagination untethered from human agency. One encounters such animate forms in all arenas of digital life: spambot messages on Twitter, software updates, search engine query results, and so on, but the ordinariness of such encounters means they fly below the radar of historical experience. In order to lay out more clearly the central dilemmas of digital inscription, we need to turn to artistic forms, which provide a richly reflexive and powerful means for seeing into and against the experiential opacity of digital inscription.

Historical Experience overboard: *John Cayley's Ambient Poetics of Digital Inscription*

No artist working with digital media has devoted so much attention to the particularity of digital inscription as the British poet John Cayley. In a series of digital poetic works and theoretical essays in the early 2000s, Cayley explores the terrain of "literal art," poetry organized around letters as the atomic units of signification apart from lines, sentences, or other measures, such as pixels. His choice to privilege letters expresses his conviction that writing constitutes the fundamental and most efficacious basis for expression in digital media. As anyone who has coded at any level can attest (or even entered a slightly incorrect password or URL into a web browser), a single misplaced letter can make a very big difference. Since the letter is both perceptible as semantically legible and readable by machines, it provides a rich lens through which to observe the stark differences between human and machine reading.[12] The "literal" in "literal art" refers to letters and also suggests the ways in which computers read code in a strikingly literal fashion, executing script with no tolerance for ambiguity or multiple meanings or connotation. Literal art provides the ideal occasion for considering the difference between digital writing's divergent addresses, to human perception and to other machines. His 2003 work *overboard* proves exemplary here for the ways in which it opens up questions of digital writing in relation to the reactivation of historical experience. In Cayley's hands, historical experience neither flourishes nor disappears. Instead, it becomes precarious, insofar as it becomes unclear as to who bears the burden of reactivating the past: human or machine readers.

Cayley's *overboard* is an example of what he calls "literal art in digital media that demonstrates an 'ambient' time-based poetics." Viewing the poem on a web browser online, the reader encounters a black screen out of which emerges the shape of an open book. Four stanzas of text appear on the recto portion. The text comes from William Bradford's *Of Plymouth Plantation*, an account of Pilgrim settlement from 1620 to 1650. A graphically similar version of the same stanzas appears on the verso side as a pixelated photograph of the surface of the ocean. Dissonant and sometimes discordant wind sounds blow as bells ring out. A white cursor follows each pixel in a steady left-to-right, top-to-bottom direction of reading from character to character, "letter" to "letter." The stanzas phase in and out of different states of legibility. When "floating," as Cayley calls it, the text tells the story of a man washed overboard in an Atlantic storm:

> in many of these storms
> the winds were so fierce
> and the seas so high
> that they could not bear a knot of sail
> but were forced to hull for days
>
> and in one of them
> in a mighty storm
> a man came above board
> and was thrown into the sea
>
> but he caught hold of the halyards
> which hung over board
> and held his hold
> though he was many fathoms under water
>
> till he was hauled up
> to the brim of the water
> and into the ship
> and his life was saved

As Cayley explains, the text passes through two additional states: surfacing and drowning. When drowning, each letter is simply not present. When surfacing, each letter undergoes a series of "transliteral morphs," a term referring to the animated transformations of individual letters

based on their visual similarity to other letters. Transliteral pairs include *a* and *e*, *b* and *p*, *d* and *b*, *m* and *w*, *v* and *w*, and *v* and *y*. In its surfacing state, then, the final stanza may read:

> lilit re was heuleb up
> tu lre bnjw of tra velar
> end jrlo tra chjp
> and ris ljta vac savab.

There is no proper beginning or ending to *overboard*. It continually and variably cycles through states of floating, surface, and drowning, reenacting legibility, illegibility, and oblivion like so many waves washing over one another.

More than an ambient work in the tradition of Brian Eno's music projects such as the 1978 landmark *Ambient 1: Music for Airports,* Cayley's poetics represent nothing less than a highly condensed conceptual allegory of digital inscription. It expresses not only the experiential opacity of digital inscription but also the precarious status of historical experience

Figure 16. Letters floating, surfacing, and drowning. Screenshot from *overboard* custom software by John Cayley, with sound design together with Giles Perring (2003).

in the digital age according to its new conditions of possibility. Most simply, *overboard* foregrounds the time-based dimension of digital inscription. Cayley writes:

> These processes are the work. The writing is not the record of an inscription or prior composition. It is a program running. It is the sum of all the phenomena which occur when a program—a "prior writing" in anticipation of performance—is set in train.[13]

Digital writing, or programs, are a form of "prior writing," *programmé*, or what is inscribed in advance as "already there" (see ch. 1). Its operation precedes human intervention. As "literal art," *overboard* exists only through the execution of computational processes. It does not evince the record of a past event in the same manner as a printed inscription. As digital writing, *overboard* is an event; it moves accordingly without end. Rita Raley observes that, as a work of code poetry, a genre of electronic literature that makes visible the dynamics of computer code, *overboard* explicitly performs the surface and depth metaphors often employed to describe the structure of computational code that is difficult to imagine.[14] Floating in and out of legibility, the letters seem to fall away into the depths of the machine only to resurface again for human eyes. The setting of the poem is the ocean, but it is also the "seas of information," a pervasive imaginary for figuring the mass of churning knowledge and transmission we "surf" on the web. Appearing in the shape of a book, moreover, *overboard* readily calls to mind controversy over the "end of the book" and debates over the fate of reading in the age of information.[15] In sum, it is difficult to imagine a piece more densely drawing together so many aspects of the broader imaginary of writing in association with digital technologies.

The central drama in *overboard* centers on the precarious nature of historical reactivation. Watching the poem disintegrate and reintegrate over time, one struggles to read the text in a traditional sense. The content of the poem itself reflects the reader's struggle to hold on to the text in its legibility. It is as if the reader becomes the unnamed protagonist cast into the ocean of data. The repetition of the word "hold" (among many other *h* words) in the third stanza emphasizes the lack of any grasp on this ever-changing text just as much as it dramatizes the man's fight to stay alive. Recalling chapter 1's discussion of the hand of the artist,

overboard's emphasis on "hold" also underscores the precarious nature of getting (or losing) a grip on the conditions of possibility for historical experience. Ultimately, the effect of this resonance between poetic narrative and reader experience gives rise to the sense that, by reading and holding the poem together, we take part as readers in saving the man washed overboard. Or, more unnerving, we also play a role in his drowning. This confluence of narrative and reader drama engenders a sense of the precarious nature of historical reactivation. The movement of the text functions as a visual allegory of the found text—and the book more generally—in a world of information. The transliteral morphs play on the unstable textual history of *Of Plymouth Plantation*. Written in the early seventeenth century, the text features arcane spellings that have since been modernized and standardized. The transformation of the words into semilegibility echoes the non-standardized spellings of the original manuscript: "yet he held his hould (though he was sundrie fadomes under water)."[16] The plunging of the letters into total obscurity also recalls the history of the manuscript, which was lost for the greater part of the nineteenth century. The action of the poem recalls the material history of the manuscript as at once a singular view both on the early colonial history of America and on the tribulations of the book until its recovery and publication in 1856. The act of reading the poem, then, feels bound up not merely with the saving of a human life but also with the experience of a historical text. When the text moves on its own through varying states of legibility, however, what does it mean to call the act of sitting in front of my laptop "reading"?

What do "reading" and "reactivation" mean in the encounter with *overboard*? What if we can't get hold of the text? Everything hinges on the animation of the text in its expression of the possible entrainment of human experience with the time of computational processes. The text churns in states of semi-opacity, rarely entering entirely into its wholly legible "floating" state. In his explanation of *overboard*, Cayley claims that, over time, this opacity may be overcome to some degree: "The text is always legible to a reader who is prepared to take time to recover its principles. A willing reader is able to preserve or 'save' the text's legibility."[17] The aim of *overboard* is to inculcate its reader in the technical dynamics of digital inscription. After some time observing and "reading" this poem, the reader may realize that the letters transform in certain predictable

patterns based on their visual similarity with other letters: *s* becomes *c*; *v* becomes *y*; *d* becomes *b*; and so on. In effect, the possibility of learning and being able to anticipate future transformations leaves open the exciting notion of the reader being able to expand her own sense of the text's legibility beyond traditional syntax and spelling. This expanded sense of reading hinges on the recognition of the algorithms underlying its transliteral transformations. The temporality evoked by the poem thus shifts from a sense of precarious unpredictability toward the potential synchronization of the time of human experience and the execution of programmed algorithms.

Cayley may be correct. It may be possible to learn the rules underlying the transformations of the text. Yet, in my experience, this is not remotely part of the text's aesthetic appeal. At most, my enhanced ability to decipher the text only demonstrates its slipperiness and my inability to grasp the text in the same manner in which I can read print. Moreover, as Cayley's own description of the piece attests, *overboard*'s aesthetic allure is primarily ambient. Its pleasures derive less from concentrated engagement in the manner of reading printed lyric poetry than from the desultory pleasures of always-on computing and idle games such as *Cookie Clicker*. Watching and listening to the poem fold and unfold as it appears, disappears, and disaggregates, it seems to make no difference. I "read" the poem and then I hang out with it. Accessing the poem on my web browser, I often keep it running as one tab among many. I mute the soundtrack or keep it on low volume as I write email, browse social media, write this book, and so on. Reading as historical reactivation happens to some degree as I encounter the poem directly, but after being accessed, the poem acts as if it hardly needs me. Unlike much of electronic literature, *overboard* demands little of its reader. There is no scroll bar. There are no hyperlinks. And this is precisely the point. Digital media largely run parallel to human experience. Reactivation, then, seems as if it happens mostly elsewhere.

Illusions of Immateriality and the Exteriority of Writing: The Nonintentional Character of Digital Inscription

The ambient aesthetics of Cayley's *overboard* make plain how much digital inscription thrives on perceptual obfuscation and indirection. Digital

inscription is, then, fundamentally a "writing elsewhere," inscription only peripherally addressed to human experience.[18] The implications of this state of affairs are tremendous. Building on my claim that digital media are *not for us*, I want now to clarify that idea in more specifically phenomenological terms. Digital inscription is *not for us* in the sense that it is primarily nonintentional. In phenomenological philosophy, *intentionality* bespeaks the classic Husserlian dictum that consciousness is always consciousness *of* something. Intentionality denotes the connection between consciousness and its objects. Because it outruns human consciousness, digital inscription cannot properly be understood as an object of consciousness. The effects of digital inscription, to be sure, are objects of intentional consciousness and perception. Yet because these effects—what Kirschenbaum calls "illusions of immateriality" and what I theorize here as *animation*—originate from a constantly complex and imperceptible elsewhere, they express a sense of indirection that is often strange.

Digital images do not appear directly for us on the same terms as printed inscriptions. If we expand our sense of writing beyond the domain of literary or linguistic modes of inscription, the peculiar specificity of digital inscription comes more clearly into view. In the spirit of Kittler's great analysis, the gramophone represents a powerful point of comparison here. The grooves on a record cannot be read as meaningful, but they can be read as material inscriptions.[19] The tasks of reading and reactivation fall to the record player. Instead of a person, the needle or "stylus" reads the grooves and expresses them as sound for human ears through the gramophone. Reading occurs via a larger technical system (the record player) to deliver human meaningful sound to a human auditor. Digital media function in an analogous, if exaggerated, manner. As Galloway explains, code is fundamentally Janus-faced. Its scriptural dimension faces toward human programmers and appears as alphanumeric characters. In its executable form, however, code addresses other machines: other parts of the same computer and other machines on a network. In its executable form, code remains unavailable to human observation, as it occurs at scales and speeds beyond human experience. Galloway writes: "At runtime, code moves. Code effects physical change in a very literal sense. Logic gates open and close. Electrons flow. Display devices illuminate. Input devices and storage devices transubstantiate

between the physical and the mathematical."[20] Code's machinic address occurs outside the purview of perception and consciousness. Yet we experience its indirect effects, such as the illumination of our screens. What's more, humans do not initiate most computational events. As Kirschenbaum emphasizes, "most of the textual events in a modern operating system, or network, occur without the impetus of a human agency."[21] In contrast to the indirection of gramophonic inscription, digital inscription takes place within a much more complex machinic system whose activities (and this is crucial) do not necessarily or even predominately accede to the domain of human experience.

Digital inscription is predominately *nonintentional*. To appreciate the full philosophical novelty of this situation, consider Paul Ricoeur's emphasis on what he deems to be the essentially intentional character of writing:

> Writing may rescue the instance of discourse because of what writing does actually fix is not the event of speaking, but the 'said' of speaking, i.e. the intentional exteriorization constitutive of the couple event-meaning. What we write, what we inscribe, is the noema of the speaking act, the meaning of the speech event, not the event as event.[22]

For Ricoeur, writing is a vehicle for human thought. He focuses exclusively on the reactivation of meaning across time and space originating in human speech, or what amounts to *human consciousness* (the "noema of the speaking act"). Writing "rescues" or reactivates the event of thought, not speech. Recalling the rescuing of the sailor in *overboard*, however, it is evident in the context of digital media that human consciousness cannot claim to retrieve the text, but rather must follow alongside the animated reactivation executed by the text itself. The main problem with Ricoeur's account, then, is that it elides the material event of inscription. As writing becomes more and more technological in origin, Ricoeur's conception of writing proves insufficient in accounting for spambots and other digital phenomena whose utterances do not primarily address human experience, but rather the systemic character of networked digital writing environments.

Prior to the advent of digital inscription, the shortcomings of Ricoeur's approach to writing might have seemed rather trivial. Except in truly extraordinary circumstances, there are no inscription mechanisms

in print culture (or scribal culture for that matter) other than those perceptibly comprehensible to living, breathing, thinking human beings. The house of cards Ricoeur constructs in his theorization of writing begins to topple when we start to look for anything other than the ideal or disembodied transmission of thought from mind to mind. His emphasis on inscription as the physical instantiation of the *noema*, the intentional object of ideation, frankly excludes inscription qua inscription, or what he terms "the event as event." What happened to bodies? What happened to technologies? Ricoeur accounts for neither, and thus neglects the vital domain of materiality and its curious activity. Computers behave perfectly "immaterially" if everything runs smoothly. Yet, when things do not work so well, when the operation of computers exceeds some kind of perceptual norm, their "behavior" can appear animate, unruly, and strikingly, if also paradoxically, immaterially material. Glitches, for instance, index the irruption of a hidden materiality, a materiality elsewhere. The technological and material reactivation of inscription beyond the scope of what digital media intend for human experience has the effect of deprivileging writing as something symbolic and sensible. The capacity of digital media for representation relies on the suppression of errors that inevitably occur when codes translate magnetic and electronic voltages into cascading layers of symbolic languages, or code. But error cannot be wholly suppressed. More importantly, even if "error" is itself suppressed, the sheer exteriority of computational inscription as so many processes displaced from human experience yields "immaterial behavior" that nonetheless points toward its suprasensible opacity.

This dimension of writing is what David Wellbery terms the "exteriority of writing," the material dimensions of writing in excess of sense. In an important essay from 1992, Wellbery theorizes this *exteriority of writing*, meaning the extrahermeneutic dimensions of writing: the materiality and event of writing over and above its linguistic capacity to convey meaning to human interpreters.[23] Though he does not invoke Ricoeur's discussion of the intentionality of writing, Wellbery's idea of the exteriority of writing works against Ricoeur's and many other thinkers' conviction that writing is a mere vessel for what is really important: the transmission of human thought. Without rejecting this idea, the *exteriority of writing* affirms the material fact of writing as a crucial component of inscription exceeding the traditionally imagined role of writing as

essentially what may be transmitted from one mind to another. Paper and ink matter. The materiality of text matters. They matter in large part because they represent qualities of writing in excess of semantic meaning, or what may be handed down from one human mind to another. For Wellbery, the exteriority of writing goes against what he terms the "hermeneutic presupposition of sense," or the demand that writing must mean something *interpretable*. The exteriority of writing, by contrast, affirms the recalcitrant and singular materiality and technicity of inscription apart from human thought, agency, or interpretation.[24] The notion of the exteriority of writing represents an important innovation in the theorization of writing in the context of print media, but in the context of digital media, the exteriority of writing becomes not simply one important aspect, but undeniably *prominent*. Seeing as digital inscription is less and less *for us*, as it is primarily nonintentional, the exteriority of writing becomes uniquely significant for expressing the experiential opacity of digital media while holding on, however tenuously, to the very notion of writing, and by extension, to historical experience.

Wellbery was ahead of his time. He developed the concept of the exteriority of writing in the context of reflections on the theorization of writing in the works of Kittler, Jacques Derrida, and Michel Foucault.[25] He did so largely prior to the emergence of the digital age. For these reasons, his idea has remained relatively unknown in digital media studies, even among scholars focusing on the materiality of digital writing technologies. Software studies since Manovich largely dispense with sustained engagement with poststructuralist theory and the notion of code as writing. However, as Wellbery himself notes, much of the vocabulary employed by Derrida and Foucault derives from the enormous influence of cybernetics and information theory in French philosophy in the 1960s. The notion of the exteriority of writing emerges as a function of the theorization of the very same ideas underpinning the development of digital computational technologies.[26] Terms like "feedback," "channels," "transmission," "signals," and most notably "noise" make their way into and deeply influence the poststructuralist theorization of writing. For Wellbery, observing the confluence of poststructuralism and cybernetics illuminates the intellectual historical complexity of Foucault and Derrida. From the perspective of digital media studies in the humanities, however, Wellbery's insights resonate differently and powerfully. Read

from the vantage point of twenty-first-century digital culture, his explication of the exteriority of writing reads powerfully as a revisionary theorization of writing opening the door for considering writing's essentially material and technogical dimensions in excess of human intentionality. Moving forward, two questions arise. What is the exteriority of digital writing? And what effect does the exteriority of digital writing have on historical experience? The next two sections examine these questions in terms of Husserl's model of historical reactivation.

Animate Opacity of the Already There: *Cory Arcangel's* Untitled (After Lucier)

There is history in the silenced collective scream of teenage girls. Arcangel's 2006 digital video installation *Untitled (After Lucier)* mutely replays a clip of the Beatles' 1964 appearance on the Ed Sullivan Show. Exhibited at the Art Institute of Chicago in 2010, the image file compresses each time it replays. Steadily and unevenly losing definition over time, the image becomes increasingly abstract. The iconic faces of the Fab Four disappear into a geometric haze, and each band member becomes recognizable only by his more general or prominent features: instrument, comportment, Ringo's nose. With each compression, the work displays less an image from the pop-historical event of the group's landmark stateside appearance and more a field of pulsating, jagged blocks of black, white, and grey. The image becomes less and less a record of a past event, as though it has absorbed the cacophony of teenage voices as a formal and technological principle of its duration. *Untitled's* fidelity to history attenuates with each iteration, becoming seemingly more and more "digital." While it begins from a recording, it is not itself a recording. Carrying no intrinsic end, *Untitled* compresses and recompresses until the exhibition ends.

Untitled (After Lucier) foregrounds a common property of digital media that remains otherwise invisible and insensible: the presentation of images as a function of code-based inscription technologies. The aberrant, pulsing visual differences of increasing pixilation in successive iterations of the Beatles' performance indexes the encoding compression algorithm at work. The image's jagged unfolding into abstraction reveals the precarious status of the digital image as a platform of history: an

Figure 17. Block, white, and Ringo. Screenshot from *Untitled (After Lucier)* by Cory Arcangel, 2006. Single channel video, computer, video projector, and artist software. Dimensions variable. Copyright Cory Arcangel. Courtesy of Cory Arcangel.

open-ended, never-ending journey into greater animate opacity always looking forward to an image of history as so much buzzing static.

At the outset of his famous 1984 cyberpunk novel *Neuromancer,* William Gibson envisioned a similar image of digital history: "the color of television, tuned to a dead channel."[27] As much as *Untitled* seems to conjure similar notions of the "end of history," I argue it does precisely the opposite. Even a dead channel displays something. A small percentage of the static viewed on an analog television tuned between channels visualizes CMB (cosmic microwave background), or the persistent remnants of the big bang. In a similar manner, *Untitled (After Lucier)* invites viewers to consider the primordial dimensions of historical experience: noise as what always seems to be somehow "already there."

Already there refers to Stiegler's gloss of Martin Heidegger's idea in *Being and Time* that humans experience the world as what precedes them.

Stiegler's main contribution to this idea is that the *already there* is essentially "technical." Before proceeding to Stiegler, I want to begin with the noisy iterations of Arcangel's *Untitled (After Lucier)* with the belief that new media aesthetics prove essential for examining these concepts and their meaning in the digital age. In order to get a handle on *Untitled*'s engagement with history and the *already there*, it helps to start with a discussion of the thing that arguably best expresses the technical nature of digital media: the "glitch."

Glitches seem to express a momentary failure or corruption. As many other scholars argue, glitches are not mere aberrations.[28] Their eruption actually demonstrates something of what digital media are and how they work. If the lion's share of computational behaviors grant the illusion of "immaterial behavior," glitches shatter this illusion and reveal the machine as a material force. Glitches evince the ways in which most computational technologies are carefully engineered to exhibit behavior *for us* when, in reality, most of their actions assume no human addressee. While some scholars argue for glitches as a cross-medium phenomenon occurring in digital and nondigital technologies alike, I argue that glitches are specific to digital media as inscription technologies. Digital media break down as writing. Here I follow Olga Goriunova and Alexei Shulgin in defining glitches as the perceptible effects of imperceptible errors on the level of code:

> Glitch is often used as a synonym for bug; but not for error. An error might produce a glitch but might not lead to a perceivable malfunction of the system. Errors in software are usually structured as: syntax errors (grammatical errors in a program), logic errors (error in an algorithm), and exception errors (arising from unexpected conditions and events).[29]

Glitches are crucial for understanding information technology because they provide a heuristic sense of their otherwise insensible operation. Their appearance reveals how the illusion of immaterial behavior derives from the functional suppression of error.[30] But let us be careful here. Glitches do not literally render phenomenal what is otherwise invisible. They do not play a "revelatory" role. Glitches cannot give us direct access to the world of microprocessural computational events. They do not teach us how things work, but they do teach us that there is something going on, something we cannot normally see or experience:

an unseen continent of multilayered code. Glitches index the immanent appearance of the unknowability of computational processes in a visual form that signifies their status precisely as computational processes without a human address.[31]

Glitches vividly instantiate one of the core ideas within digital media studies: the constitutive role of noise in communication. As per Claude Shannon's mathematical theory of information, which underlies much of contemporary computational technological communication, there is no such thing as communication without noise.[32] For Shannon, noise defines the measure of disorder in a technical system, such as the telephone system.[33] Shannon includes noise within his diagram as a constitutive component of communication, not something to be eradicated. Glitch aesthetics become possible and thrive on the inherently noisy nature of digital technologies. As the Shannon-inspired *Simple Net Art Diagram* (1997) by artist collective MTAA makes clear, "the art happens here." As the blinking lightning-flash symbol indicates, the art happens in between, in the channel, but also—crucially—in the animated movement standing in for the noise in the channel.

Noise seems destructive of history, at least at first blush. In Arcangel's *Untitled (After Lucier)*, noise corrodes the legibility of the image over time as it recompresses. Compression algorithms exist to facilitate the

Simple Net Art Diagram

The art happens here

MTAA ca. 1997

Figure 18. Net Art Reimagines Claude Shannon. *Simple Net Art Diagram* by MTAA (1997). Creative Commons.

easy transmission of large files across networks by reducing their size. Instead of easing transmission, however, *Untitled* unleashes the logic of compression as a game of historical telephone. Degrading with each transmission, *Untitled* seems directly opposed to history because of the way it works against the future-oriented faith on which any sense of history is arguably predicated: that someone at some point in the future might be able to read, recall, or otherwise reactivate something of the original message. Yet *Untitled* does not oppose historical reactivation so much as it reframes it. In the context of digital media, following Shannon, noise is essential. Perpetual recompression is not simply, or even primarily, the foreclosure of the image as something to be reactivated by human viewers, but rather, at the same time, its opening as an object and event addressed to digital media themselves.

The work's durational veering away from human comprehensibility does not necessarily move it away from history. In fact, noise functions as a way back into history. *Untitled* expresses the fundamental significance of noise for expressing historical experience through its citational and technohistorical relation to musician Alvin Lucier's landmark avant-garde sound work *I Am Sitting in a Room* from 1969, to which it is an homage, reimagining the fifteen-minute recording.[34] During the piece, Lucier recites an approximately ninety-second statement:

> I am sitting in a room different from the one you are in now. I am recording the sound of my speaking voice. And I am going to play it back into the room again and again until the r-r-resonant frequencies of the room r-r-reinforce themselves so that any semblance of my speech, with perhaps the exception of r-r-r-rh-rhythm, is destroyed. What you will hear then are the natural r-r-resonant frequencies of the room articulated by speech. I regard this activity not so much as a demonstration of a physical fact but more as a way to s-s-smooth out any irregularities my speech might have.

The statement is recorded, played back, and rerecorded. The rerecording is played back and rerecorded, and so on until the sound of human speech disappears into a cacophony of noise. The first iteration of the recording already features a substantial amount of crackling, as well as Lucier's own stutters. As Lucier rerecords his statement, the original elements of human and machinic noise in excess of "correct" speech blend

together as increasingly garbled sound. Lucier's final line refers to his stutter and may be understood as a deadpan joke masked in the seriousness of avant-garde performance. Lucier isn't making art to cure his stutter. And even if he were, the performance remains an unmistakable demonstration of physical fact. It is a performance that processurally underscores the material technical conditions of recording through its emphasis on the nonsensical as such, the noise inherent in both the technical and human expression of sound. In this way, *I Am Sitting in a Room* perfectly expresses the ways in which noise always ever and already permeates any expression as an *already there*. This provocation forms the basis for Arcangel's own exploration into the inherent noisiness of digital media.

Arcangel offers more than a tribute. If that were the case, one might imagine Arcangel himself speaking the same lines spoken by Lucier in the 1960s. Instead of his own speech or Lucier's, Arcangel substitutes a recording of one of the most famous live events in television history. Like Lucier's speech, the recording of the Beatles connotes liveness. While Lucier gestures toward the technological conditions of his live performance, in 2010 it would be impossible to grasp the liveness of the Beatles on Ed Sullivan as anything other than a technological artifact. While cribbing the basic logic of Lucier, Arcangel emphasizes both his subject's technological nature and its recorded nature, the pastness. What's already there is not just noise. What's already there is not just technology, whether analog sound recording or digital inscription. Indeed, what's already there in *Untitled (After Lucier)* seems to be the very pastness of noise and technology. What's already there is, in other words, historical experience itself. But where did this come from? Just how deep, how immanent, and how primordial does the noise in digital inscription go? The answer, as we will see, is: very deep, quite primordial, and absolutely immanent.

Writing and the Already There: *Husserl, Stiegler, Dehaene*

Writing makes historical experience possible. But what makes writing possible?

In his late essay "The Origin of Geometry," Husserl turns his attention to the topic of history squarely in terms of the very possibility of

writing. As Ricoeur notes, it is difficult to overemphasize the oddness of Husserl's late turn to history. Very little in his previous writings anticipates this. Ricoeur writes: "Phenomenology's properly transcendental problem-set includes no manifest historical concern; rather it seems to eliminate this concern by the initial operation of 'transcendental reduction.'"[35] In the most "classical" version of Husserlian thought, phenomenology brackets the natural attitude in order to attend to the immanent contents of consciousness, a move that divests itself of any concern with history or even a philosophy of history.[36] And indeed, Husserl's deep-seated and intractable commitment to the *epoche* prevents him from cashing out the meaning of his own remarkable investigations into what, following Wellbery, we may call the exteriority of writing, although Husserl cannot himself name it. Building on Wellbery and Husserl and with an eye cast toward Arcangel's *Untitled (After Lucier)*, in this section, I elaborate the deep roots of the nonintentional dimensions of historical reactivation so crucial to the expression of history in the age of digital media.

Husserl's notion of historical reactivation may be briefly summarized as follows. Writing constitutes the condition of possibility for the transmission of ideas, or what Husserl calls "ideal objects," the very things reactivated in the general process of historical reactivation, in the handing down of traditions via varieties of writing. However, how "ideal" can an ideal object be if it emerges only through the material possibility of writing? Can writing really be only incidental to the process of historical reactivation if that process depends on it? The answer, I believe, is an emphatic *no*.

To his credit, Husserl recognizes the irreducible materiality of writing. Yet he fails to grasp its significance for his discussion of historical reactivation. He writes: "Written signs are, when considered from a purely corporeal point of view, straightforwardly, sensibly experienceable; and it is always possible that they be intersubjectively experienceable in common."[37] Unfortunately, the shift from the "purely corporeal point of view" to one of intersubjective communication effectively disembodies and dematerializes geometry as a practice of inscription. This shift, in turn, echoes the existential disenfranchisement charted in chapter 1's genealogy of the "out of hand." As Mark Paterson argues, while geometry begins with the human body as the basis of measurement, it

becomes "an abstracted, universalizable model" precisely through its disavowal of the hands and the body except for an extremely abstract visualism in the spare line drawings of triangles, circles, and squares conventionally signifying it.[38] For Husserl, the sensible materiality of writing makes reactivation possible: the act of handing down knowledge from generation to generation, or history. But Husserl cannot bring himself to say that history depends on writing (this idea would later be expressed by Derrida, who devoted most of the first decade of his career to Husserl's work). For Husserl, to admit the significance of writing's material technicity would be to ascribe an originary technicity or empiricity to history. This is unthinkable from the perspective of a properly transcendental phenomenology that always privileges the immanent contents of human consciousness. As a result, Husserl attempts to drain from his philosophy of history any and all trace of technicity, and he assigns this endeavor to his notion of "reactivation," which he places at the absolute genesis of history:

> [Reactivation] belongs to every human being as a speaking being. Accordingly, then, the writing-down effects a transformation of the original mode of being of the meaning-structure, [e.g.] within the geometrical sphere of self-evidence, of the geometrical structure which is put into words. It becomes sedimented, so to speak. But the reader can make it self-evident again, can reactivate the self-evidence.[39]

For Husserl, reactivation is a hermeneutic process that occurs in the mind of the human reader. It belongs to every person by virtue of an innate capacity for speech—not literacy, so not precisely on the grounds of cultural practice. As readers of Derrida well know, the primacy Husserl accords speech over writing seems deeply suspect for the way it functions as the privileged domain of meaning itself beyond writing. It is as if Husserl denies the foundational role of writing for reactivation at the same time he appears to valorize it. Writing becomes necessary as a mere supplement, an inert material support. To imagine an analogy from everyday life, it's as though Husserl conceives of writing as a shipping box. The box is necessary to ship an item from one place to another, but in the end, we throw away the box and preserve the contents. Husserl conceives of writing as *containing* the "original mode of being of the meaning-structure, [e.g.] within the geometrical sphere of self-evidence":

"It becomes sedimented, so to speak. But the reader can make it self-evident again, can reactivate the self-evidence." Meaning's apodicity, then, is not to be found in the material facticity of writing, or at least not essentially connected to it. Meaning lies in "the geometrical structure which is put into words." In sum, Husserl officially privileges the ideality of speech and ideas in the process of historical reactivation as a handing down from one mind to another. This process inevitably involves the material form of writing, however, and Husserl's analysis consistently runs up against the constitutively nonideal and nonintentional, meaning the technical dimension of writing that is irreducible to sense: its exteriority.

Husserl conceives of geometry at every turn as originating in technical and material practices. Noting these key moments in his analysis helps to update his model of historical reactivation in terms friendly to Wellbery's notion of the exteriority of writing, its dimensions in excess of interpretation and intentionality. Husserl's repeated description of measurability and exactitude born of human activity such as the polishing of stones poses an insurmountable chicken-or-egg dilemma for idealist phenomenology, insofar as it seems impossible to maintain the pure autonomous apodicity of ideal objects. In an early analysis of Husserl's "Origin of Geometry" Derrida asks, "why and how are this rigor or this exactness engendered out of an inexactness?"[40] Husserl's continual recourse to a technical-empirical world as *already there* violates the transcendental spirit of his project. At the crucial point when he comes to the question of the "origin" of geometry, an aporia emerges, which he effectively sweeps under the rug. Derrida comments: "At the moment when we get to the most originary constituting source, the constituted is always *already there*. The supposed *a priori* possibility of reactualization will always suppose a constituted tradition in some form or other."[41]

Husserl's final recourse to a sense of reason "hidden in history" merely compounds the young Derrida's dissatisfaction. Notwithstanding Husserl's efforts to articulate a transcendental phenomenological philosophy of history, he relies on the prior existence of a "constituted tradition" that precedes the scene of ideal reactivation. This tradition is, of course, exemplified by writing. And, crucially, the geometric shapes of written characters are, for Husserl, born of technical practices such as polishing that make possible the expression of geometrical form in its

exactitude. At the *origin* of geometry, and thus at the origin of historicity, Derrida discovers what Husserl earlier discovers but disavows. At the very origin of history, both authors discover technics!

The task of theorizing technics falls to Derrida's student, Stiegler. Leaving behind Derrida's quasi-transcendental discussions of the "end of metaphysics," Stiegler argues for a firmly empirical understanding of technics and writing. At the outset of *Of Grammatology*, Derrida writes: "The meaning and origin of writing precedes, or at least merges with, a certain type of question about the meaning and origin of technics. That is why the notion of technics can never simply clarify the notion of writing."[42] In a moment of decisive and wry judgment, Stiegler notes: "'Simply' would seem to be the operative term. For the notion of technics *can* clarify the notion of writing *if* our understanding of the former is heavily revised."[43] This moment is absolutely decisive for Stiegler. The question of technics becomes the path for Stiegler to expand Derrida's project. Because Stiegler defines technics as not simply technology, but rather as a process of exteriorization, his thought opens the way for grasping the constitutive significance of technical exteriority for theorizing historical reactivation.

Technical exteriority in Stiegler's philosophy of technics operates at the level of an evolutionary claim about the essential technicity of the human as a form of life. Stiegler argues that humans and technics co-evolve in concert with one another: we have always been posthuman because we have been tool users longer than we have been *homo sapiens*.[44] Following André Leroi-Gourhan's definition of technics as a process of exteriorization, Stiegler theorizes the essential technicity of human beings in a manner that questions the boundaries of the human as such. For Stiegler, humans are essentially technical in the sense that they are always already bound up with an evolutionary process exceeding individual, and even species, specificity: the project of exteriorizing themselves into the environment.

In an extraordinary synthesis, Stiegler brings together Leroi-Gourhan's evolutionary theory of technics with Heidegger's notion of the *already there*, which names how *Dasein*'s "own past . . . is not something which *follows after* Dasein, but something which already goes ahead of it."[45] The past is *already there*. We are never charged with the task of making the world: the world always precedes us; human evidence of the

past always precedes us. The evolutionary *longue durée* of Stiegler's approach pushes this Heideggerian concept into new territory. Drawing on Leroi-Gourhan, Stiegler theorizes the already there as essentially technical. In place of the Heideggerian notion of *Dasein*, in Stiegler's empirical imagination, it is rather *technics* that precedes us as an evolutionary process both defining and exceeding the human. As a process of exteriorization, technics names a process that properly exceeds individual experience, and thus sense and consciousness. As an evolutionary force operating beyond the scope of individual action or thought, technics names an essentially exterior and exteriorizing force at work in the production of history. In his synthesis of Leroi-Gourhan and Heidegger, Stiegler effectively moves past the chicken–egg impasse of writing as the condition of possibility for ideal objects and, all the same, stays within the general problematic of historical reactivation, albeit in a more existential-empirical manner.

Following Stiegler, the *already there* designates the ways human life always already encounters the world as containing evidence of past human activity. How can we best grasp the foundational reach of this claim? Frankly, its existential reach exceeds the archaeological record. Here French neuroscientist Stanislas Dehaene's speculative neuroevolutionary account of the origin of reading proves invaluable. In what would seem to be a counterintuitive and historically inaccurate move, Dehaene's work allows us to grasp writing as an important aspect of the *already there*. Histories of writing treat it as archaeologically validated technologies. But Dehaene's theoretical reach extends far beyond literal history and gestures toward an unlikely synthesis with Husserl's phenomenological account of the origins of history in the possibility of writing.

In describing the origins of writing in a "technical praxis always aimed at the production of particular preferred shapes," Husserl specifies:

> First to be singled out from the thing-shapes are surfaces—more or less "smooth," more or less perfect surfaces; edges, more or less rough or fairly "even"; in other words, more or less pure lines, angles, more or less perfect points; then, again, among the lines, for example, straight lines are especially preferred.[46]

The precise straightness of objects and figures makes writing possible in concert with a measuring technique, which is, as Derrida notes, "always

already there."[47] But from whence does this measuring "technique" derive?

Dehaene provides insight into the ongoing agony over writing's dual status as ideal and material. His neuroevolutionary account of the origin of reading dovetails in surprising and productive ways both with Husserl's notion of "preferred shapes" and with Stiegler's evolutionary account of the technics of the *already there*. In his book *Reading in the Brain*, Dehaene inquires into the puzzling fact that humans can read at all. Writing, Dehaene reminds us, is a relatively recent phenomenon in the context of biological evolution: "Nothing in our evolution could have prepared us to absorb language through vision."[48] The human ability to read derives, then, not from any evolved predilection for reading in the conventional sense, but rather as a result of evolutionary pressures toward "an invariant perception of the world."[49] "Invariants" are something like what Husserl describes in "The Origin of Geometry" as "preferred shapes."

In Husserl, the question of why any shapes might be "preferred" is never answered. For Dehaene, the preference for invariant shapes arises from the brain's capacity to recycle previously existing neuronal circuits from evolutionary experience predisposing individuals to select information from their environment in increasingly sophisticated ways. "Fragments of visual scenes," then, such as two tree branches crossing, amount to what Dehaene terms "protoletters" because of their resemblance to written characters from across the world, such as the letter T.[50] Such shapes "belong to what is known as 'non-accidental properties' of visual scenes because they are unlikely to occur accidentally in the absence of any object."[51] Dehaene's notion of protoletters affirms Husserl's phenomenological claim for the primordial basis of the exactitude of writing within the larger context of "preferred shapes." The human predilection for such shapes precedes and exceeds their more abstract and refined codification as alphabetic or symbolic writing. For Dehaene, writing codifies a more basic, variable and plastic response to preferred shapes that are not just always already in the environment, but more precisely characterize the human perception of the world as a biologically historical species.[52]

The existence of reading and writing reflects the fact that humans have evolved to select information from their environments in particular

ways. Practices aimed at establishing material rectitude, such as polishing or inscribing, in effect reproduce what amounts to a preferred shape born of invariant perception. Writing emerges because we already perceive or "read" the world as a kind of writing. Writing is not an individual accomplishment or invention, but an expression of the evolution of our species in interaction with the environment. The constitutive exteriority of writing, in its tendency toward exactitude, reprises this primordial exteriority of the *already there*. "Writing," in this fundamental sense, derives from a measuring technique of perceptual invariants that derive from the primordial coupling of organism and environment constitutive of the very dynamic of technics as an evolutionary process of exteriorization.

The ultimate payoff for the exteriority of writing figured by digital glitches, then, is that they produce "preferred shapes" that are manifestly *not for us*. Computers glitch in undeniably consistent ways: pixelated, jagged edges, blocky chunks of wrong colors and mysteriously appearing overlaid text. Everyone knows what a glitch looks like. As familiar as glitches appear, of course, they also appear "random." This is what it means to say that glitches evince the extra-intentional character of digital inscription as *not for us*. At the same time, glitches provide an ambiguous and possibly paradoxical form of opaque access to the very material conditions of possibility for historical experience in the digital age. This dimension of the exteriority of writing has always already operated in the experience of traces of the past. But it becomes much more important in the context of digital media because of their non-intentional operation.

The Time of the Already There

Following Husserl, Derrida writes, "historicity is tied to the possibility of writing."[53] In a decisive media historical elaboration of the same claim, Stiegler writes: "Writing, in its alphabetic specificity, as exact recording, an orthographics, that liberates a new possibility of access to the past, configures properly historical temporality."[54] For Stiegler, writing not only makes history possible, but actually *gives rise to* historical temporality. Different historical regimes of writing, it follows, give rise to different senses of historical temporality. Stiegler's basic idea runs

thus: events occur, a version of the events is written down, and such inscriptions are kept with the faith that they may be accessed later.

As Stiegler notes, nonalphabetic forms of inscription alter this basic dynamic, such as when photography collapses the temporal gap between the occurrence of events and their capture beyond human meaningful experience. Stiegler claims that the incredible speeds of digital technologies altogether collapse the entire dynamic of historical reactivation, a claim effectively again sounding the death knell of history. Essentially an updated model of Husserlian reactivation, Stiegler's model does not adequately consider the essential exteriority of inscription in his theorization of historical temporality. Building on the previous sections' excavation of the technical exteriority of writing, I want in this final portion to reopen the question that Stiegler's analysis too quickly forecloses: what sort of temporality does digital inscription engender? Put otherwise, what is the time of the digital *already there*?

Recall the endgame fantasy of *Untitled (After Lucier)*: a picture of history as so much television static. While this fantasy is no doubt crucial to *Untitled*'s evocation of history, it is not the primary textual means, the *actual* means, by which it expresses historical temporality. In my own experience of *Untitled*, the image never dissolves totally into static. In fact its compression algorithm works quite slowly in its literal deconstruction of the image. Bracketing the foreclosing image of the end of history, let us close by attending to the varieties of comparative historical temporality *Untitled* elicits us to see and to feel.

Untitled addresses the temporality of human experience in neither the time-stretching nor the endurance-testing manners of other, more famous recent digital video installations, from Douglas Gordon's *24-Hour Psycho*, to Bill Viola's *Passions* series, to Christian Marclay's *The Clock*. Each of those works maintains a vested interest in digital manipulation rooted in the possibility of a kind of superlatively responsible museum goer: someone who might put in the time to view the entire thing (in, e.g., special day-long viewings of *The Clock* at the Walker Art Center), or someone who might slow his or her viewing habits in order to depart from the rhythms of everyday life and experience a technologically enabled and uncannily retarded articulation of the emergence of affective intensities (Viola's *Passions* series).[55] These works gain their aesthetic impact from the presupposition that one might put in "significant" time

in front of the object, the time necessary to adjust, attune, or cotemporalize along with the object. *Untitled* makes no such demands because it is actually a very different sort of work. *The Clock*, *24-Hour Psycho*, and the *Passions* series are all recordings to be played back, looped, and repeated. *Untitled* is a process, not a recording. *Untitled* departs from the aesthetic promise of technology-induced transformation in favor of the quiet performance of infrastructural opacity. It runs on into darkness.

Untitled radically extends the temporal form of Lucier's project. *I Am Sitting in a Room* iterates and undoes the rectitude of the recording of a temporally defined event. It foregrounds the inherent noise of recording through analogous processes of repetition. But here *Untitled* goes further than *I Am Sitting in a Room*. While it begins from a recording, *Untitled* extends the time of performance far beyond the capacity of an individual to experience its entirety. Unlike *The Clock*, *Untitled* solicits no ideal spectator who can view the whole thing. In fact, it has no entirety; it has no end. The work's indefinite temporality emphasizes the autonomy of its computational processes running in excess of human intervention or spectatorship. Beholden only to institutional or technical constraints, the inhuman temporality of *Untitled* underscores the quasi-autonomous activity of digital technics as processes operative beyond the paradigm of recording. It is not just for us but also, apparently, for processes exceeding the limits of perception.

Notwithstanding the fact that the work's extension into unbounded temporality works increasingly, as time goes on, against its being human-readable, some indeterminate space remains reserved for human experience. After all, this is an image of the Beatles! The choice to elongate and reanimate the Beatles' appearance on *The Ed Sullivan Show* belies the interpretation of *Untitled* as a purely technical-formal homage to Lucier in the manner in which, say, Arcangel's 2007 *Structural Film* adds digital artifacts in reworking Nam June Paik's famously blank 1965 *Zen for Film*. The Beatles are among the most recognizable icons of Western popular music and culture. As the image distorts, the band remains surprisingly recognizable. Lucier's piece proceeds fairly quickly into a condition of near-pure noise, but the image of the Beatles in *Untitled* remains, at least by comparison, fairly legible over a much longer period of time. This occurs by design in a technical sense, but it also occurs by virtue of the recalcitrant familiarity of the image of the Beatles. Arcangel's

choice of the Beatles' epochal 1964 performance demonstrates an interest in the priority and the endurance of history in excess of its technical homage to Lucier. The persistence of the image of the Beatles affirms the noncoincidence of the multiple temporalities at work in our experience of history. We see something of a recording, and yet we see so much more of it because we have already seen this image before so many times. It is here and not here. History emerges as a present matter of conceptual and material excess that shows in the precarious insistence of a human-accessible iconicity: a sense of historical connection that is amidst the noise and emerges precisely from noise.

From scratches to the presence of a certain patina on the surface of things, material exteriorities often guarantee the historicity of objects. Yet the technical exteriority of *Untitled* guarantees this historicity in an unconventional way. Scratches on the surface of an old table guarantee that something happened once, and more specifically that something happened once in the same world we now inhabit. The time of those scratches may have passed and we may not know what produced them, but we can see them nonetheless. The technical exteriority of compression, however, guarantees a comparatively insular sense of the past. The exteriority of writing appears as an animate formal dimension of the technology itself in its time-based executions, not as the result of human action. A nonintentional reactivation holds sway in the direction of history's unfolding. To be sure, intentionality persists even in the wake of its technical demotion. Viewers see things and recognize them as historical. All the same, the nonintentional dimension of writing emerges as newly primary as an agent of historical reactivation.

There is finally the matter of *Untitled* as a self-proclaimed work that comes "after." On the one hand, it is certainly possible to understand the *(After Lucier)* in the title as an example of a fairly typical art historical gesture. It cites an older artist's work as a means of establishing the younger artist within a recognized tradition. But something is out of joint. Certainly the "after" in Arcangel's title means something like "in the style of" Lucier. Since Arcangel's work is certainly a twenty-first-century version of Lucier, why does it reach back to the Beatles in 1964? It might seem more appropriate to employ more contemporary footage, something *after* Lucier's 1969 recording. Here the piece's unending duration hints at something more. It is not just the logic of art historical citation

or the "art system" that grants the work its remarkable sense of history, or even the linear course of "time's arrow" across the events of history. The title being curiously askew gently suggests the queer dynamics of a technological system reorienting the meaning of historical temporality.[56]

The *after* in Arcangel's title may also mean something like "after an era," or a bit more precisely, "after the 1960s." As Pamela Lee shows, the 1960s were a crucial decade for imagining art's relation to time and technology: "The Sixties are endless in staging endlessness as a cultural phenomenon. Of revealing, in the long shadows cast by its technological entropy, a vision of the future ever quickening and repeating. This is one legacy of sixties art that continues to haunt us today."[57] Lee conceives of art's incipient engagement with information culture, cybernetics, and computers as the preface to the digital age. Andy Warhol and On Kawara furnish Lee with her two major case studies for her discussion of the emergence of temporal endlessness anticipating the always-on character of networked digital media. Warhol and Kawara respectively produce and enact de-dramatic aesthetics of endlessness. Warhol's cinema, especially *Empire*, and Kawara's *Today Series* paintings and *One Million Years* book project dilate the presumptive correlation between artist and art object. Warhol's famously durational and relatively unedited film *Empire* displays an image of the Empire State Building for eight hours. Kawara, on the other hand, produced paintings of dates and a multi-volume print book containing a list of a million distinct years going back into the past and a million into the future. While Warhol seems uninvolved and Kawara seems hyperinvolved, both artists respond to what Lee diagnoses as the sixties preoccupation with genres of endlessness. For Lee, importantly, Warhol's and Kawara's respective practices demonstrate the capacity of artists to intervene in the inhuman circuits of an increasingly technological world:

> And this is one lesson we might take from that decade: that possibilities exist, whether in art or politics or both, to move within that network, to play with its temporal fortunes, to show us something about that time— even manipulate it—as it would seem to manipulate us in turn.[58]

For Lee, Warhol and Kawara respond to the problems of time and technology newly emergent in the 1960s by playfully intervening in time's apparently technological character, its antihuman character. Following

Lee, we might then imagine Arcangel to be doing something similar to Warhol and Kawara. But something feels amiss.

The *after* in Arcangel's title may read as "in the style of" the 1960s; or it may signify "beyond" the 1960s. Perhaps it means both. Following Lee, we might say that *Untitled* "plays" with the time of digital media, and I believe that assessment to be correct. Yet there is something distinctly "sixties" about Lee's oppositional liberal rhetoric of resistance surrounding the relevancy and cultural power of Warhol and Kawara that does not fit with respect to Arcangel. Lee rightly asserts that "we" can learn a lesson from the sixties, but it is not the lesson she imagines. Who is the subject of Lee's "we"? Since its antagonist is "the network," I presume it to be humankind or humanity. Lee's rhetoric of fighting back or playing with the implicit forces of technological domination strives to universalize the historically specific position of computers in the 1960s. In that decade, computers were closely and unavoidably linked to the military-industrial complex.[59] Today, while digital media continue to be coupled with military research (e.g., "cyber warfare"), they are also simply the technology we use. Digital media have become profoundly ordinary, a twenty-first-century condition that defuses Lee's gesture toward the old oppositional man-versus-machine narrative.

All the same, Arcangel does follow in Warhol's and Kawara's footsteps, but not for the reasons Lee notes. Rather than raging against the machine, Warhol's and Kawara's works evince a sense of disengagement of human experience in favor of a primacy of the automatism of the machine (for Warhol, the camera) and the machinic (for Kawara, the rote task of recording every date). Arcangel alters this important aspect and advances their project for the twenty-first century. Instead of producing a sense of critical endlessness legible to the historical present as unending infinity or exhaustion, *Untitled* exemplifies the quiet, nonreciprocal and slackened dimensions of network time in its continuous environmental character: always on, always processing, withdrawn from human affairs yet still impacting experience from the peripheries of experience. To be sure, one might resist or play with digital networks, but it is difficult to say one might actually adopt an oppositional stance to a technological process indifferent to individual human existence.

Importantly, both Warhol and Kawara produce a sense of endlessness from the perspective of finite storage media: films, paintings, and

books. For Arcangel, *(After Lucier)* means after Lucier, after the Beatles, after the 1960s, and after recording. In the same way that *Untitled* re-animates Lucier, the Beatles, and 1960s art, it also reanimates recording. And yet it does not seem to reanimate these things precisely *for us*. The temporal elongation of the piece begs the question of whether Arcangel means to suggest a time *after* as generally understood. Whether we are present or not, the work stages an encounter with something that we ourselves cannot encounter: the "time after." In the meantime, we experience pulsating blocks of black, white, and Ringo. Or it just runs on and on in another room somewhere else. It's no wonder that the imagination of the *time after* frequently involves apocalyptic scenarios or the end of the history; the *time after* simply does not address *us*. But what if we again bracket this projection of the *time after* or, as Derrida also might put it, the time "to come"? What if we focus instead on the time at hand, or at least the opacity of time that seems so commonly and precisely out of hand or off to the side of experience? In the service of this thought, I want to stay with the textual opacity of digital media. It is only by developing a vocabulary attentive to the instability of the encounter with digital media that we will be able to inquire more deeply into the transformation of historical temporality.

It would be too much to say that *Untitled* is literally *not for us*, that it is *not for human experience*. It is installed in museum galleries, after all. And yet it powerfully expresses a not-for-us-ness that is merely latent in Marclay, Gordon, and Viola. *Untitled*'s not-for-us-ness should not be seen as a refusal, denial, or dramatic form of protest against human vision. Its aesthetic is instead manifestly de-dramatic, not against anything, but just alongside. At the Art Institute, you actually had to look off to the side of a couch to see *Untitled (After Lucier)*. In displaying *Untitled* in this way, the Art Institute curators brilliantly grasp its quietly nonreciprocal indifference to human experience. One catches sight of the image at the periphery of perception while another, more cinematic video installation plays more conventionally facing the seated viewer. Glancing over the armrest, one sees the image projected at waist level in a comparatively small-size screen, reminiscent of older televisions. *Untitled* is almost more like an appendage to the couch, a piece of furniture, than it is a video installation. Its ambient character suggests a connection to an aesthetic lineage stretching back at least to Erik Satie's furniture music and

Warhol's films. Still, its frank digitality marks it as a profoundly twenty-first-century aesthetic intervention at home in the environmental saturation of contemporary life by always-on digital networks.[60] The time of historical reactivation native to digital inscription, then, may actually depart meaningfully from the temporal before–after structure that is so central to the theorization of time and history since Aristotle. Instead, time moves laterally to human experience, and consequently, so does historical temporality.

3

LATERAL TIME
Historical Temporality in the Age of Networks

"Writing Files . . ."

A blue horizontal bar pulses across a window on my computer screen. Prompted for the umpteenth time, I'm installing software. Several announcements appear: "writing package scripts . . ." "writing files . . ." The bar advances left to right in a few sudden bursts of micro-motion. A caption displays the estimated time to completion: ten minutes, five minutes, done! The whole process maybe takes maybe a minute. So why did it ever say it would take ten?

Everyone knows what a progress bar is, although few know its name. It is certainly a curious thing. It tells the user that files are being written, but it does so through the irregular advancement of an animated, blue bar, not by displaying any scripts or code. Progress bars narrate processes that they cannot narrate, computational events occurring beyond human perception or intervention. Unlike their ugly step-cousins the spinning beach ball of death and the ever over-turning hourglass (so-called "throbbers"), the progress bar promises a correspondence between lived experience and the time of computational events, or digital writing. Quite obviously, the progress bar fails to deliver on that promise.[1] Its jerky ephemerality feels marginal, peripheral to thought. If the progress bar seems unimportant, perhaps that's because it appears when we're waiting for something else: the resumption of constant, instantaneous contact with the network in its ostensible 24/7 availability. This small blip of kind-of-not-quite-maybe waiting provides a tiny window opening onto the maddeningly expansive problem of time in the digital age. Like glitches, lags, or other interruptions in the accessibility of digital media, the progress bar demonstrates the stark difference between the

time of human experience and the time of digital computation. I argue that, far from being insignificant, the progress bar is paradigmatic of a qualitative revolution in the experience of time native to the saturation of contemporary experience by digital media. The progress bar's manifest inability to synchronize human and machine time expresses the impasse of an experience of time neither linear nor nonlinear, but *lateral*.

"Lateral time" names the temporal aporia native to the experience of processes operating at a remove from, but unevenly alongside, human experience. Computational time is lateral to the extent that we live alongside it, within it, in a significant sense according to it, and in ways such that it is thinly, diaphonously correlated with our human experience, barely cognitive or perceptual but somehow also copresent. As Kris Cohen notes, "the two realms, ordinary life and data, proceed together but apart."[2] The laterality of *lateral time*, then, denotes the feeling of living in a paradoxical state of felt nonrelation to the infrastructure informing lived experience; lateral time does not literally describe the ultimate separability of machinic and human time, even if it does inform that idea. Lateral time can be weirdly promiscuous and only *mostly* opaque. As Patrick Jagoda notes, "networks . . . are accessible only at the edge of our sensibilities."[3] So, that is where we must dwell. In order to keep sight of the vanishing horizon of experience, we need something to hold onto. Crucially, as the progress bar demonstrates, the lateral time of digital media may be refigured in textual form even if it may be not properly recuperated or appropriated. The progress bar does not translate or synchronize computational time into human time so much as it marks the experiential opacity characterizing their uneven coexistence. However, the progress bar remains a critically impoverished form. It doesn't say much about itself or what it does. Instead of sticking with the progress bar, then, I turn in this chapter to several works of new media art that, as aesthetic cousins of the progress bar, provide reflexively rich occasions for analyzing the nature of lateral time in digital media.

Following the analyses of animation in chapter 1 and of writing in chapter 2, in this chapter I focus on the issue of time in the service of my larger inquiry into the transformation of historical temporality in the digital age. Following Paul Ricoeur, "historical temporality" names the technical synthesis of *lived time* with times exceeding individual experience: the time of the family, the nation, nature, the cosmos. Insofar

as historical experience depends on a sense of lived time, the task of articulating the changing face of historical temporality requires considering the transformation of temporal experience catalyzed by digital media. It is only then that we may reckon with the transformation of lived time's synthesis with timescales exceeding the individual and, hence, historical experience. The experiential opacity of digital media as time-based technologies requires us to revise Ricoeur's theorization of historical temporality.

Specifically, this task requires reconsidering the centrality Ricoeur accords the trace as the fundamental hinge or point of synthesis between lived time and the times exceeding it. Ricoeur's notion of historical temporality, while still valuable today, derives in large part from the perspective of print culture. In print culture, it was still possible to encounter directly the presence of the past in its literal, material traces. This presupposition no longer holds true in the digital age. While the trace persists, it also vanishes from any direct encounter with human experience. In seeking to update Ricoeur's conception of historical temporality, then, it becomes necessary to account for the experiential *indirection* of lateral time.

In the first part of this chapter, I discuss the aesthetic indirection of lateral time, or the matter of how new media art gives formal contours to a dimension of time at the hazy margins of lived experience. I do this in two ways: through the analysis of John F. Simon Jr.'s *Every Icon*, an online work of new media art, and through related analyses of time important to Ricoeur's notion of historical temporality. I reassess Edmund Husserl's key concept of the temporal object in the context of lateral time and digital media, and I elaborate my revision of Husserl by returning to the very origins of the Western philosophy of time in Aristotle's *Physics*. This discussion of temporality and digital temporal experience prepares the way in the latter half of this chapter for a critical modification of Ricoeur's theorization of historical temporality.

Theorizing historical temporality in the digital age requires replacing the print-centered notion of the "already there" with a broader, more technologically and environmentally oriented conception of the trace appropriate to the networked era. The primary experiential fact of lateral time is that it just *is*. Digital media are, in a fashion, always on. The operation of digital networks has no human-meaningful edges or contour. It

is defined simply by its operational existence on multiple scales, from the local to the global. In seeking to retain the force of Ricoeur's argument while updating his discussion of the trace for the digital age, I look beyond human inscription to the technical rendering of Cosmic Microwave Background (CMB) as a more appropriate model of synthesizing the trace to lived experience in the digital age. In pursuing this argument, I ground my analysis throughout in careful attention first to Simon's *Every Icon* and then to a second work of long-duration new media art: Barbara Lattanzi's *Optical De-dramatization Engine*, or *O.D.E.*

Every Icon: *Lateral Time and the Impossible Temporal Object*

In 1997, Simon launched *Every Icon*. A simple, geometric example of modern design rendered in a Java applet running on his artist website, *Every Icon* appears visually restrained and modestly presented. It may be, however, the most ambitious work of art ever undertaken.

The basic idea of *Every Icon* is strikingly simple: much too much from way too little. A short embedded text explains, "Given: An icon described

Given: A 32 X 32 Grid

Allowed: Any element of the grid
 to be black or white

Shown: Every Icon

OWNER: JOHN F. SIMON, JR.

ARTIST PROOF EDITION

STARTING TIME: JAN. 27, 1997, 9:42:30

Image courtesy of numeral.com

Figure 19. Two raised to the power of 1024. *Every Icon* by John F. Simon Jr. (1997). Courtesy of the artist.

by a 32×32 grid. Allowed: Any element of the grid to be colored black or white. Shown: Every icon." Any combination of black and white squares in its grid represents a single "icon." Begun in 1997 and running continuously to the present, *Every Icon* has technically displayed many, many "icons," but never any icon in the semiotic sense of a likeness. It is composed mostly of white squares, and a few squares buzz with activity on the top row and on the far left side of the second row down. Why do so few squares display black? Because it is a 32×32 grid, the total number of possible combinations ("every icon") is 2 raised to the power of 1,024. That is a very large number, 309-digits-long, to be exact. Patrick LeMieux writes: "Despite the fact that 2^{1024} is a discrete number, that each of its 309 digits are known quantities, and that mathematical operations may be carried out both with and within it, enumeration of such a figure not only outpaces human consciousness but time and space. We cannot count to duocentillion."[4] Even though *Every Icon* has been displaying one hundred icons per second since 1997, it has advanced only to combinations including black squares in the top two rows. It will take about a billion years to get to the third row. It will take an amount of time longer than the age of the known universe to execute its algorithm completely. Humans will not live long enough to see anything resembling an "icon" in the traditional sense of a likeness. While *Every Icon* suggests an ambition to display *every icon*, it will never produce anything like a smiley face, Apple logo, or Nike swoosh. As long as the website, the internet, and Java (and so many other infrastructural nodes) hold up, *Every Icon* will continue to display a silent buzzing of irregular, animated movement.

With an eye cast toward this chapter's ultimate problem, the revision of historical temporality as the synthesis of lived time and the times exceeding it in the digital age, I discuss Simon's *Every Icon* in three overlapping and progressive ways: as a paradigmatic expression of lateral time in digital media, as an example of the "impossible" temporal object native to networked digital media, and as an occasion for revising the meaning of historical temporality in the digital age.

Lateral time is not strictly new. Plenty of events such as the formation of galaxies surpass the meaningful measure of experience. Scientific instrumentation and theory has long allowed for the cognition (if not perception) of geological and cosmological events. Technological forms

from the telescope to the telegraph, seismograph, and the cinema have long offered ways of sensing time differently, including variants of lateral time. Lateral time, then, does not belong exclusively to the digital age. All the same, lateral time has become newly prominent, ordinary, and unexceptional due to digital media's infrastructural ubiquity. So, even if lateral time is not exactly new, it is newly ubiquitous, and this changes the *experience* of it. Lateral time is not so much something we encounter as what we now live within. Along with mobile, wireless, and ubiquitous and ambient media, the contexts for lateral time have proliferated so wildly as to saturate contemporary life in a massively general fashion. Instead of being a temporality native to highly specific and definable disciplinary contexts in particular experimental apparatuses in astronomy, physics, or geology, the specificity of lateral time in the digital age emerges from the popular generality of technoenvironmental ongoingness. Lateral time is *always on*.[5]

Like lateral time, *Every Icon* is also, in many ways, not "new." By Simon's own account, *Every Icon*'s appearance recalls the 1960s and 1970s conceptual gridworks of artists such as Sol LeWitt and Lawrence Weiner. But this isn't your father's modernism. Like LeWitt's famous wall drawings, *Every Icon* features a set of instructions both recounting how the work was created and how to create the work. For this reason, both works might be said to be "algorithmic" in the sense of being based on a set of rules or instructions. The resulting artworks, however, are worlds apart. For LeWitt, concept is king: "In conceptual art the idea of concept is the most important aspect of the work. When an artist uses a conceptual form of art, it means that all the planning and decisions are made before and the execution is a perfunctory affair. The idea becomes the machine that makes the art."[6] The artist's ideation reigns supreme. For Simon, however, it is not so much the concept on which everything depends, but the execution. Without the ongoing action of digital computation, there simply is no work of art, no *Every Icon*. Whereas LeWitt privileges human consciousness as the locale of artistic production, the timescales involved in *Every Icon* are so incredibly expansive that it would be absurd to assert anything like the concept—understood as a kind of property originating with and belonging in some sense to the artist—as the defining feature of the artwork. In *Every Icon*, what matters is not just the idea of such an ambitious project, but rather the simplicity of the algorithm

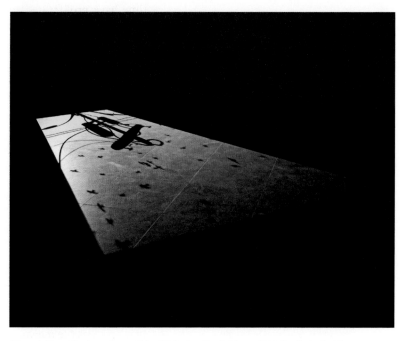

Plate 1. Installation view of *1st Light* by Paul Chan (2005), digital video projection, 14:00. Courtesy of the artist and Greene Naftali, New York.

Plate 2. Sceenshot of ASCII Norman/Mother (shower scene in Alfred Hitchcock's *Psycho*), from *ASCII History of Moving Images* by Vuk Ćosić, with programming by Luka Frelih and production by Ljubljana Digital Medialab (1998). Courtesy of the artist.

Plate 3. Julian Walking on Boston's Northern Avenue bridge. Photograph of *Julian Walking* by Julian Opie (2005). Courtesy of the artist.

Plate 4. Horse and rider ripple, recalling Muybridge. Screenshot from *The Memory of a Landscape* by Tatjana Marusic (2004). Courtesy of the artist.

set against the obvious inability of digital machines to realize that algo-rithm. Crucially, that incommensurability takes the form of an impos-sible scale of time perceptible by human experience, notwithstanding its being always on, in terms of the movement of black and white squares.

Yet *Every Icon* is also inescapably digital. In stark contrast with LeWitt's monumentally unmoving modernist grids, *Every Icon* is quietly animated.[7] The blurry, uneventful movement of combinations reveals the profound difference between digital algorithms and the artistic instruc-tions of nondigital works. *Every Icon* presents the stark difference between the scriptural and the executable forms of digital code. Telling us what is given, allowed, and shown amounts to a neat summary of the essen-tial ideas underpinning not only the Java applet grid of black and white squares but also digital computation more generally. This is an artistic presentation of what Alexander R. Galloway calls the "scriptural" dimen-sion of code, the human-facing and letter-based side of code legible to human cognition. The grid presents us with an aesthetic version of what Galloway identifies as the machinic side of code: its execution.[8] Nor-mally, of course, the execution of code remains hidden and impercepti-ble. In *Every Icon*, however, the grid's animation at high speeds expresses the otherwise opaque domain of computational execution. Crucially, Simon himself frequently discusses his work in terms of "writing," or sometimes as "creative writing." Echoing Friedrich Kittler's notion that digital inscription is able to write and read by itself, Simon states, "when I have finished typing, it is the writing itself that starts to create."[9] No statement better exemplifies the peculiar quasi autonomy at the heart of digital media. In *Every Icon* we see this writing at work indirectly through the animated movement of black and white squares. The blinking of black and white squares allegorizes the binary logic of on and off, 1 and 0, that supports their movement. Such animated movement clues the viewer in to more than just the uniquely computational nature of *Every Icon*, how-ever. It also presents an aesthetic version of the lateral time native to such digital processes generally.

Digital technical operations are indeed so tiny, so fast, so complex, and seemingly ubiquitous that they appear to withdraw from human experience entirely in their operation at the "speed of light," or at least as seemingly "instantaneous." For this reason, analyses of time in the digital age often breathlessly declare the end of time itself! This leads

to odd and paradoxical pronouncements such as sociologist Manuel Castells's description of the time of digital networks as "timeless time." His and similar declarations participate in what Sarah Sharma rightly critiques as the "rhetoric of instaneity."[10] Such statements participate in a tradition stretching back to the advent of the railroad in the nineteenth century betokening the "annihilation of time and space": the general narrative of modernity as one of seemingly inevitable cultural acceleration, urbanization, and technological development resulting in the shrinking of the world in its becoming globally networked via trains, telegraphs, planes, highways, shipping lanes, and finally, the internet.[11] No doubt, digital networks participate in this longer story of cultural modernity.

Yet digital media are also unique for the ways their operation remains constitutively unobservable and unintuitable from the standpoint of human experience. Cultural metaphors of time and history such as acceleration and progression cease to make sense when you start moving fast enough. Even when explained, digital networks fail to make sense in purely technical terms as measuring the movement of data in any discernible way, such as in the manner of a filmstrip. Even though one cannot see the individual frames of a film projected at conventional frame rates of 16 or 24 FPS (frames per second), one can still imagine and keep in mind in a somewhat intuitive fashion the way film renders time measurable according to the predetermined division of frames. Experimental films such as Peter Kubelka's 1960 *Arnulf Rainer* play on precisely this imagined possibility.[12] You just can't do the same thing with networks. The operational time of digital networks is so far beyond the scale of human experience that, for example, Wall Street trading algorithms do battle in microseconds (seconds divided into millionths).[13] And astoundingly, internet traffic between two countries in South America may actually be most efficiently routed via the United States.[14] Internet speed tests mean much more as animated visualizations than they do as any appreciably meaningful measurements of the time of network connectivity. The lateral time of digital media generates peculiar, and frankly weird, realities.

Every Icon, I want to propose, represents an instance of what might be called an "impossible" temporal object. A topic of debate in recent media theory, Husserl's notion of the temporal object provides a strong basis for articulating *Every Icon*'s aesthetic expression of lateral time. Husserl's

classic example of a temporal object is the melody, an "object" consti-
tuted precisely in its temporal flux demonstrating the thickness of the
present as a combination of past, present, and future, or what Husserl
terms "retention," the "primal impression," and "protention".[15] In Hus-
serl's treatment, the temporal object is largely a matter of time as inner
sense or self-affection. In his important retheorization of the temporal
object, Bernard Stiegler shifts the terms of Husserl's transcendental phi-
losophy toward contemporary media culture.[16] Stiegler theorizes the
temporal object as an artifactual, technological, or textual form coinci-
dent with human consciousness, but importantly not the same thing
as consciousness. For Stiegler, films and television shows are temporal
objects because, as "objects," they consist of their material, temporal flux.
They appear in time as surrogates for our own experience because they
appear in a time coincident with our own.

While Stiegler advances a properly media theoretical expansion of
the temporal object, Mark B. N. Hansen questions the limits of con-
sciousness that Stiegler inherits from Husserl for fully appreciating the
transformation of the temporal object in the digital age.[17] Hansen con-
tests Stiegler's characterization of such temporal objects as wholly co-
incident with human thought. The advent of digital media occasions
Hansen's own reflections on the temporal object. Seeking explicitly to
move beyond the media artifactual confines of the temporal object as a
perceptual re-presentification *for* human experience, Hansen prizes what
he terms "the primacy of sensation" over and above any possible syn-
chronization between lived experience and the operational timescales
of digital media.[18] In his view, "the technical singularities of computing
cycles have aesthetic correlates which generate asubjective affects that
do not contribute to narrative understanding."[19] For Hansen, time in
the digital age emerges in the production of affect first and foremost.
Crucially, affect is, for Hansen, *asubjective*: untethered or willfully imag-
ined as separable from subjective experience.[20] While building on Hus-
serl and Stiegler, Hansen's intervention ultimately consigns the temporal
object to the dustbin as an approach to time in the digital age and values
it only as a means to historicize and theorize the novelty and singularity
of digital media. For my part, I believe there is much to be gained by
emphasizing the artifactuality and the objecthood of the temporal object
in the digital age, while still also retaining the significance of affect.

Building on Stiegler's and Hansen's discussions of the temporal object, my own account of the aesthetics of lateral time in *Every Icon* remains devoted to the textual manifestation of the opacity of digital media even, and *especially*, in terms of its manifest partial presentation to perception. Like a film or television show, *Every Icon* is a temporal object because it is only ever constituted in its artifactual flux. Like some film and television objects, *Every Icon* is only ever constituted in its artifactual flux as *animation*. And yet, its flux clearly fails to coincide with human cognition or perception. *Every Icon* counts too quickly (and perhaps also too slowly), and it appears too quickly without showing very much by which to perceive its movement in any robustly semiotic manner. As Hansen suggests, sensation and affect become newly primary in the regime of lateral time, and yet the affects produced by *Every Icon* are not purely affective.

Following Eugenie Brinkema's insistence on the formal and textual dimensions of affect, it is crucial to observe how *Every Icon*'s aesthetic and affective impact derives from—and indeed solely from—its formal appearance to human experience.[21] Because my interests lie ultimately with the aesthetic powers of digital media, the novel primacy of affect must, I argue, remain rooted in its textual appearance rather than the imperceptible operations of digital technology. Any perceptual manifestation of movement, I venture, solicits human perception precisely in terms of a possible synthesis or synchronization, however remotely possible or seemingly impossible. The impossibility of such synthesis does not foreclose the perceptual solicitation of human time so much as it emphasizes this fundamental possibility native to the experience of movement. Moreover, animation grants special insight into this problem of the lure of synchronization native to the experience of movement. As apparently unmotivated movement, animation often appears unhinged from the conventionally tight correlation of human experience with the times represented by the image, and most classically by what Stiegler calls "the time of cinema."

In order to unfurl these problems of time further, and to clarify with greater precision the centrality of animated movement to my characterization of *Every Icon* as an "impossible temporal object," I now turn to a heuristic discussion of two dominant strands in the Western philosophical approach to the continually vexed topic of time. For simplicity's sake,

I restrict my discussion largely to Aristotle, whose writings in large part pave the way for both of what I will schematically call the "objective" and "subjective" approaches to time. Attention to Aristotle allows for clearer insight into the ways in which lateral time lies at the odd nexus of two dominant paradigms of time in Western philosophy: time as the measure of movement of a before and after, and time as inner sense or self-affection.

One of the most venerable definitions of time comes from Aristotle's *Physics*. Time, says Aristotle, is the measure of movement of a *before* and an *after*.[22] For Aristotle, time itself is imperceptible. It is only available or evident in the measurable movement between some point labeled "before" and another labeled "after." From a material, technical standpoint, digital computational media most definitely "produce" or "reveal" time in measurable, countable terms. Wolfgang Ernst convincingly argues this point. For Ernst and other hardline media archaeologists in the generation after Kittler, however, the human experience of time explicitly drops away in the analysis of time-critical computational media in their technical and material specificity. Focusing on the history of time-critical media preceding the computer, Ernst and others privilege nineteenth-century science's discovery of time below the threshold of a tenth of a second. Bernhard Siegert writes: "The realm of the humanities is founded on data with a temporal differential larger than a tenth of a second. . . . Media begin where the humanities stop."[23] Statements such as this reveal much about the difficulty of thinking about time in the digital age. At the same time, it casts doubt on the ability of scholars in the humanities interested in culture and experience to even speak about time in the digital age. For my part, I entirely reject Siegert's declaration that media archaeological approaches such as Ernst's begin where the humanities stop. Their approach remains valuable, but it's not the only game in town. It's just not big news to observe the difficulty of speaking about time.

St. Augustine famously writes: "What then is time? If no one asks me, I know; if I wish to explain it, I know not."[24] Augustine's words still resonate. The difficulty of time, he suggests, lies with an ability to speak about it. It is as though language itself, and by extension higher-order consciousness, or the speaking I, poses an obstacle to grappling with time. The approach promoted by Ernst and others does much to articulate the ways computers still, following Aristotle, generate time by measuring.

Yet, by excluding human experience from the discussion of time in the digital age, their approach misses the possibility of expanding on the implications of Augustine's fundamental insight into the nature of time: that the difficulty of speaking about time, the partiality or incoherence of expressing time, is just as fundamental to theorizing time as is Aristotle's definition of movement as the measure of movement. We must not mistake the inability to speak about time for an insufficiency or perceptual or cognitive flaw foreclosing engagement with the question of time. Following Augustine, time is itself distinguished within human experience precisely in terms of the strongly implied difficulty of speaking, not the words themselves in their being spoken or not, but rather in the felt difficulty of speaking adequately to the experience of time. If this is true for time generally, I propose it is also significant to engage the opacities of technological media providing the historical a priori for feeling the difficulty of expressing time. Difficulties in speaking vary across different media historical eras. The question is: how is it difficult to speak about time in the digital age? Answering this question requires moving away from time merely as the "objective" measure of movement from before to after and attending also to a second prominent definition of time, time as feeling or self-affection.

More than a matter of measuring or counting, time is also a matter of feeling. To continue this heuristic distinction, in contrast to the "objective" imagination of time following from Aristotle's definition of time as the measure of movement, an alternative strand of Western philosophy variously investigates time in a more "subjective" manner through the lenses of feeling, inner sense, and self-affection. This group of thinkers, from Immanuel Kant, to Husserl, to Henri Bergson, and beyond, conceive time as something felt by the mind or the body in a qualitative manner distinct from more "objective" accounts emphasizing measure or counting. For those more interested in the experiential dimension of digital media than in their technical reality or logical underpinnings, the qualitative paradigm of time in its affective dimensions offers a powerful perspective.

Time is more than a measurable, artifactually renderable entity; time is also felt. Lateral time exceeds the domain of "time-critical," machinically measurable intervals. It is more properly the felt problem of the disjunct between experience and the inhuman realm of so-called

"time-critical" measurement. From the standpoint of experience, digital media are not so much time-counting or time-keeping machines as they are *time-losing* machines. Even beyond academic criticism, it is common to hear various refrains on the diminishment of time in the digital age. Where does the time go? One frequently hears about losing time online. Not just *wasting* but actually *losing* time in various "time sucks" like so many digital black holes: gaming, social media, porn, texting, or whatever. *Every Icon* offers insight into this phenomenon of feeling time in nonrelation to digital media in something of a photo-negative fashion. Instead of intensely preoccupying its viewer with variously phatic and constantly irregular prompts to type, ping, poke, like, and stream, *Every Icon* involves its viewer to an astonishingly impoverished degree. Watching *Every Icon* on my web browser, it is evident that computations are taking place but not much else. The movement of black and white squares is momentarily interesting. But, mostly, *Every Icon* is remarkably quiet and undemanding.

Because *Every Icon* deals with mathematics and vast timescales, it is tempting to define it in terms of Kant's notion of the mathematical "sublime." Yet the sublime is much too dramatic a category of aesthetic encounter to hoist on *Every Icon*, much less anything happening on the ordinary space of a web browser. As Sianne Ngai observes, Kant's "sublimity applies only to a quality or state of the subject's mind, and not to the object that excites that state of mind."[25] In an era when the word/number "google" becomes perfectly banal, *Every Icon*'s exponential mathematics inspires neither dread nor the unbearable comprehending incomprehension of a mind grasping its own limits. Encounters with *Every Icon* more than likely take the form of a slackened boredom.[26] It is not a big, bad, and bossy object that teaches viewers how to be small or finite. To be frank, it doesn't seem all that interested in us. *Every Icon*, after all, affords little in the way of visual pleasure. The overwhelming feeling of its computational operation is that it occurs in a manner primarily *lateral* to human experience. Put in more formal terms, there is little in the movement of the black and white squares of *Every Icon* that moves us.

Neither of these august traditions in the history of Western philosophy's treatment of time feels entirely appropriate or adequate for addressing the lateral time of *Every Icon*. On the one hand, its time seems entirely measurable and countable. Yet the movement of that counting

merely demonstrates the impossibility of measuring and counting any-thing in any human-meaningful sense beyond the billion-plus-year scales of its operation. On the other hand, the constant movement of its black and white squares generates a feeling of time, albeit a manifestly de-dramatic and slackened sense of its passage in relation to human experi-ence. The insufficiency of both paradigms of time requires, I believe, a synthesis of the two via a closer look at what they have in common: a sense of time whose ultimate stakes derive from the animated elements of *Every Icon*.

Movement is key to Aristotle's famous definition of time as measure. Movement is also crucial to his theorization of time as self-affection.[27] Synthesizing these two dimensions, we might say that the lateral time of *Every Icon* is something like *movement without measure*, an unmeasur-able time from the perspective of experience—that is, without discernible befores and afters. Time without measure denotes also the experience of the suspension or impossibility of measure, measurement present or functional yet unavailable to experience.

More native to the critical imagination of affect and embodiment than are objectivity and science, the notion of time as self-affection imag-ines time as what *moves* us. Aristotle also discusses this notion of time. In an often-overlooked passage from the *Physics*, Aristotle discusses possi-ble objections to the definition of time as the measure of movement. For instance, what happens to our sense of time in the dark? Aristotle writes: "Now we perceive movement and time together: for even when it is dark and we are not being affected through the body, if any movement takes place in the *mind* we at once suppose that some time also has elapsed, some movement also along with it seems to have taken place."[28] Even in the absence of measurable, perceptible motion in the world, a sense of time persists as movement in the *mind* (Greek ψυχη [*psyche*] or Latin *anima*). Movement does not just transpire "out there" in the visual field waiting to be observed and measured; movement happens within the living organism in the mind, or soul, precisely as the felt symptom of time's passing.

Here it is impossible to overlook how Aristotle's discussion of time as self-affection relies on a sense of embodied animation absent from his more famous discussion of time as the measure of movement. The term *psyche* or *anima* is, of course, complex. But, without delving far into

Aristotle's *De anima* or other ancient Greek discussions such as the account of the soul as a chariot in Plato's *Phaedrus*, what is most important here is to recognize that, at a crucial moment in Aristotle's elucidation of the nature of time and how we perceive it, he notes not only the usual, vanilla sense of bodies moving in the external world but also a sense of bodies moving in excess of themselves as if from within: time as self-affection. Time is felt not only through the body, but rather through the body's core sense of itself as informed by *anima*, as animated by a principle of life common to all living things from humans to animals to plants. The translation of *psyche* as "mind," then, should not be read as indicating a movement of cognition in the sense of higher-order consciousness as the personal property of the individual in his/her quintessence (as in the dime-store version of the Christian notion of the soul). In Aristotle's text, *psyche* has a much more impersonal quality, as it denotes the movement-granting principle of life itself operative within the body. Time is at least just as much, if not more, something that happens to the body as it is something the body experiences through its own power.

The animated movement of *Every Icon* expresses both senses of movement in Aristotle's account of time: as observable, measurable motion *and* movement as self-affection. Now, it is frequently the case that objective movement and subjective movement appear as different dimensions of the same thing. The observation of movement solicits a felt sense of proprioceptive motion; movement *moves* us. As Scott C. Richmond argues in his fine theorization of proprioceptive aesthetics in cinema, the embodied experience of motion often involves feeling bound up with the motion of the world in its technical presentation.[29] One of the more striking examples is the dizzying feeling solicited by the extraordinary camera movement of *Gravity*'s opening sequence. In contrast with the ways *Gravity* and other perceptually demanding movies call directly on the body of the viewer, *Every Icon* presents its viewer with a sense of motion with which it has little or no hope of synchronizing. It does not make the viewer feel like she is floating or flying in the manner of a flight simulator, roller coaster, or IMAX screening. By comparison, *Every Icon* is profoundly dull. The little that occurs highlights the narrow fact of a computational event in an even narrower sense of relation to the time of lived experience, in a felt sense of nonrelation or relation nearly untethered or available as overwhelmingly unavailable.

If *Every Icon* catalyzes a decidedly weak sense of time as self-affection in the viewer, it also seems to feel *itself* in time. Here things get a little weird. While *Every Icon* does not place demands on human viewers, it does place serious demands on one's laptop. Kept running for more than a moment, it is likely that the Java applet will make the computer work hard enough to make the keyboard heat up and the fan spin. Such actions occur more commonly during videogame play or streaming video, online actions featuring rich graphics that evidently tax a computer's graphics card. Execution, once again, is not an afterthought; it is everything. "Execution" names not merely the setting into motion of *Every Icon* but also the motion itself, machines continuing to talk to other machines producing a sense of time alongside human experience but also at its margins: quiet, peripheral, nonreparative, noninterpretive, nonrecipro-cal. It's just there, or perhaps (expressed in a manner more true to human experience) somewhere, or perhaps everywhere. As the aesthetic corre-late of the impossible temporal ambitions of *Every Icon*, animation grants textual specificity to this sense of the networked quality of *Every Icon* as always on. Animation provides a site of encounter for human experience to come into reflexive contact with the indirect opacity of lateral time in the digital age. Thus, not only do the animated images of *Every Icon* present the viewer with a sense of time without meaningful perceptible measure; Simon also presents the viewer with a complementary sense of self-affection rooted as much, if not more, in the machine's experience *of itself* as in the user's considerably slackened relation to its movement. Both dimensions of *Every Icon*'s expression of lateral time convey the experiential opacity of digital media. Both dimensions of animate opac-ity, moreover, inform *Every Icon*'s expression of historical temporality.

What does a buzzing 32×32 grid have to do with historical experi-ence? As Simon explains, *Every Icon* pays homage to the history of com-puters, not just his modernist forebears. A 32×32 grid, he notes, "was the original Macintosh definition for an icon when the first Mac system came out."[30] *Every Icon* is a 32×32 grid in accordance with Susan Kare's classic designs for the Macintosh: the manicule "pan hand," the bomb for system errors and crashes, the trash can for unwanted files, and many more. Put into context with Kare's enduring Macintosh icons, *Every Icon* reads as a tribute to the power of technological design. The work's ambi-tion to display "every icon" radically extends Kare's pioneering interface

designs. *Every Icon*'s technoformalist historical debt to Kare's designs helps us dislodge its aesthetic project even more from the art historical stories of its modernist predecessors. For Rosalind Krauss, the modernist grid is fundamentally antihistorical. Gridworks by LeWitt and others, for Krauss, express a sort of universality antithetical to development, narrative, and history.[31] While it may be antinarrative and experientially antidevelopmental, *Every Icon* clearly expresses a sense of historical time, albeit one primarily lateral to human experience. More precisely, *Every Icon* expresses a sense of historical time through its animate citation of the history of computers and computation. With Kare's icons in mind, it becomes easier to grasp the feeling of witnessing *Every Icon*, as it were, on the "outside." *Every Icon* feels itself in history, but it does so in ways we can recognize only as if from afar, not in ways in which we might participate ourselves.

Every Icon expresses a sense of historical experience that is *not for us*. This situation recalls the premonitions of media theorist Vilém Flusser. In a remarkable passage from 1987, Flusser imagines historical experience belonging less and less to human beings and more and more to machines. The increasing divergence of human experience from technological development gives rise to an incipient imagination of "another history."

> We are just about to leave notation (writing as such) to apparatuses and focus our attention on making and looking at images. We are about to emigrate into the "universe of technical images" so that we can look down from there at history being written by apparatuses. . . . These apparatuses do not write in the same way we did; rather they use other codes. History written (and made) by apparatuses is another history.[32]

In the dramatic scene Flusser conjures, humans peer down from their universe of technical images upon history "being written by apparatuses," a history that is *not for us* so much as it is "another history." Attending to Flusser more as a speculative provocation than as a guide, in the following section, I attend to the importance of digital moving-image aesthetics for articulating an answer to the following question: what does *a lateral historical temporality* look like? What does it mean to encounter a history that does not address human perception, a history that is not *for* us? If *Every Icon* provides one sort of answer, I want to ask whether

we can ascertain any others that preserve the crucial experience of lateral time without holding its viewers at such a distance. The de-dramatic aesthetics of animation in *Every Icon* suggest that historical experience bifurcates over the opaque gap between human action and the activity of the machine. *Every Icon* presents these two domains as far apart. Is it possible to close the gap?

Networked Historical Temporality: Barbara Lattanzi's Optical De-dramatization Engine (O.D.E.)

Historical temporality is a problem of conjugation. Following Ricoeur, historical temporality synthesizes two dissimilar scales of time: lived time and universal time, "phenomenological time and the time phenomenology does not succeed in constituting, which we call the time of the world, objective time, or ordinary time."[33] Historical temporality connects the time of lived experience to the timescales exceeding it: the times of the family, cultural movements, nations, nature, or the cosmos. What happens when the time that phenomenology does not succeed in constituting no longer *exceeds* experience so much as it *runs lateral* to it? Running on and on, *Every Icon* barely synthesizes lived experience with lateral time in the new experiential grammar of networked digital computation. The distance between the two seems still so great that the sense of historical temporality evoked by *Every Icon* feels as if it does not quite belong to human experience. Recalling Flusser, *Every Icon* seems to express something less like human history than "another history," something historical-like in character but running aside from human history at some distance. Is it possible to encounter lateral time with greater proximity?

Every Icon is not alone in its exploration of networked long-duration aesthetics. In fact, the web is chock full of impossible temporal objects. YouTube features a number of ten- and twelve-hour videos: hours and hours usually of one iconic sound, viral video, or meme, from ten hours of the engine noise of the Starship Enterprise or Darth Vader breathing to hours and hours of Nyan Cat or the Trololo guy. Like *Every Icon*, these popular long duration videos are not meant to be viewed from beginning to end (even as the comments section often discusses the videos as challenges to the individual viewer's endurance). Why are there

so many videos that are far too long to watch? There is certainly a kind of experimentation at work; clearly many viewers revel in maxing out the upload limits of YouTube. Yet the sheer number of these long-duration videos suggests something more is at play than delight in testing the network. The appeal of these videos, I want to suggest, has to do with the ways they engage the ambient, ongoingness of lateral time. At the same time that they go on far too long, their artifactual form foregrounds the extreme limits or possibilities of engaging the temporal aporia of lateral time. Because the videos do end after ten or twelve hours of playback and do not run infinitely, they evoke a fantasy of viewer endurance, of aligning one's body in a Sisyphean fashion with the lateral time of networks at the edge of human experience. Departing from *Every Icon*, then, long-duration videos suggest the value of cinematic form in the basic sense of bounded, discrete moving images with actual beginnings and ends.

In this section, I argue that the persistence of cinematic form in long-duration network aesthetics proves crucial for explaining the ways lateral time inflects historical temporality in the digital age. Beyond YouTube, a number of new media artworks online and in galleries share *Every Icon*'s concern with nonhuman timescales. At the same time, many of these works draw extensively on cinematic forms and aesthetics in ways that demonstrate an abiding interest in the history of media forms and, more generally, the changing status of historical experience. For many artists, the great strength of coupling digital media with cinema is that the latter offers a rich resource of aesthetic styles and strategies of address through which to give form and friction to digital experience.

In trying to "close the gap" between the machine history of *Every Icon* and more humanly scalable forms of historical temporality, it may be helpful to sketch a continuum among long-duration works, several of which have become quite well-known in discussions of new media aesthetics. At one extreme of lateral time lies Italian artist Maurizio Bolognini's anti-cinematic *Sealed Computers*, one piece in a series of *Programmed Machine* works produced in the 1990s. In this work, Bolognini networks computers in the gallery and programs them to generate abstract images indefinitely. One doesn't actually get to see the images, as Bolognini has encased the computers in silicone to prevent access. Save for the whirring of fans cooling hard disks, there is little indication to the

viewer that these computers are actually doing anything. Nonetheless, they run on and on, speculatively marking a kind of time through the production of images we cannot see. At the opposite end of the continuum, another branch of long-duration works incorporates cinematic footage and form. Among the most famous of these works are Wolfgang Staehle's 1999–2004 *Empire 24/7* (a five-year-long webcam view of the Empire State Building inspired by Andy Warhol's eponymous eighthour film from 1964), Douglas Gordon's 1993 *24-Hour Psycho* (a daylong version of Alfred Hitchcock's horror classic), and most recently, Christian Marclay's 2010 *The Clock*, a twenty-four-hour video installation synchronized with local time and composed of shots of clocks and watches culled from film history. This continuum of long-duration works runs between Bolognini and Marclay: sightless and endless at one end and intensely visual, constantly hailing human perception and yoked to the human-friendly scale of the twenty-four-hour day and local time, on the other end. On this continuum, *Every Icon* leans away from Bolognini and toward Staehle. In trying to close the gap between lateral time and human experience in order to address more clearly the problem of

HOUR 9 20,56 / 8:56:31 p.m. The Next Day

Figure 20. Addressing the network. Screenshot from *Optical De-dramatization Engine (O.D.E.) applied in 40-Hour Cycles to Thomas Ince's 'The Invaders,' 1912* by Barbara Lattanzi (2006). Courtesy of the artist.

historical temporality, however, I want to move further on the continuum, somewhere between Staehle and Marclay. Here we discover Lattanzi's 2006 *Optical De-dramatization Engine (O.D.E.)*, a work running in forty-hour cycles online that elongates and transforms Thomas Ince's 1912 film *The Invaders*.

The full title of Lattanzi's 2006 work is *Optical-De-dramatization Engine (O.D.E.) applied in 40-Hour Cycles to Thomas Ince's 'The Invaders,' 1912*. For convenience's sake I refer to Lattanzi's work as the *O.D.E.* Of course, it is also an "ode." Not unlike the poetic conventions of apostrophe and prosopopeia by which the poet addresses nonhuman entities—as in Percy Bysshe Shelley's famous ode that begins "O Wild West Wind"—Lattanzi's titular invocation of the ode foregrounds the question of address. Like so many nondigital odes, Lattanzi's *O.D.E.* emphasizes the question of address in a manner that resists narrative and replaces it with an insistently self-authorizing "vocal" presence, what literary scholar Jonathan Culler calls an "animate presupposition." Retaining threads of human-scaled narrative precisely in order to hold them in jittery abeyance, the *O.D.E.* focuses on the machinic event of its happening, or computational writing. Writing on (print-based) poetic odes, Culler writes, "Apostrophe resists narrative because its *now* is not a moment in a temporal sequence but a *now* of discourse, of writing."[34] Lattanzi's *O.D.E.* also resists narrative. Its images are animated. Its animations similarly resist narrative as a *now* of discourse, but with a crucial difference from Culler's theorization of the printed or handwritten poetic ode: the *O.D.E.* instances the profoundly *lateral* now of digital inscription. In the mode of print poetry, for Culler, it is as though apostrophe conjures or animates the poem by foregrounding the poem's presence on the page as *reactivating* itself beyond the mind or voice of any human reader. This dynamic surely changes in the digital arena. The question arises as to whom or what a forty-hour cycle of heavily manipulated and seemingly self-authorizing networked cinematic footage addresses itself.

On one level, Lattanzi's *O.D.E.* addresses history. Adapting cinema history and aesthetics to the networked digital era, the *O.D.E.* draws on *The Invaders*, a forty-minute film from 1912 directed by Thomas Ince. In the film, the eponymous "invaders" are the U.S. Cavalry, a perspective that certainly stands out in the lopsided history of representations of Native Americans on the silver screen. And, as Lattanzi explains, she

chose *The Invaders* to spur reflection on contemporary historical events, particularly the American invasions of Afghanistan and Iraq.[35] The *O.D.E.* thus addresses its viewers as historical subjects, agents able to conceive their relation to the past on the basis of its representation, for good or ill.

On another level, the *O.D.E.* seems to address neither history nor human experience at all. It runs whether or not you're there to look at it or not. Unlike Marclay's *Clock*, which runs in the museum at night when there is nobody around to see it, the *O.D.E.* runs regardless of its being projected. You can project the *O.D.E.*, but you don't have to; it runs on servers. Like *Every Icon* or Bolognini's *Sealed Computers*, Lattanzi's *O.D.E.* runs in the dark light of the internet without images or eyes. In this regard, one can say that it addresses not human perception, or even its possibility. *O.D.E.* addresses the network itself.

O.D.E., then, addresses both human experience and the lightless realm of lateral time in digital networks. The image itself bears out this stark tension. Flickering black and white squares populate the screen throughout much of its mute re-presentation of *The Invaders*. Often the squares seem to move in contrary directions, dancing diagonally while another pattern jitters in place. Like the animated squares in *Every Icon*,

HOUR 2 22,35 / 10:35:55 p.m. Treaty between the U.S. and the Sioux

Figure 21. Representation flashes into legibility. Screenshot from *Optical De-dramatization Engine (O.D.E.) applied in 40-Hour Cycles to Thomas Ince's 'The Invaders,' 1912.* Courtesy of the artist.

these flickering pixel-like squares allegorize the basic materiality of digital computation and visualization as at once so many states of *on* and *off*. Recognizable compositions soon come into view: nervously oscillating stills from *The Invaders*. These stills never crystallize into stable or "seamless" photograph-like clarity. They also never graduate from still to properly moving images in the sense of playback. Instead, a virtual camera scans over the surface of the image with a machine-like exactitude, the image always flickering as a field of pulsing black and white squares to and fro very quickly. In sum, the image shimmers even as it moves back and forth between extreme abstraction and filmic representation.

Viewed as an installation or projected on a large screen, the *O.D.E.* appears especially sensationally aggressive. Like the flicker films of Kubelka, Tony Conrad, and Paul Sharits, the *O.D.E.* continuously throws its viewer back on her own embodied limits of perception. Its images flicker, and they just never end. At the same time, the flickering stasis of the image suggests its limits and a sense of finitude. The expansion of *The Invaders* from forty minutes to forty-hour cycles is also significant. The *O.D.E.* runs in forty-hour cycles, not four-hundred-hour cycles. While it may not be practical, it's at least *possible* to imagine watching a complete cycle. This strategy recalls the clock-like and day-long timescales of *24-Hour Psycho* and *The Clock*. By pushing beyond the twenty-four-hour mark, however, Lattanzi's *O.D.E.* suggests the ways network time exceeds human experience. Forty-hour-cycles are too much to view and too odd to synchronize with lived experience. The expansion of *The Invaders* from forty minutes to forty hours does not merely evoke the lateral time of networks, however. By elongating the time of *The Invaders* tenfold, the *O.D.E.* formally installs cinema as the mediating power between the times of lived experience and the endlessly expansive domain of networked lateral time.

A former student of avant-garde filmmakers Sharits and Hollis Frampton, Lattanzi owes much to the aesthetics of structural film, a branch of experimental film focused on the material bases of film itself, from light and celluloid to shadows, projection, and the material degradation of film over time. At the same time, the *O.D.E.* advances the stylistic and philosophical project of structural film in the context of digital networks. In style and form, the *O.D.E.* recalls Ken Jacobs's experimental classic from 1969, *Tom, Tom, the Piper's Son*. Like the *O.D.E.*,

Jacobs's *Tom, Tom* extends the duration of its source material: in Jacobs's case, from a few minutes to two hours. Like *Tom, Tom*, the *O.D.E.* zooms in on the filmic image to highlight its hidden dimensions. In *Tom, Tom*, these zooms have the haunting effect of revealing the figurative line at which persons represented in the film nearly break down into the substance of the film itself as so many silver halide crystals on degraded film material. Yet their primary purpose is to discover unnoticed events in order to expand the viewer's sense of what is happening in profilmic space, to bring marginal moments and "characters" to attention. By contrast, Lattanzi's zooms do not work to recuperate narrative content. Whereas *Tom, Tom* zooms in on aspects of film stock in order to magnify otherwise unnoticeable narrative details, the *O.D.E.*'s material gaze animates the experiential opacity operative at the convergence of cinematic and networked time. More than narrative detail, the *O.D.E.* animates the very basis of our encounter with the past: the traces of what is *already there*.

In a singularly remarkable statement, Lattanzi addresses the deep meaning of the visual aesthetic of the *O.D.E.*:

> I see the ODE cracking open "The Invaders'" representations (ostensibly focused on human drama) to include a coinciding non-human expressivity. The aggregate arrangement (sky, landscape, actors, props, costumes, interiors, etc.) in front of an optical light-gathering system and its chemical fixing on a material substrate circa 1912, now registers as a fractal-like motion texture that has (fractional) dimensionality and visually coherent patterns entirely distinct and separate from the representational reading. The point is that the fractal-like patterns of the ODE can be understood as *already there*, embedded during the actual period of film production, circa 1912. . . . They are not abstractions of the representations.[36]

"The fractal-like patterns of the ODE can be understood as *already there*." Critics of the digital image have long remarked on the computer's capacity to remediate or to simulate, manipulate, and transform source material. But Lattanzi claims something much different here. For her, digital media provide the technological means to reactivate what she calls "a coinciding non-human expressivity" captured by film cameras in 1912. To follow her logic, digital media operate on the same data

recorded by Ince but produce it in an astonishingly different fashion from *The Invaders*. If cinematic images are conventionally presented as *for us*—as represented for human enjoyment and experience—Lattanzi underscores the historical contingency of this approach. Film cameras need not represent images back to human consciousness at scales and speeds reproducing the flux of reality. The advent of digital networks, then, provides the catalyst for a radical aesthetic exploration into the ways in which cinema is not necessarily for us. This insight crucially historicizes the largely nonhuman domain of networked lateral time by connecting to the earlier regime of photographic film technologies. The technology and time of digital networks allow the traces of the past to reveal something new that film could not: the animate shimmer of the *already there*, the history dancing between the edge of narrative representation and the spare pulses of black and white pixels.

For Ricoeur, the trace represents the fundamental hinge between lived experience and the times exceeding it. The trace constitutes the material conditions of possibility for the emergence of historical temporality. Considering that Ricoeur worried about the rising prominence of digital media as breaking "with the notions of the trace and the testimony

HOUR 2 22,49 / 10:49:44 p.m. Treaty between the U.S. and the Sioux

Figure 22. Pixels flicker and shimmer. Screenshot from *Optical De-dramatization Engine (O.D.E.) applied in 40-Hour Cycles to Thomas Ince's 'The Invaders,' 1912.* Courtesy of the artist.

of the past," and even more dramatically as "announcing the suicide of history," Lattanzi's *O.D.E.* should afford us a sigh of relief.[37] Hooray, history does not end! Lattanzi, after all, seems to be working with a notion of the trace in her statement that the *O.D.E.* features images that are *already there* in the original film. The real issue, however, is to grasp how historical experience changes in the digital age, not merely to affirm its persistence.

In the final portions of this chapter, I build on the foregoing discussions of *Every Icon* and the *O.D.E.* to focus squarely on the matter of the changing nature of historical temporality in terms of the trace. My contention has been that the blinking, shimmering black and white pulses of animation featured in both *Every Icon* and the *O.D.E.* refigure the traces of the past in terms amenable to the network. I now want to back up a few steps to reconsider this claim. I do so by examining Ricoeur's theorization of the trace. Though he provides an invaluable guide to this problem, Ricoeur theorizes historical temporality and the trace in decidedly print-centered terms. Looking backward to Simon and Lattanzi but also forward to chapter 4's focus on the increasingly environmental character of digital media, the final portion of this chapter aims to rethink Ricoeur's discussion of historical temporality and the trace in terms more amenable to lateral time: as time-based, ambient, and largely peripheral to human experience.

For Ricoeur, historical temporality comes about as narrative crafted by historians and novelists alike. Throughout this book, I have been arguing that historical experience now takes place in a rather different way. Animation displaces narrative as the privileged textual form of historical temporality in the age of always-on networked computing governed by suprasensible forms of digital inscription. This shift matters for a number of reasons. Paramount among these is the idea that the shift toward animation from narrative changes what Ricoeur terms the "creative capacity" of history. He writes:

> History initially reveals its creative capacity as regards the refiguration of time through its invention and use of certain reflective instruments such as the calendar; the idea of the succession of generations—and, connected to this, the idea of the threefold realm of contemporaries, documents, and traces. These reflective instruments are noteworthy in that they play the role of connectors between lived time and universal

time. In this respect, they bear witness to the poetic function of history insofar as it contributes to solving the aporias of time.[38]

History's creative capacity relies on the refiguration of time synthesized by "reflective instruments." For Ricoeur, such instruments remain instruments of and belonging to *thought* [*instruments de pensées*]. Here the *of* [*de*] in his striking phrase recalls the Husserlian notion of intentionality: all consciousness is consciousness *of* something. For Ricoeur, then, history remains tightly tethered to human consciousness. As argued in chapter 2, however, digital inscription is primarily nonintentional, taking place predominantly outside human sensory experience. This does not mean we ought to toss Ricoeur's project aside, however. The emergence of networked digital computing changes the context for theorizing historical temporality. It thereby requires rethinking Ricoeur. For Ricoeur, the trace represents the most fundamental connector or "reflective instrument." As Matthew Kirschenbaum observes, the trace persists in the digital age.[39] Yet its microscopic and microprocessural existence and operation fundamentally changes our relation to it. In the twenty-first century, the trace continues to function as a connector or hinge between lived time and universal time, but it also does so differently. Animation takes the place of narrative as the appropriate aesthetic correlate of our relation to the trace: no longer directly experienceable, but rather opaque and diffusely quasi-autonomous.

As much as Ricoeur privileges narrative and higher-order consciousness, close scrutiny of his discussion of the trace reveals the latent non-human exteriority of the trace. Examination of this aspect of Ricoeur's thought, in turn, sheds light on the creative capacities Simon and Lattanzi cite when they respectively speak of their projects as "creative writing" or as the nonhuman expressivity of the *O.D.E.* in its shimmering, fractal flashing pixels of black and white. Unearthing the exteriority of the trace in Ricoeur's account reveals its affinity with Heidegger's notion of the *already there* (importantly glossed by Stiegler as essentially technical). For both Ricoeur and Stiegler, the trace names the fundamental hinge between lived experience and the times exceeding it. For Stiegler's Heidegger, the *already there* names the sense of encountering the presence of the past in the environment. Along similar lines, for Ricoeur, the trace artifactualizes the presence of the past, the evidence of absence.

The trace figures a time exceeding lived experience, the time of the individual, as the times always already preceding "me." Ricoeur writes: "Here is the heart of the paradox. On the one hand, the trace is visible here and now, as a vestige, a mark. On the other hand, there is a trace (or track) because 'earlier' a human being or an animal passed this way. Something did something."[40] The trace is here and now; we perceive it in the present as a material thing. But it also provides access to a past activity of which we have no direct perceptual access. It is in this sense that the trace functions as a "connector" between lived and universal time. In a crucial footnote, Ricoeur cites a decisive passage from historian Marc Bloch emphasizing the way the *already there-ness* of the trace applies to history.

> Its [history's] primary characteristic is that knowledge of all human activities in the past, as well as of the greater part of those in the present, is, as François Simiand aptly phrased it, a knowledge of their traces. Whether it is the bones immured in the Syrian fortifications, a word whose form or use reveals a custom, a narrative written by the witness of some scene, ancient or modern, what do we really mean by *document*, if it is not a "trace," that is to say—the mark, perceptible to the senses, which some phenomenon in itself inaccessible, has left behind?[41]

Ricoeur comments: "Everything is stated here. But everything is an enigma."[42] History depends fundamentally on the endurance of traces "perceptible to the senses." But what is the "enigma" in question? Ricoeur's footnote ends abruptly with this comment.

What is the "enigma" of the trace? For Ricoeur, I propose, the problem may be summed up thus: how is it possible to jump from the perception of traces of the past to historical narrative? Ricoeur's discussion of historical temporality appears within the much broader context of his magisterial treatment of the relation between time and narrative. For Ricoeur, narrative time amounts to human time: "Time becomes human time to the extent that it is organized after the manner of a narrative."[43] This sweeping claim defines historical temporality as fundamentally *narrative*, and it assigns any notion of nonnarrative to the murky realm of nonhuman time. It seems instructive, then, that, when Ricoeur emphasizes the polyvalent sense of the term *trace* in French as denoting not only inscription but also the tracks an animal leaves behind, his discussion

stops in the face of an "enigma." It is as if the nonhuman intrusion of an animal's movement into his analysis seems both vital and impossible to account for fully. Ultimately, for Ricoeur, the "creative capacity" of history rests tacitly but firmly with the power of human historians to refigure the traces of the past into historical narratives.[44] That history is written by human historians seems like an innocuous claim. Yet something of the enigma of the nonhuman dimension of the trace, I argue, arises again in with resounding force in the era of networked digital media.

What is the network trace, and how does it appear to human experience? In a chapter evocatively titled "Always Already There, or Software as Memory," Wendy Hui Kyong Chun theorizes the technological specificity of digital memory, and thus implicitly the unique character of digital history. She clarifies the ways the digital trace differs from its analog, handwritten, and *perceptible* predecessors. In concluding this chapter, I want to affirm two ideas. First, while acknowledging the critical significance of accounting for the technological specificity of digital media, my emphasis lies with the experiential opacity of digital media. Because my interest lies with the experiential opacity of digital media, my question is really not the small *o* ontological question (what is the network trace?), but rather the aesthetic question of *how the trace appears to experience*. In pursuing this question, I find Chun's medium-specific account of digital media marvelously suggestive yet also inadequate to the task of scaling up from the problem of computer memory to broaching the topic of digital historical experience. Aesthetic works such as *Every Icon* and the *O.D.E.* here prove crucial. These flickering, shimmering works resonate with Chun's notion of computer memory as an "enduring ephemeral." Yet, especially with the *O.D.E.*, it becomes possible to see their animated aesthetic refiguration of the digital trace as opening onto the question of the environmentalization of digital media, or the relative insignificance of the experience of the digital artifact in accounting for the experience of the trace, and thus for historical experience in the digital age.

The flickering black and white animated images of *Every Icon* and the *O.D.E.* perfectly resonate with Chun's notion of the "enduring ephemeral." Drawing extensively on the material and technological logics of digital media, Chun argues that discussions of computer memory have conflated storage with memory. There are powerful reasons for this.

The very idea of storage evokes a sense of putting things down or away precisely so that they may be recalled or reactivated later for future use.[45] As Chun observes, however, software does not work like a book in a library or a film canister in an archive. Software is not one thing or object that might be put away and retrieved: "Through a process of constant regeneration, of constant 'reading,' it [software] creates an enduring ephemeral."[46] The key phrase here is "constant regeneration." By virtue of their material functionality, digital media constantly make and remake their objects: images, documents, files, and so on. Opening up an old Word document, for example, is not like taking a book off the shelf. While the book can be trusted to be actually the same material thing from use to use, digital media constantly compose and recompose their objects by virtue of the very technological logics producing them. Importantly, this action of constant re-generation occurs overwhelmingly beyond the threshold of human experience. As Chun writes: "These images are frozen for human eyes only. Information is dynamic, however, not only because it must move in space on the screen, but also, and more important, because it must move within the computer."[47]

Chun offers a fundamental insight into the nature of computer memory. However, I disagree with her claim that the movement of information inside the computer is more important than what appears to experience on screen. The flickering and constantly regenerating visual aesthetics of *Every Icon* and the *O.D.E.* prove indispensable here. Even if the normative functioning of computers actually obscures the material logics of their technological operation, aesthetic works have the power to present visions of the experiential opacity between the screen and the black box. The animated aesthetic of the *O.D.E.* may not provide a pedagogical lesson in how computers work, but it does something that is arguably much more meaningful. Its *re-generating* images refigure the dynamic nature of the digital trace in terms meaningful for human experience that embrace the experiential opacity of digital media.

As *networked* works of art, *Every Icon* and the *O.D.E.* also powerfully gesture toward a key issue in the study of the experiential opacity of digital media: their increasingly environmental character. Neither *Every Icon* nor the *O.D.E.* has one artifactual "home." Neither can be stored in a conventional sense. You can watch either anywhere as long as you have properly updated software and a network connection. And

for the Western postindustrial world, these requirements are increasingly easy to come by. While it would be wrong to suggest that the status of the image diminishes in the network era, it is also less and less clear what the image means in its capacity to refigure the technological conditions of possibility of historical experience. Galloway even goes so far as to argue that networks are fundamentally "unrepresentable."[48]

In privileging two works of networked new media art, this chapter obviously disagrees with Galloway's claim. In concluding this chapter, however, I want to propose a speculative model that might maintain the experiential tension of Galloway's chapter title: are some things unrepresentable? Material figures for imagining the trace are many: the handwritten inscription, the wax impression, the tracks of a wandering animal. Yet, when it comes to the digital trace, it remains difficult to imagine an appropriate figure of thought. Here I want to suggest that digital media as of yet has no material figure for the "enduring ephemeral" nature of its traces. Taking a cue from the visual aesthetic of *Every Icon* and the *O.D.E.*, I suggest that analog television static may provide something of a conceptual placeholder for imagining and figuring the experiential opacity of the digital trace in the era of networked lateral time.

In 1965, Bell Laboratories scientists accidentally discovered Cosmic Microwave Background (CMB) radiation, the first hard evidence of the faintly persistent remnants of the big bang, the earliest known event in the universe. CMB persists as microwave "traces" uniformly distributed throughout the cosmos. What's more, you can actually see these traces visualized on television. While statements as to the exact percentage vary, scientists agree that a portion of such "white noise" visualizes CMB when an analog television is tuned between channels. Thus, broadcast television technology arguably provides human eyes with an image of one of the most profound and beguiling events of history in its deepest depths and most impenetrable opacity. Having scrutinized the flickering animations of *Every Icon* and the *O.D.E.* in the composition of this chapter for some time, it is hard for me to escape the visual affinity each work suggests with the appearance of CMB on television. CMB provides a better model for imagining historical experience in the digital age than does "digital inscription." The problem is that the phrase "digital inscription" just sounds like a very small, very fast version of the handwritten trace, a concept clinging perilously to the imagination of print culture.

The digital trace is something else, and the comparison with CMB on TV makes this clear.

Let us grant that we may call the data culled by scientific instrumentation and television sets "traces" insofar as they conjugate the present and the past. While the televisual visualization of CMB performs the same structural function as Ricoeur's *instruments de pensées*, it bears noting how much this model departs from written narrative conceived and recorded for human readers, and indeed how far such images stray from human meaning. Unlike the trace thought in terms of print culture, CMB cannot be mistaken as originating or belonging to human consciousness. The movement and time of CMB is nonhuman and *already there*. Yet it's not at all there *for us*. CMB is also a technological discovery; it was discovered indirectly through sound technologies. This fact refutes Bloch's notion, affirmed by Ricoeur, that history requires direct perceptible access to traces of the past. Access to traces of the past may be mediated so as to render to human perception what would otherwise not be phenomenally available. Due in large part to the highly mediated character of these traces, the encounter they engender stresses their non-relation to perception just as much it does their relation or availability to human life, if not much more. Unlike the now-and-then conjugation of past and present implied by human encounters with perceptible traces of the past, televisual static is more properly ambient. Its movement is perpetually ongoing and unpunctuated from the perspective of human life. It hovers or buzzes in the background. It comes to us as activity, or *movement without humanly meaningful measure*. To be sure, such traces remain measurable under the auspices of science. But as a visual phenomenon, static on a television screen, they give rise to a sense of time by virtue of the indeterminancy and opacity of movement, a movement that has no legible before and after because no change seems to take place. This sense of time appears to human experience as textual movement, an animate opacity.

Finally, like the always-on and ubiquitous character of digital networks, CMB is diffuse and environmental. Its animated appearance is visual, but it fails to anchor its viewer in any kind of relation. But that does not mean the historical experience it generates simply floats away. More than a sense of time passing, the encounter with televisual static produces a series of low-level affective responses: disconnection, irritation,

boredom. In this chapter, I have sometimes noted the ways *Every Icon* and the *O.D.E.* elicit similar responses. While such affects may seem minor or incidental, they suggest the ways images may refigure traces of the past in ways that animate the body even and especially as they fail to cohere as narrative representation. In the following chapter, I turn my attention from problems of time to problems of space. In particular, I explore the increasingly environmental character of digital networks and what they mean for historical experience. Given the expansive and largely nonhuman address of networked digital media, it becomes important to build on the intuition voiced here that affect, or more properly, *sensation*, plays a crucial role in registering the environmental exteriority of digital media.

4

THE SENSATION OF HISTORY
Motion Studies from Muybridge to Ken Jacobs

Eternity is not a separate order beyond time, it is the atmosphere
of time.
—Maurice Merleau-Ponty

Muybridge and Atmospheric Media

In 2005, British artist Julian Opie installed two of his animated "walking
portraits" on Boston's Northern Avenue bridge in conjunction with the
opening of the new building for the Institute of Contemporary Art. Illu-
minated twenty-four hours per day on forty-six-inch-tall LED computer
screens, Opie's nearly-life-size images invite and usher pedestrians from
downtown to the ICA and the revitalized waterfront. Like so many works
by Opie, *Julian Walking* and *Suzanne Walking* recall the nineteenth-
century motion studies of Eadweard Muybridge. Each portrait features
an abstracted whole-body portrait of an individual walking in profile.
Beyond their local function, Opie's Muybridge-inspired works exemplify
a larger and more general transformation of mediated images in the last
hundred or so years from individual objects and artifacts to media envi-
ronments and networks. This trend seems to have sped up in the last
several decades, suggesting the displacement of the moving image from
its privileged position in mediated experience, a change sometimes dis-
cussed in mournful distress as the "end of cinema."

What is the status of the moving image in a media landscape where
technology itself seems to recede invisibly and insensibly into the back-
ground of ordinary life? Moreover, what is the status of the moving image
in an age characterized as the end of the historical formation of moving

images called cinema? Or when we move from the society of the spectacle to a culture of connection? Strangely enough, Muybridge's presence seems to have actually increased at the same time. Often cited by film historians as a forerunner to cinema, his continued popularity suggests that his motion picture studies have always been much more than "precinematic." The persistence of Muybridge in digital visual culture affirms the continuing vitality of the moving image within new media environments. Redolent of the historicity of the moving image, moreover, new media artists often draw on Muybridge iconography to express the historical experience of the digital age in terms of its increasingly environmental manifestations as always on and "already there."

The past quarter century or so has witnessed the incipient rise of the ubiquity of digital computation. This trend is still so new as to travel by several different names: ubiquitous computation, calm computing, everyware, ambient media, pervasive media, the Internet of Things, and most evocatively, atmospheric media.[1] The last refers to the exponential proliferation of digital media beyond specific sites of mediation such as the cubicle, the personal computer, or the game console and toward more environmental, mobile, and everyday technological experiences.

Figure 23. Julian Walking on Boston's Northern Avenue bridge. Photograph of *Julian Walking* by Julian Opie (2005). Courtesy of the artist.

N. Katherine Hayles characterizes this shift succinctly as "the movement of computation out of the box and into the environment."[2] An eclectic variety of digital technologies and concepts instantiate this general shift: smartphones, wireless technologies, cloud computing, Big Data, predictive analytics, embedded sensors, smart chips, GPS (Global Positioning Systems) satellite-navigation systems, and RFID (Radio Frequency Identification).

The development of these and other technologies lead to what Nigel Thrift calls a massively generalized "standardisation of space" predicated on "a continuously updated, highly processed background which renders all sequences calculable."[3] More colloquially, we might call this development the emergence of "always-on computing," a historical experience of digital technology characterized by the ever-present possibility of being connected via networks. Succinctly described as "atmospheric media," such trends evince the emergence of a programmed and calculable environment and the movement of computation into the infrastructural background of human experience, or into a state of what Mark B. N. Hansen terms "transparent ubiquity."[4] Encounters with digital media within the context of atmospheric media entail neither viewing nor handling a specific textual object or even processes, but rather reckoning with the diffuse and environmental character of contemporary technics.[5] This shift, as Hansen argues, has brought about a correlative shift in the ways technologies address human experience. No longer primarily visual, atmospheric media now privilege sensation itself, a more general, peripheral, and diffuse arena of embodied experience beyond the discrete modality of any of the traditional five perceptual senses.

The shift in media's address toward sensation would seem not to favor visual culture. This chapter argues that, even in the context of atmospheric media, the image remains just as important as always, if differently so. As a counterpoint to the rise of atmospheric media, consider the ubiquity of Muybridge's chronophotographic motion studies. To recognize the contemporary ubiquity of Muybridge, I propose, means to encounter an unappreciated and perhaps counterintuitive aspect of atmospheric media: their expression of historical experience. As insensibly as the microtemporal computational processes of digital networks operate, they nonetheless seem to bleed both image and history. Opie's series of abstract motion studies represents just one of a plethora of

homages to Muybridge in digital media aesthetics.[6] A longer list would include works by Lillian Schwartz, Nobuhiro Shibayama, Simon Biggs, Jim Campbell, Joseph Squier, Tatjana Marusic, Tim Macmillan, and Martin Reinhart, among others. More generally, Muybridge's influence extends far beyond the sphere of experimental media practice. Remarking on their inclusion in two major museum exhibitions and a dance performance, a contributor to the *New York Times* writes: "The Victorian motion-study photographs of Eadweard J. Muybridge feel oddly ubiquitous right now."[7] They have even recently been featured in popular news and commercial media. His iconic motion studies appear in a 2012 Jaguar car advertisement.[8] They supply the basis for a popular line of Scanimation children's novelty books. Muybridge himself is the subject of a 2010 segment of *All Things Considered* on National Public Radio (NPR). His images were even chosen for a proof of concept study of the genetic encoding device CRISPR for storing and reactivating "information into the genome of a living cell."[9] And lest the word "ubiquitous" feel hyperbolic, it is instructive to recall another example. Google, perhaps the greatest arbiter of the ubiquitous, celebrated Muybridge's 182nd birthday on April 12, 2012, with a "Google Doodle," an animated image of Muybridge's motion studies on its homepage.

How does the rise of atmospheric media relate to the rage for all things Muybridge? Exemplified by Muybridge's encyclopedic studies of human and animal locomotion, one might say that chronophotography has a remarkable affinity with contemporary media experience. NPR's Neda Ulaby speculates: "Something about his work feels very contemporary. Maybe it's because his photos are from a moment, not unlike ours, when conceptions of time are in flux. Now you can send snapshots by cell phone in seconds across the world."[10] Muybridge represents a placeholder for a felt historical condition of the technological transformation of temporality. One might say that the present "feels" a little like the late nineteenth century, a time when the arrival of technologies such as instant photography and cinema ushered in new experiences of time and space.[11] Importantly, Ulaby distinguishes the present transformation of time through the example of cell phones transmitting photos around the world. She evokes the specter of chronophotography in terms of the circulation of images as data bound up with global circuits, *not* in terms of taking pictures or the instantaneousness of photographic

capture. Muybridge's motion studies bespeak something more than the familiar modernist tale of the transformation of time and space usually embedded in stories of the development of instantaneous photography and cinema. The transformation of time that Muybridge and chronophotography express resonates with the contemporary problem of the relation of human experience to the largely formless yet apparently animated infrastructure of media environments. This idea has proved especially powerful for new media artists, many of whom incorporate Muybridge's imagery into their work. Muybridge's images afford aesthetic and historical purchase on the felt saturation of ordinary experience by largely invisible informational infrastructures. Atmospheric media render the transmission of images around the world not so much a marvel of speed, of how fast one thing can travel somewhere else, as a matter of commonplace sensation, or the felt *historical* experience of the infrastructure that gives rise to the very sensation of global speeds of transmission and access.

Muybridge Out for a Walk: Chronophotography and the Digital Environment

In many ways, Muybridge's iconic chronophotographic images of people and animals in motion perfectly allegorize the subject and situation of contemporary atmospheric media. Whether it be man, woman, or horse, Muybridge's images are *on the go*. They not only resonate with the paradigm of mobile computing but also suggest the up-and-running qualities of software in the milieu of always-on computing and digital networks as *already there*. Indeed, until 2006, the Adobe Premiere video-editing software package featured one of Muybridge's galloping horse images, *Sallie Gardner at a Gallop* (1878).

The curious mix of the ordinary and the pornographic in Muybridge's images, moreover, suggests an affinity with the general pornification of culture catalyzed by the web.[12] Typically represented against a white grid and black background, Muybridge's images have the air of scientific measurement, abstraction, and exactitude. The solemn expressions and physical imperfections of his subjects, from men and women in various states of undress to lions, elephants, and capybaras, stand in contrast to this scientific background. The obvious contrast between bodies and

their technological background expresses a basic tension between lived experience and the technological nature of the image. As anyone who has ever flipped through the multiple heavy volumes of his *Complete Human and Animal Locomotion* may attest, Muybridge's chronophotographic project also aspires to a sort of encyclopedism. A desire for totality informs his project and resonates with what Alan Liu describes as the synoptic fantasy of digital information.[13] Before there was Google Image, there was Muybridge! In seeking to express the historical experience of the emergence of the digital age, it is no wonder that so many artists working in new media elect to cite and refashion the nineteenth-century chronophotographic aesthetics of Muybridge. Artists discover in Muybridge's images a potent means for navigating the increasingly digital terrain of not just visual culture but also the broader media environment with the rise of atmospheric and ubiquitous technologies.

Most famous for the first three films in the CGI (computer-generated imagery) blockbuster series *The Pirates of the Caribbean,* Gore Verbinski directed a 2003 music video featuring an antihero protagonist lifted straight out of Muybridge's motion studies. The video allegorizes the multisynchronous times of the digital age in terms of the lateral relation of the image to the broader media environment. "Born Too Slow," the title of a four-minute song by the electronic pop duo The

Figure 24. Waking up in the late nineteenth century. Screenshot from *Born Too Slow,* directed by Gore Verbinski (2003).

Crystal Method, evokes the friction of continually encountering the changing dynamics of an increasingly technological landscape. In following the adventures of a nineteenth-century image magically transported to the twenty-first century, the video exaggeratedly narrates this sense of asynchronous friction between the time of lived experience and the outpacing speeds of technological development. A Muybridge image on the go represents the digital subject. By turns alienated, mystified, and aggressive, the video portrays the Muybridge man as continually challenged by invitations to be more *in synch* with his environment. Always rejecting possible synchronicity, he unfailingly responds by continuing on his way, by staying up and running as if he were himself more software technology than human subject.

How does a nineteenth-century image belong to the twenty-first century? Uneasily. *Born Too Slow* introduces its antihero protagonist standing, with grey skin in the full-body profile posture made famous by Muybridge. For the first few moments, he remains still with eyes closed as the image quakes along with the song's scratchy opening guitar riff. The rattling of the image seems to wake him up. Eyes opened in a decisively searching and curious moment of media historical consciousness, he soon breaks his nineteenth-century frame and appears in present-day urban southern California. First presented against a white grid, he now finds himself in motion before several new grids: the windows of an office building, the windows of an apartment complex. Everything is different, but some things stay the same. The point is immediately apparent: the twenty-first century has much in common with the nineteenth. Yet, in the twenty-first century, the context for visual culture has definitively shifted from the specific local sites of scientific and aesthetic experimentation (the lab, the studio) outward into the world. As much as these two historical moments map onto one another, the grey man sticks out like a sore thumb. Past and present may coexist, but they do so unevenly and never without drama. As the song title puts it, our hero remains, as the dragging vocals emphasize, "born just a little too slooooowww." This is one of the ways history hurts today.[14]

How to assuage or embrace this agitation? As it does so often in music videos, dancing plays a decisive role. In videos from Michael Jackson's 1986 *Beat It* to OK GO's tightly choreographed YouTube videos such as the 2006 *Here It Goes Again*, dancing offers a way to overcome

conflicts or express unity, to resolve tensions, or in a word, to be in synch.[15] Because *Born Too Slow*'s central themes are slowness and historical asynchrony, however, a crucial dance scene articulates something decidedly other than togetherness or unity. Midway into the video, the grey man encounters a similar figure: another Muybridge-like figure bald and clothed in an identical loincloth but with greyish green coloring. Suggestive of a green screen of the type Verbinski employs so often in his Hollywood feature filmmaking, this second figure's green coloring subtly suggests he has in some way adapted to the contemporary age of effects magic. The two exchange blows until the green man proposes an alternative way of being together: a dance battle! Unfortunately, the grey man does not take the bait. Witnessing a brief, impressive display of electric boogaloo, the grey man kicks his counterpart in the groin and moves along. Togetherness is not this video's endgame. Other moments of dancing, however, do express something more like "alongside-ness." Dancing together but apart is a major aesthetic convention of music videos in the global network age of YouTube.[16] In these instances in *Born Too Slow*, the grey and green men do not dance with each other so much as they dance and walk in tandem with the built environment.

The real historical drama of historical asynchrony in *Born Too Slow* takes place in the space between the body and the environment, not

Figure 25. Dancing alongside the digital environment. Screenshot from *Born Too Slow.*

between bodies per se. The video imagines the drama of media histori-
cal consciousness as figured in terms of the lived experience of the *non-
interaction* between image and world. Following the fight, the green man
gets up and starts dancing again. This time he dances against the back-
drop of a nondescript wall suddenly animated like so many pulsing *Tetris*
shapes. He doesn't acknowledge or come into contact with the wall;
they just dance alongside one another in an implied lateral sympathy
between body and the built environment. Our antihero walks on, also
appearing against similarly animated backgrounds, but not dancing. It
is here in these moments of strange synchrony or nontogetherness that
the nineteenth century seems to fit best with the twenty-first: dancing (or
not) alongside the background of its technological infrastructure imag-
ined in terms of the animation of the built environment. In a fashion,
these moments update the first moments of the video. Whereas the ini-
tial Muybridge grid-like figure shook while the body remained still, how-
ever, in the present day, everything moves. Yet perhaps not everything
or everyone dances, at least not at the same time.

An ambivalent relationship of image and environment also informs
Tatjana Marusic's ambient, dream-like 2004 *The Memory of a Landscape*.
If *Born Too Slow* presents image and environment as laterally animated,
The Memory of a Landscape collapses any difference between image and
environment within its digitally animated presentation. In the process,
it weaves together different meanings of both memory and landscape
while simultaneously deconstructing their relation to historical experi-
ence. Marusic's ten-minute glitch video employs Muybridge-like imag-
ery to express the historicity of a landscape whose capacity to signify
rests on its variously mediated histories. For Marusic, the mash-up of
Muybridge and digital media conveys both the erasure of history and
the lingering presence of its phenomenal absence.

Exhibited as a three-channel video installation or as a theatrically
projected single-screen work of experimental video, *The Memory of a
Landscape* features an array of datamoshed images. In a beautiful, slow
sequence, a horse and rider depicted in profile leave a trail of pixels
in their wake. The image, of course, recalls Muybridge's most iconic
image of the frame-by-frame seriality of protocinematic photography:
the Pegasus-like galloping horse with all its hooves off the ground. To
achieve the effect of a rippling image, Marusic deletes what are known

as "keyframes" in compressed digital moving-image formats. For compressed .MOV files, keyframes tell the image to refresh the color values of individual pixels when necessary. Compressed files take advantage of the fact that it is not necessary to retain redundant data from frame to frame. Without keyframes, however, color values dramatically fail to update when there is a cut or when movement changes within the frame. The resulting "bleeding" effects give rise to the sense of figures bursting through layers in the image. Like other varieties of glitch art, datamoshing is typically understood as unmaking, destroying, or "deconstructing" the image. *The Memory of a Landscape* employs datamoshing to similar ends. Remarkably, the video also employs the destructive aesthetic of datamoshing as an act of recuperation and historical reactivation.

Resonating with the video's visual aesthetic, the titular landscape refers to an actual landscape that was but is no more. *The Memory of a Landscape* employs footage from the *Winnetou* films from the 1960s, a series of German-language westerns filmed in a region of the former Yugoslavia (now Croatia). These actual landscapes were largely destroyed during the Croatian War of Independence following the collapse of the Soviet Union. In retrospect, the *Winnetou* films provide a documentary record of what the land used to look like. On another level, the video's title refers to a landscape that was only ever intensely mediated, a fact drawing into question the presumption that the "memory" of any

Figure 26. Horse and rider ripple, recalling Muybridge. Screenshot from *The Memory of a Landscape* by Tatjana Marusic (2004). Courtesy of the artist.

landscape might itself be natural or somehow afford direct access to a natural vision of the past. The *Winnetou* films are set in the American West. The Yugoslavian mountains depicted act as a sort of stunt landscape. In this sense, the landscape is more a virtual property of a film genre (and perhaps of global film history) than a property of any specific mountains in Croatia. Eastern Europe appears here in western drag, decorated by all the chronotopic accoutrements of the American Wild West of the nineteenth century: horses, rough terrain, cowboys and Indians.

The "memory" in the video's title is even more fraught than the landscape. Triply mediated across three centuries, memory drifts unevenly in exchange with chronophotography, film history, and digital glitch aesthetics. Through the lens of such a thickly mediated recollection of place, it is fair to wonder what exactly the word "memory" means. Whose memory is this? The landscape appears in three centuries at once, a series of sedimentations formally evoked by rippling glitches like so many streams in the river of media history. More so than in Muybridge but crucially evoked via the modification of the aesthetics of his motion studies, what seems most fundamentally to be *already there* in *The Memory of a Landscape* is not any particular memory or any particular physical landscape so much as a state of noisy, overlapping, asynchronous media temporalities. Held together precariously by a rippling opacity, *The Memory of a Landscape* brings these times together in a mode of noncontemporaneous contemporaneity triply reactivated by Muybridge, *Winnetou*, and digital media precisely as the noise of an environmental history.

While landscape as a genre of European painting typically evokes an experience of frontal, visual presentation in the form of rectangular canvases or screens, the digital landscape evokes a more total-body experience of omnidirectional sensation. The description of the contemporary media environment in terms of ubiquity, however, can have a kind of flattening effect. The word "ubiquity" evokes a sense of totality, harboring within itself a fantasy of complete mediation, absorption, and immersion. Fortunately, we're not there yet, even if we're either worried or excited by the horizon of ubiquitous computation. One of the downsides of alarmist dramatizations of the media historical present, from *The Matrix* in 1999 to Dave Eggers's 2013 novel *The Circle*, is that such narratives tend to collapse critical differences between the fantasy and the reality of "ubiquitous media," leaving little space for historical breathing

room. *The Matrix* remains exemplary for promoting the informatic fantasy of "total mediation." This idea plays out in the development of Neo's (Keanu Reeves) messianic powers. It also features memorably in several bullet time sequences. Produced by a circular battery of cameras, 360-degree bullet time shots such as the iconic image of Trinity jumping before delivering a kung fu kick suggest a seamless conjoining of reality and technology. In bullet time shots, the camera composes the world, rather than merely inhabiting a limited perspective in time and space. The magisterial sweep of these sequences promotes an exhilarating sensorial attachment to the fantasy of total mediation, a feeling that digital media might really facilitate *seeing everything*.

In stark contrast to *The Matrix*'s valorization of ubiquity, British artist Tim Macmillan pursues a more critically ambivalent approach to the fantasy of ubiquity. Predating bullet time by over a decade, Macmillan's Time Slice works similarly create images of motion produced by spatial and not temporal succession. Working against the fantasy of seamless, total mediation, Macmillan employs a digital chronophotographic aesthetic toward more frankly analytic and open-ended effects. Macmillan's 1998 controversial and prize-winning digital video installation *Dead Horse* provocatively foregrounds the mutual finitude of its technique and subject. While Macmillan himself cites cubism as an influence, *Dead Horse* vividly evokes Muybridge's most famous epistemological achievement: the realization that a galloping horse does in fact have all four hooves off the ground at the same time. The video captures a similar instant with a deadly twist: the moment of a horse being slaughtered in an abbatoir. A man stands with dirty rubber boots posed with a gun positioned just off the horse's head. Presumably due to the force of the shot against its skull, the horse remains suspended in the air between life and death.

In marked contrast with the 360-degree movement of bullet time, *Dead Horse* fluidly rotates around the horse and back and again within about a 90-degree curve. This is not a technical deficiency. Macmillan had completed 360-degree rotations in his work prior to *Dead Horse*. The partial, swiveling rotation suggests an aesthetic incompletion or incommensurability at play between the act of viewing and the technical processes of recording and projection employed. By denying its viewer a 360-degree view, *Dead Horse* negatively foregrounds the issue of technological surrounding so crucial not only to the generally environmental

issue of how atmospheric media surround us in everyday life but also to the fantasy of total mediation native to information technology.[17] *Dead Horse's* partial representation of an incomplete environmentalization of digital form strikingly contrasts with the satisfying exhilaration of bullet time images. Its depiction of the moment of death forecloses any sense of action. The bullet time shot of Trinity jumping is essentially a moment of cinematic kinetic energy, suspended and pent up and then released when she kicks her opponent through a wall. *Dead Horse,* by contrast, lacks any such release of energy, suspending any sense of potential action or possibility only to then deflate it. There is nothing more to see here because there is nothing for the image to do except maybe crumple in a heap. Instead of inspiring narrative propulsion, *Dead Horse* holds its viewer in lilting abeyance against the invisible contours of the technical capture of the image.

In all three of the new media artworks examined here, Muybridge's chronophotographic legacy opens up a space for historical experience unassimilable to the fantasies of synchronization, immersion, and totality often informing the rise of environmental, ubiquitous media. More than a mere stranger from the late nineteenth century in the strange land of twenty-first-century atmospheric media, Muybridge's aesthetics today play a critical aesthetic role in imagining the emergence of ubiquitous media as something other than suffocating or homogenizing, on the one hand, or libidinally expansive or naively exhilarating, on the other. In their critical interventions, Muybridge-inspired works of new media art capitalize on the historical experiential opacity of digital media and harness this opacity as a bulwark against the hype and hot air that typically bracket historical experience. They express the manifold difficulties of articulating one's relation to the past, as well as the ways in which encountering such difficulties proves vital in expressing historical experience in the digital age.

Addressing Sensation: Ken Jacobs's "Eternalism" Videos

More than textual allegories of historical experience sensitive to the environmentalization of digital media, Muybridge-inspired art in digital media also allows for more direct reflection on the frankly embodied character of the digital image. As Hansen argues, the digital image is

historically unique for the ways the body enframes and produces it.[18] Haptic and kinetic interfaces such as touch screens and motion-capture-enabled game systems demonstrate this profound shift. But even beyond specific platforms or devices, the oblique bodily address of always-on networks, atmospheric, and ubiquitous media promotes sensation over vision as the privileged bodily registration of digital technics. Sensation here denotes the amodal, general, affective, and peripheral feeling of the world in excess of the traditional discrete senses, a feeling that may be conceived as routing more directly (if not necessarily) to higher-order consciousness. Sensation, by contrast, need not graduate to consciousness. As a dimension of experience at its margins, sensation denotes the zone of variable convergence and divergence between body and world. As Hansen argues, one of the primary achievements of digital media has been precisely to address or target this nebulous zone of sensation over and above other forms of address to specific sense modalities such as sight or hearing. Drawing on Warren Neidich, Hansen argues that "the creation of certain types of images and . . . media environments can promote certain patterns for the assembly of macrosensations out of the microtemporal operations of cognitive and visual processing."[19] The fine-grained operation of digital technics at microtemporal scales allows for the technical address of embodied sensation, which is composed of the body's distinct and variably temporal biological processes and rhythms, such as the neurological processing of color, motion, location, and so on. Because digital media operate at fine-grained microtemporal scales, their composition can more effectively address embodied sensation at the margins of experience. Crucially, even as the environmental character of media and the peripheral-sensation address of the body become more and more significant, perceptible images continue to play a crucial role in catalyzing encounters with the sensational address of atmospheric media.

In the second half of this chapter, I argue that Ken Jacobs's "eternalism" videos effectively update Muybridge's motion studies for the digital age. This should not come across as controversial. Brooke Belisle has already characterized the eternalism videos as "time/motion studies."[20] And Jacobs himself states, "advanced filmmaking leads to Muybridge." In claiming that Jacobs "updates" Muybridge, however, I want to work toward an understanding of Jacobs's digital eternalism videos that at once

embraces the environmental character of new media art's fascination with Muybridge and departs from film criticism that claims Jacobs as an inheritor of the modernist tradition in the dual sense of both modernist aesthetics and the culture of modernity. Whereas Tom Gunning terms Jacobs's work "films that tell time," I argue that the eternalism works are videos that *feel* time.[21] And whereas Malcolm Turvey argues that Jacobs "teach[es] us 'to watch movies' with an eye trained toward film's capacity to reproduce and transform reality," I argue that Jacobs teaches us to feel cinema in the digital age.[22] Indeed, in my estimation, the singular achievement of the eternalism videos is the manner in which they solicit a primarily sensational experience of nonoptical movement subtended by their technical form.

In allegiance with Belisle's emphasis on the "radical relationality" between viewer and technics informing so much of Jacobs's paracinematic practice, I read eternalism as addressing the sensational sensorium of atmospheric media. More specifically, I discuss eternalism in its capacity to address historical experience in terms amenable to the digital age. Videos such as his 2006 *Capitalism: Child Labor* powerfully address sensation. More than a means of producing bodily effects, the strikingly historicist vocation of Jacobs's videos encourages consideration of the relation of sensation and historical experience enabled by the fine-grained operation of digital media. Drawing on Maurice Merleau-Ponty's discussions of sensation in his *Phenomenology of Perception*, I argue that Jacobs's videos express the sensation of history in terms of its opacity to conscious experience, a dynamic deeply suggestive of the historical experience of the "deep opacity of contemporary technics." More than textual reworkings of Muybridgian iconography, then, Jacobs's eternalism videos pursue an ambitious project of enlisting the embodied experience of sensation in the service of the historical experience specific to the digital age.

In investigating the sensational address of digital media, I follow W. J. T. Mitchell's notion of "addressing media." For Mitchell, following Louis Althusser, "addressing media" entails considering how images hail and produce subjects. [23] It also means attending to the ways in which we treat images as though they are alive. "The point," Mitchell clarifies, "is not to install a personification of the work of art as the master term but to put our relation to the work into question, to make the *relationality* of image and beholder the field of investigation."[24] To this end, Mitchell

explores the task of addressing media "as if they were environments where images live, or personas and avatars that address us and can be addressed in turn."[25] Mitchell's focus on the "lives" of media resonates with this project's emphasis on animation aesthetics. "Animation," as Andrew R. Johnston notes, names the "relation between our own perceptual operation and the technology of cinema, an intertwining that encompasses all cinematic experience but that animation pronounces, or exposes, more fully."[26] As a field of aesthetic forms indebted to the perception of absent causes, animated images always at least implicitly ask to be treated as "alive," because they thematize the limits of perception as bound up uncertainly with the opacity of the very technological processes producing images and experience. The periphery of perceptual experience gives way rapidly to animate experience. In the context of ubiquitous computation—or pervasive computing, where, as Beth Coleman notes, "everything is animated"—addressing digital media entails considering the ways they hail the porous edges of embodied sensation.[27] The task of investigating the sensational address of Jacobs's animated digital videos requires us to account for the sensational dimensions of historical experience at the uncertain nexus of the quasi-autonomous domains of both embodied experience and digital technics in the context of atmospheric media.

If Muybridge were to pursue motion studies today, what would they *look* like? As Opie and others do, he might incorporate the iconic imagery of his chronophotographic motion studies into digital contexts. Perhaps he'd work on motion-capture technology for Industrial Light and Magic. To tweak the question slightly: if Muybridge were to pursue motion studies today, what would they *feel* like? Jacobs's digital videos provide insight into this question. Although Jacobs himself does not employ Muybridge imagery in the manner of Marusic or Macmillan, he has earlier referred to his filmography as "time/motion studies."[28] I therefore propose to regard his eternalist videos as twenty-first-century digital-motion studies. Whereas Muybridge famously breaks down and reanimates the motion of subjects captured by his battery of cameras, Jacobs's videos solicit a sense of movement felt more properly within the viewer's own body than on-screen in any textual sense. This utterly unique aesthetic addresses sensation, and it does so in the service of historical experience.

Figure 27. Screenshot from *Capitalism: Child Labor* by Ken Jacobs (2006).
Courtesy of the artist.

Sitting in the movie theater watching *Capitalism: Child Labor*, I can
see what's happening. And, then again, I can't. I see two slightly different
images on the screen from an antique stereograph oscillating in flicker-
ing succession. Boys and men stand amid rows and rows of spindles in
an industrial factory. The camera periodically focuses on small, zoomed-
in aspects of the image. The image vibrates and flashes. I can see what's
presented, and to a significant degree, I see it in a way that allows me
to intuit how the image is produced. Stereograph images such as the
one depicted on-screen were popular in the late nineteenth and early

twentieth centuries as images to be viewed with a stereoscope, an optical device pressed up against the viewer's face and adjusted to produce a sense of depth or three-dimensionality. The image I see onscreen also appears in a curious sort of depth, as if Jacobs has made the entire movie theater into a stereoscope. I see what's presented, and I see the film working to foreground the technology of vision. I recognize this effect as a version of the time-honored political formal technique of modernist avant-garde filmmaking: laying bare the device in order to demystify the means of production.[29] All the same, I remain mystified!

What mystifies me is that I can't escape the *sensation* of a kind of movement exceeding what I see and my sense of what the video wants me to know about how I'm seeing things. Much more than a depth effect, I encounter a sense of *movement at its recurring genesis.* The image seems to be moving with a definite sense of direction, left to right or right to left. Strictly speaking, I can't really see this movement because it's not "happening." The video merely oscillates between two similar photographs of the same subject. The simple resonance of two images doesn't seem like it ought to be enough to produce a sense of directional movement. Depth, yes. Flickering stasis, ok. But movement left to right? What's going on? As much as I doubt my own senses, I can't escape the sensation of the image always beginning to move. Of course, all cinema produces sensations of movement that we know aren't literally present except as images. But this movement is stranger in *Capitalism,* and more precisely, it is nonrepresentational. This movement doesn't even seem to belong to the textual manifestation of the image itself onscreen. Nor does this movement, like conventional 3D images, seem at all to float "artifactually" between my body and the screen as though I might "grab" it. The video somehow solicits a sense of movement primarily from *my own body,* not any movement "out there" on-screen or in the theater. It is present only in my profound sensation of its beginning over and over again, a sensation I feel in my turning head, my craning neck. What is this movement?

Jacobs calls his patented technique "eternalism." In his patent descriptions, he defines eternalism as "an appearance of sustained three-dimensional motion-direction of unlimited duration, using a finite number of pictures."[30] Eternalism features prominently in Jacobs's digital video works since 1999's *Flo Rounds a Corner,* including such films

as *Capitalism: Child Labor*; *Capitalism: Slavery*; *The Surging Sea of Human-ity*; *Razzle Dazzle: The Lost World*; and other shorts and features. This remarkably singular and still-evolving body of work has received signi-ficant attention within film studies. For scholars of avant-garde film in particular, Jacobs's digital work provides productive inroads into larger, field-wide discussions probing the so-called "ontology" of film or the fate of film and cinema in the era of digital media.[31] Jacobs's digital works provide a powerful locus for discussing the power of the moving image to express a sense of history at once unique to both the digital age and the history of the moving image. His employment of found footage and stereographs in his digital practice seems of a piece with the grow-ing scholarly recognition of the history of cinema as much longer and more expansive than the history of film that begins with Edison and the Lumière brothers. This is an idea of no small consequence for a disci-pline frequently described as facing obsolescence in the digital age. In stark contrast to discourse around the "death of cinema," Jacobs's eter-nalism videos help to renew the theorization of cinema in tandem with digital media. And yet, even as Jacobs's eternalist works recognize the long history of visual technologies and the cinema, they remain even more compelling for the way they confront the open future of the moving image. Jacobs's videos do much more than romanticize the structural poetics of film's history to glorify film as a historical medium. They actu-ally provide insight into the changing nature of historical experience.

The spirit of Muybridge animates Jacobs's eternalism videos. As Belisle notes, Jacobs's digital eternalism videos reimagine Muybridge's motion studies: "Jacobs used digital software to lay out each frame of this film [*Capitalism: Child Labor*] in a linear arrangement, with uneven gaps of intervening black frames."[32] Their presentational variability en-genders a panoply of related motion effects, including the dominant effect described succinctly by Jacobs in his patent description of an ever-nascent movement. How to engage this perceptual adventure? In place of ana-lyzing the materiality and logic of the film strip, I aim to build on the connection Belisle forges between Muybridge and Jacobs as turning away from medium specificity and toward a more frank concern with perception.[33] As the master of the frame-by-frame animation of move-ment, Muybridge represents a lodestone for bridging the nineteenth and twenty-first centuries. But here, to be clear, Muybridge matters much

more as a conceptual hinge than as a literal technical precedent. Instead of looking back to Muybridge proper, we ought to look around and recall the field of new media art engaged simultaneously with Muybridge and the atmospheric turn in digital media.

At the same time, it's difficult to ignore the primacy of history in Jacobs's work, a strong dimension of the work that seems to look backward rather than forward or laterally.[34] Indeed, the stereograph pieces, including *Capitalism: Child Labor*, practically scream "history"! The clothing is archaic to our eyes. The machinery looks almost grotesquely enormous and heavy. The patina of the image appears weathered. In its staging of different media, the image seems clearly intended as not merely an encounter with *a* past, but more forcibly as an encounter with the heterogeneity of media historical experience in general. Stereography and the heritage of photochemical reproduction are prominent, but the powers of digital technology are also clearly on display. The interpretation of the *Capitalism* videos as Marxist allegories of media history largely ignores the film's most prominent aesthetic effect: the sensation of eternalism. No mere effects, I argue, Jacobs's eternalism effects are central to his engagement with history. While accounts of the video's representational or logical engagement with history (as photographic, as stereographically "dialectical") remain important, they fail to treat what is most distinct about eternalism: an ever-renewing sensational movement effect that does not take place on-screen, but rather somehow in my body, or more precisely, in my body's adherence to the image.

At this point, Merleau-Ponty's writings on sensation and history prove indispensable. To better grasp how the sensational address of eternalism catalyzes a sense of historical experience specific to the digital age, let us unpack Merleau-Ponty's utterly unique phenomenological excavation of the relation between sensation and history. His focus on perception and embodiment furnishes a robust theoretical armature for specifying not only the meaning of sensation but also sensation's opaque relation to consciousness. Due to his overriding concern with "sensation" as an embodied sensation beyond the direct purview of consciousness, Merleau-Ponty's theory of sensation, with its relation to history, demonstrates ready affinities with the experiential opacity of digital technologies, which similarly operate largely outside the scope of intentional consciousness. More plainly, Merleau-Ponty helps us to understand not

only how sensation contributes to historical experience but also how it does so in a manner significant to the dynamics of the digital age. Describing sensation as the body's variable resonance with the microtemporal rhythms of the world, his project clarifies the matter of how microtemporal operations of digital media address the embodied rhythms of lived experience in such a way as to catalyze "macrotemporal" or perceptible experiences like the illusion of eternalism in Jacobs's digital videos.

Because Merleau-Ponty asserts a deep affinity between sensation and history, moreover, he enables us to grasp how Jacobs's videos (and digital media more broadly) address the conditions of possibility for historical experience in the atmospheric adhesion of body and world native to twenty-first-century always-on networked culture. Pursuing these threads in Merleau-Ponty's thought leads ultimately toward a revised understanding of the role animation aesthetics play in digital media's relation to historical reactivation. Whereas predominantly textual forms of animated reactivation such as *overboard* or *Every Icon* thrive on the nonintentional operation of digital media, Jacobs's videos capitalize on the exteriority of embodied experience, or sensation as the body's sense of its own relational opacity to its environment. More than mere images depicted on screen, Jacobs's eternalism works animate the very relation between body and world that gives rise to the possibility of historical orientation. In Jacobs's hands, motion studies become studies of historical experience to the precise degree that they function, too, as studies in the perceptual aesthetics of the body's open and technically plastic relation to its environment.

Illusions are key to Merleau-Ponty's philosophy.[35] It therefore seems only fitting to rely on and elaborate his work in order to examine the illusion of eternalism in Jacobs's videos. As he writes in his last, great, and unfinished work, *The Visible and the Invisible*, we pay illusions disrespect if we treat them as demonstrations of the inherent insufficiency or fallibility of our brains and senses. Instead of regarding illusions with a Cartesian skepticism, we ought to see them as opportunities for grasping the fundamental existential drama of our body's adherence to the world in their mutual and dynamic partiality, in their ongoing calibration, adjustment, attunement, and irresolvable difference. As Scott C. Richmond argues, Merleau-Ponty's devotion to illusion provides a crucial resource

for theorizing the ways technologies modulate our bodies' relation to the world.[36] Illusions demonstrate how we struggle, succeed, and fail to align ourselves with the world in its manifold flux. Illusions provide occasions for examining the changing relation of body and world, a crucial insight for twenty-first-century media theoretical engagements with the rise of ubiquitous and atmospheric media.

Merleau-Ponty is often evoked as a resource for theorizing embodied experience, but not history. At several key points in his writing, however, Merleau-Ponty synthesizes these topics in important and surprising formulations and reflections. In his last few years, Merleau-Ponty lectured on Husserl's philosophy of history.[37] Fascinating and enigmatic working notes on the Husserlian notion of reactivation take shape in tandem with Merleau-Ponty's notes on his evolving conception of the "flesh," the central concept of his *The Visible and the Invisible*. This is all the more striking for the way a kind of postphenomenological—or at least forcefully post-Husserlian—mission informs *The Visible and the Invisible*. One famous working note declares Merleau-Ponty's ambition to move beyond the privilege Husserl accords consciousness, which he himself had espoused in *Phenomenology of Perception*.[38] Even in his working notes on the philosophy of history, one finds a pronounced devotion to the necessity of delving into the nonintentional dimensions of experience. As intriguing as the notes on "vertical history" remain, their chief benefit may be the way they provide insight into Merleau-Ponty's reading of his own philosophical project. Taking his late ideas in this way authorizes the reading of his earlier *Phenomenology of Perception* as looking forward to his later ideas. It is in this late context that Merleau-Ponty writes, "one will not clear up the philosophy of history except by working out the problem of perception."[39] Since *Phenomenology of Perception* examines perception extensively, it provides a key resource for taking up Merleau-Ponty's twin late interests in history and the nonintentional dimensions of experience.

As philosopher Alia Al-Saji persuasively argues, the "Sensing" [*Le sentir*] chapter of Merleau-Ponty's *Phenomenology of Perception* contains a host of related statements on the relation of time and history to the prepersonal horizon of sensation.[40] The culmination of his discussion even ends with an evocative statement defining sensation in terms of historical experience. Sensation is, for Merleau-Ponty, "like an original past,

a past that has never been present."[41] The simile in his statement is important; sensation and history are not the same thing. All the same, his statement suggests that they not only harbor similar dynamics but also thrive on a mutual affinity.

Sensation is, for Merleau-Ponty, "the most basic of all perceptions" (251). More primordial than the traditional *sense faculties* of vision, hearing, touch, and so on, *sensation* is characterized by its amodality and its lack of bodily localization. Crucially, it is also partially and significantly opaque from the perspective of consciousness. Sensation is a "prereflective fund," an aspect of sensory experience at once both more primordial and more synthetic than any of the individual, discrete senses. Largely unavailable to conscious experience, sensation remains nonetheless available precisely in its perceptual opacity. The persistent illusion of Jacobs's eternalism videos perfectly demonstrates this dynamic. The feeling of seeing movement at its recurring genesis is not anything I can explain. Textually speaking, it's not even something I can see in a literal sense. All the same, I feel the sensation of eternalism, and it's an impossible feeling to shake.

In Merleau-Ponty's formulation, moreover, sensation denotes the relation of body and world more than any experience proper to an individual body. A fundamental mode of experience beyond the traditional purview of intentional consciousness, sensation functions as a medium articulating the adhesion of the body to the world in their incomplete, ongoing, and mutual constitution. It is not the property of a subjective consciousness or "I." Anticipating his later concept of the "chiasmatic" nature of "the flesh," Merleau-Ponty's concept of sensation sees it as marking the relation of "body" and "world," where these terms do not denote divided or ultimately distinct physical entities, but rather "a synergetic system of which all of the functions are taken up and tied together in the general movement of the world" (243). I said earlier that, when watching *Capitalism: Child Labor* or any other eternalism works, it feels like Jacobs has remade the theatrical space of cinematic exhibition into a sort of giant stereoscope. Following Merleau-Ponty, the truth is a little weirder. In soliciting sensation, these videos catalyze an environmental perspective whereby the viewer experiences her own body's simultaneous openness and adherence to the animate technics of its surroundings.

A story from Jacobs's predigital work demonstrates his long-standing interest in the environmental character of images. In a retrospective 2005 essay, Jacobs describes an early unnamed installation work produced for Charlotte Moorman's New York Avant Garde Festival: a stall with slits attached to the Staten Island Ferry. Ever unconventional, Jacobs refers to this cameraless and filmless work as "a 3D movie." Even though Jacobs employed a variety of 3D techniques in his work for decades, his account of this first "3D movie" eschews any description of depth effects. He writes instead of the whole-body environmental sensations accompanying the rocking of the stall attached to the ferry:

> Stepping into the dark stall one could steady oneself holding a wooden bar and lean forward to look through a slit towards another cutout, in a second blackened panel a foot away, having the dimensions of a widescreen movie. . . . The finders transformed the seeing of approach and departure, the side to side jockeying of the ferry into docking position; one now saw a 3D movie. *Pictorial events* took place within the rectangle at the same time that you could feel with your whole body massive motions connected to what you saw, the picture wagging the ferry, and hear tremendous related surround-sounds especially when the ferry would go crunching against the piles and the picture would settle for a while in a grand confluence of energies.[42]

Jacobs's account of this early work privileges sensation over a sense of depth, the typical quality attributed to "3D" cinema. For Jacobs, it is more important that the viewing situation take place in a space acting on the viewer's proprioceptive capacities than that the image should generate an image one might want to reach out and touch. Here, the lurching of a body in a boat constitutes a more important basis for producing images than any strictly pictorial or optical effects. From the historical perspective of Jacobs's career, the sensation of eternalism continues and elaborates a longstanding interest in 3D moving images in terms of their whole-body address.

Digital eternalism works vividly realize the environmental potential of Jacobs's early ferry installation. While critics often discuss Jacobs's eternalism videos as a form of 3D cinema, they actually require *no glasses*. Watching a conventional 3D or digital "RealD" showing, I'm always

struck by the clunkiness and the necessity of the glasses. Watching *Beowulf* or *Avatar*, I've sometimes slid the glasses down the bridge of my nose to find out what the image "really" looks like. Judging by its blurriness, it's evident that the glasses do quite a bit of work. Eternalism dispenses with this experience entirely. As Jacobs notes, *even a one-eyed person* could experience eternalism's depth effects. Eternalism is more than an optical technique rooted in binocular parallax, the physiological structure of vision that makes stereoscopy possible. The eternalist image appears to me both within my body and in the space of cinematic exhibition itself. Its intense flickering quality lends the entire theater a sort of stroboscopic porousness. This experience scrambles perceptual cues at the same time that it elicits illusions of a movement I know isn't there and yet feel quite strongly nonetheless, even *kind of* seeing it. Without any glasses or colored filters, it becomes clear that the video itself operates on the bodily sensorium as part of its environment.

In what sense does it matter that Jacobs's eternalism videos are digital? In his patents, Jacobs insists that nothing prevents the execution of similar effects with analog media. In other words, film could do the same thing and there is nothing *ontologically* special about the computer (at least when it comes to eternalism). The computer, he notes, is merely the most expedient platform for generating eternalism. Jacobs may be technically correct, but the fact is that he has employed digital video and software for the production of *all* his eternalism works. It is simply undeniable that digital media play a strong role in the production of eternalism and should not be regarded as unimportant, even if they are "inessential" in a philosophical sense. Jacobs even "thanks" Final Cut Pro in the credits of many of his eternalism works! Eternalism is profoundly based in software, even if it is technically not necessarily so.

Putting aside questions of ontology and medium specificity, however, it seems obvious that digital media play a profound role in facilitating the production of eternalism. Facilitating here does not mean just that the computer helps to produce these videos faster. What goes unobserved by Jacobs and others is that video-editing software enables a certain exactitude of composition, editing, and timing difficult for human hands to match. The specific technicity of digital media, then, catalyzes the production of eternalism through the microtemporal precision of its

existence as software. In other words, eternalism thrives on the dimensions of computational media unavailable to human consciousness: the technical exteriority of digital writing. While directly insensible, the animated images of eternalism represent its perceptible correlate. Unique to eternalism, however, these animated images do not just appear on screen. They appear in the embodied experience of sensation.

Merleau-Ponty again helps to clarify what is happening. For Merleau-Ponty, sensation comprises the body's experience of the microtemporal rhythms of the world. The task of sensation is to adjust and recalibrate the body's rhythms to those of the world under the surfaces of consciousness and perception. Merleau-Ponty writes: "The subject of sensation is neither a thinker who notices a quality, nor an inert milieu that would be affected or modified by it; the subject of sensation is a power that is born together with a certain existential milieu or that is synchronized with it" (219). As an impersonal and general power that is not "me" and that is not the "world" either, sensation emerges from the "proposition of a certain existential rhythm" (221). Crucially, the body attunes itself to the world in a fundamentally temporal manner. In an illuminating passage, Merleau-Ponty alludes to Husserl's discussion of the melody, the classic example in his theorization of time-consciousness.[43] Pushing beyond the imagination of intentionality, Merleau-Ponty writes, "we can discover a 'micro-melody' within a sound." The "sonorous interval" is thus "nothing other than the final articulation of a certain tension experienced at first in the whole body" (218). In other words, the incipient movement of the body denotes sensation as more than an affective sympathy. Sensation arises as affective sympathy only by virtue of a prepersonal synchronization with rhythms below the threshold of consciousness through so many microtemporalities.[44] In place of the intentional address of Husserl's melody, Merleau-Ponty claims, the micro-melody addresses sensation. More than the melody itself, the micro-melody represents what Merleau-Ponty terms an "atmospheric sound" articulating the relation of instrument and body (236).

Merleau-Ponty pushes his analysis even further. Beyond his theorization of sensation, he specifies that the temporal constitution of sensibility gives rise to "historical orientation." In effect, the very possibility of historical experience derives from the opacity of sensation in the microtemporal transit between body and world:

> In every movement of focusing, my body ties a present, a past, and a
> future together. It secretes time, or rather it becomes that place in
> nature where for the first time events, rather than pushing each other
> into being, project a double horizon of the past and future around the
> present and acquire an historical orientation. (249)

In Merleau-Ponty's account, sensation gives direction and force to his-
torical experience. It stands at the genesis of time going *somewhere*. The
origin of that orientation remains shrouded and insensible. It remains
opaque because it derives from sensation. There remains, however, an
instructive sense of this opacity: "Between sensation and myself, there
is always the thickness of an *originary acquisition* that prevents my experi-
ence from being clear for itself" (224). The perceiver has a "historical
thickness" because perception is narrower than sensation (247). What
sensation intends "is not constituted in full clarity"; "it is reconstituted
or taken up through a knowledge that remains latent and that leaves to
it its opacity and its *haecceity*" (221). Such knowledge "remains latent"
from the point of view of perception. It constitutes, in turn, the basis for
historicity as the experience of what is *already there* by virtue of the body's
constant microtemporal synchronization with the world.

Watching *Capitalism: Child Labor*, I see an image in its ever-recurring
genesis. I don't just see it coming into existence; I actually perceive it as
going somewhere, as moving left to right. Unlike the Necker cube and
other illusions, this image cannot be willed to appear in reverse or in an
inverse fashion. I can't see the image moving right to left, for example. If,
as I have argued, following Merleau-Ponty, the illusion of eternalism rep-
resents a macrotemporal image giving form to sensation as the microtem-
poral transit between world and body, then in what ways does this image
demonstrate "an original past, a past that has never been present"?

What is most compelling, I believe, is the fact that eternalism gives
rise at all to any sense of orientation that might give incipient narrative
shape or direction to its flickering images. The generically "historical"
character of the vast majority of Jacobs's eternalism videos becomes
valuable here. The videos prime the viewer to respond to this perpetual
beginning of motion precisely as historical orientation. Despite the pow-
erful nature of the images Jacobs selects (an African-American woman
bending to pick cotton or children employed as industrial labor), the

primary historical concern of eternalism remains its sensational possibilities and the open-ended questions of where those possibilities might flow. While provocative and significant, the representational narrative politics of these videos remains secondary to the sensational experience of historical orientation. What is important about history in Jacobs's eternalism films is the way they solicit a historical posture in the sensorial conjugation of the viewer and the environment. As opaque as these feelings of movement and illusions of sensation remain from the perspective of consciousness, then, what is important is that they might cross over into conscious experience as a series of bodily habits, orientations, and dispositions, not only toward explicitly historical content but also toward the world as such.

The magic of eternalism is simply that it perpetually begins. Instead of taking its viewer anywhere, such as on some kind of imaginative narrative journey, eternalism holds its viewer in suspension at the very genesis of historical experience. This phenomenon offers powerful lessons for gauging the transformation of historical experience in the digital age. Rather than negating or cancelling out history, Jacobs's videos reveal how digital media privilege the sensation of history by soliciting dimensions of embodiment with striking affinities to the opacity of digital experience. The opacity of sensation from the perspective of consciousness has clear affinities with the animate manifestation of the largely opaque operations of digital machines.

Far from abandoning historical experience altogether, then, Merleau-Ponty's philosophy of sensation allows us to see how historical experience appears and persists in the digital age. Historical experience in Jacobs's eternalism videos appears as *not for us*, a felt relation of nonrelation to our digital world, but also precisely as a function of that divergence. More than a representation or narrativization of the past, eternalism shows how digital media reactivate the past as sensation by employing their microtemporal operation to macrotemporal effect. "Animation" here names the felt aesthetic correlate of this transit from microtemporality to embodied experience constitutive of the porous, ever-attuning relation of body and world whose relational character has become so vivid in the context of ubiquitous media.

It is equally important that, as much as digital media depart from their analog predecessors, they continue to draw on the conceptual and

experiential lessons of older media regimes such as Muybridge and cinema. In transforming our reception of these older forms, digital media present the mutual articulation of body and world as always *already there*. "Sensation," Merleau-Ponty writes, "is a reconstitution, it presupposes in me the sedimentations of a previous constitution" (222). In the same spirit, digital media reconstitutes cinema. Yet digital media reconstitutes cinema and other forms as a means to realize a more primordial reconstitution of sensation itself. As long as body and world remain in transit, historical experience persists within human experience. This does not mean that historical experience favors any particular technical shape or modulation of historical experience. In Husserlian terms, Merleau-Ponty's discussion of sensation enables us to see how sensation is the very condition of possibility for reactivation. There is no beginning or ending of the handing down of tradition. But its flux can be dramatic. Historical experience remains *already there* in perpetual motion, always *in medias res*.

Now, in a sense, the computer has done exactly what you told it to do. It's hard *mescalita bitle some for Vanderbeek. Now shown*

Conclusion

DATA INCOMPLETE
The Web As Already There

"DATA INCOMPLETE, DATA INCOMPLETE, DATA INCOMPLETE . . ."

At the dawn of the digital moving image, this phrase punctuates an awkward moment in a conversation between an artist and an engineer recorded in a short film. Working at Bell Labs in the late 1960s, the experimental filmmaker Stan Vanderbeek notes to programmer Ken Knowlton that, even though one can program a computer "so you know what it's supposed to do," you still "don't know what it's *exactly* going to do in terms of images." Before Knowlton responds, the all-caps message "DATA INCOMPLETE" flashes on a screen between them as Knowlton appears to consider how to respond. Accompanied by a series of cartoonish blips and bloops—audio chronotopes of the early computer age—the words flash like a danger message. But there's no crisis here, just the parodic signification of data processing. Something's missing. Standing up beside a screen that might as well be a blackboard, Knowlton appears the teacher to Vanderbeek's student. Seemingly a bit confused and annoyed by Vanderbeek's question, Knowlton finally responds: "It's interesting to me that you say the 'unexpected things that happen.' Because, in a sense, the computer has done exactly what you told it to do, right?" It's hard not to feel a little sorry for Vanderbeek. Now shown in close up, he nods subtly, but it's not clear he understands. In fact, it's pretty clear he doesn't. His look of dumfounded agreement would make a perfect reaction GIF. The engineer is clearly correct, but it's also clear he hasn't really responded to the artist's perplexity. Data incomplete, indeed.

This remarkable exchange hails from *We Edit Life*, a 2002 ten-minute found-footage video by People Like Us, the moniker of London-based

artist Vicki Bennett.[1] It illustrates one of the core themes of this book: that new media art represents an especially rich lens through which to consider the experiential opacity of digital media. Even as early as the late 1960s, Vanderbeek grasped this fundamental problem. What goes into the black box becomes inevitably, unaccountably transformed when it comes back out. The technical opacity of digital machines gives rise to an experiential opacity. This opacity, I have argued, defines the historical experience of the digital age, and the unique visions of new media artists provide crucial resources for expressing this otherwise difficult to articulate relation of nonrelation we have to the infrastructures governing so many aspects of our lives. Comprising an impressive array of archived film from the 1940s through the 1960s of robots, synthesized speech, and early computer interfaces from Bell Laboratories, Westinghouse, and other sources, *We Edit Life* presents a kaleidoscopic prehistory of the digital age.

Figure 28. DATA INCOMPLETE. Screenshot of *We Edit Life* by People Like Us (2002). Courtesy of the artist, with thanks to the Prelinger Archives.

An explicit yet critically ambivalent meditation on the changing nature of historical experience, *We Edit Life* also exemplifies another key aspect of this study: the critical significance of animation aesthetics for the expression of historical experience. The moments of disconnect in the exchange between Vanderbeek and Knowlton are gentle, but also demonstrably artificial. Not only do the flashing words "DATA INCOM-PLETE" animate their exchange as if providing cartoonish thought balloons for *both* artist and engineer; Bennett also slows and loops the brief moments between their individual statements. This strategy elongates the exchange, produces subtly awkward silences, and renders their expressions a little fidgety. Foregrounding the tension at the core of their exchange, this animation of a conversational ellipsis marks the technical opacity that new media art uniquely makes visible.

New media, if we can even call digital media "new" anymore, are a moving target of critical investigation. The time involved in researching

Figure 29. Stan Vanderbeek stares in confusion. Screenshot of *We Edit Life* by People Like Us (2002). Courtesy of the artist, with thanks to the Prelinger Archives.

such a contemporary topic inevitably introduces different sorts of para-doxically proximate forms of historical distance. In the time since I began working on this book in the late 2000s, the digital landscape has shifted in different ways. The rise of social media, mobile computing, and always-on computing have all since come to prominence. Alongside the release of increasingly ubiquitous smartphones such as the iPhone (2007) and the Android operating system (2007), the mid-2000s appearance of mas-sively popular Web 2.0 sites indexes this shift: 4Chan (2003), Facebook (2004), Vimeo (2004), Reddit (2005), YouTube (2005), Twitter (2006), Tumblr (2007), and SoundCloud (2008). There is much to say about the ways these technologies and social media sites have changed differ-ent aspects of contemporary culture. Perhaps the most succinct way to describe their influence is that they signal the mutation of digital culture into culture as such. No longer something exotic or future-oriented in the manner of such 1990s buzzwords as cyberspace, the digital media of the mid-2000s has now become ordinary. Most relevant here in terms of my discussion of digital aesthetics is the way sites such as 4Chan, You-Tube, Reddit, and Tumblr give rise to a seismic shift in aesthetic pro-duction in an explosion of networked genres. Memes, animated GIFs, emoji, supercuts, selfies, vaporwave, and much else now rule the land-scape of contemporary (digital) culture.

Most of the artworks examined in the present book were produced in the late 1990s or the first decade of the twenty-first century. They were created largely before the emergence of our ordinary media land-scape, before the meteoric rise of social media and always-on computing. Chapter 4 addressed aspects of this shift under the rubrics of ubiquitous computing and atmospheric media, but a fuller consideration of ordi-nary media remains beyond the scope of this project. Like the artworks examined in this book, from Vuk Ćosić's ASCII of *Psycho* to Phil Solo-mon's *Last Days in a Lonely Place*, Cory Arcangel's *Untitled (After Lucier)*, and Barbara Lattanzi's *Optical De-dramatization Engine (O.D.E.)*, the new genres make extensive use of appropriated or found text, especially memes and GIFs. But unlike the new genres, the artworks examined here not only employ content from older media regimes but also foreground older media technologies as part of their general historicist vocation to express the experience of the incipient digital age. Much of the historical force in, for example, John Cayley's *overboard* or Ken Jacobs's *Capitalism: Child*

Labor, derives from the friction each piece generates in the formal and material collision and forced collaboration of old and new media. This tendency supports one of the main ideas guiding this study: that these works address historical experience as a matter of its technological conditions of possibility. These conditions of possibility often come most clearly into view when funneled through the formal aesthetics of older media. Things are different, however, for the new genres. There is less apparent need to mine the experiential and formal logics of older media for material because everything is already online. Why think about the internet in terms of the history of cinema or the book when older forms now feel genuinely subordinate to the web as the master medium of contemporary life?

The conceptual thread running through each chapter in this study has been the "already there." Throughout this book, I have discussed multiple iterations of the *already there*. Animation is its aesthetic symptom, and its source varies: the exteriority of writing, lateral time, sensation, and so on. In analyzing these iterations of the *already there*, I have sought to elaborate Bernard Stiegler's media theoretical expansion of the term from Heidegger. For Heidegger, human experience encounters the world as what precedes it, as *already there*. Stiegler, in turn, emphasizes the technical and historical dimensions of the *already there*. It is not only essentially technical; its technicity informs the relation between human experience and the world. Living requires constant adjustment and attunement to the environment. Technics represents one of the ways in which human life constantly recalibrates its relation to the primordial exteriority of the world, an exteriority that is simultaneously both "textually" out there and part of the human body's experience of itself. Up to the Industrial Revolution, and in many ways not even until the digital age, the complex character of technics remained undiscovered. Until recently, technics had been conceived as primarily *instrumental*, as technology as "tools," as the humanly scaled means of accommodating and compensating for disparities between the body and the world. Digital technologies expose the insufficiency of such instrumentalist conceptions of technics. In the digital age, it is not simply that the manifold primordial exteriority of the world as *already there* becomes not only deeply technological; its digital technological nature functions *primarily* and *ordinarily* beyond human oversight and agency.

What this means is that technics—our means of adjustment and relation to the world and ourselves—appears as newly *animate*. Technics no longer represents merely the index of an existential exteriority that might be overcome. To the extent that it "appears" at all, technics now manifests primarily in its experiential opacity, shedding much of its once-defining sense of relative significance to human perception and cognition. With digital media, the *already there* appears primarily as quasi-autonomous and *not for us*. Throughout this book, I have argued that the proliferation of animation aesthetics in the digital age represents an aesthetic symptom of the opacity uncertainly tethering experience to its technological infrastructure. I started, therefore, with animation as the occasion for inquiry and as the first iteration of the *already there* in contemporary digital culture. In subsequent chapters, I attempted to dig deeper and deeper into related aspects of the *already there* in its discursive manifestation as *not for us*: from technics and the out-of-hand to noise and the exteriority of writing, and from flickering grids of black and white static, finally, to sensation as the primordially embodied site of historical orientation.

But, now, with the rise of always-on computing and the proliferation of new genres endemic to the web, a new dimension of the *already there* emerges. The web itself after social media has come to function as the *already there* of the historical present. Want to know how to do anything? YouTube has a video for that. Want to know virtually anything? There's always Google. In a mere ten to twenty years, it has become perfectly ordinary to expect that, if something exists, it exists *online*. Even the terms "digitization" and "born digital" now feel musty. Why digitize anything from its analog existence when you can just ask Siri or Alexa? Why specify anything as *born digital* when it makes more sense to mark something as *born analog*? I'm only slightly exaggerating. The idea that online content not only mirrors but also supersedes nononline content is newly pervasive and unexceptional. The infamous "rule 34" states that, if it exists, there must be a porn version of it. This morsel of web wisdom vindicates Jean Baudrillard's now seemingly ancient proclamation that the map exceeds the territory![2] More than a crass appreciation of the web's substantial powers of pornification (turning everything into porn, from building ruins to weather and much else), rule 34 testifies to the transformative hyperautomated powers of digital media to remix,

recycle, and reanimate content at breakneck speed, to reactivate the past so quickly and manifoldly as to erase the prefix *re* from the perspective human experience. When all production is seemingly reproduction it seems pointless to call it *re* anything. Does all sense of the past recede into sameness?

Let us not make the same mistake breathlessly promoted by so many media theorists who correlate computers with the end of history. While the new networked genres proliferating on and sustained by the web, from memes to GIFs, seem not to need the historical-formal friction of older media forms, artists investigating the ordinariness of digital media remain concerned with older technologies and aesthetics as the productive means and scaffolding for articulating the opacity of digital experience. As Mashinka Firunts shows, Hito Steyerl's 2011 video *How Not to Be Seen: A Fucking Didactic Educational .MOV File* explores biometric surveillance not only through the idiom of YouTube how-to videos but also through the much older film genre of military instructional videos (and their televisual parody by Monty Python).[3] Frances Stark's widely exhibited 2011 video *My Best Thing* makes extensive reference to Frederico Fellini's *8½* at the same time as it explores interpersonal cam sex. Lorna Mills's 2014 video compilation project *Ways of Something* adapts the audio track from John Berger's seminal 1972 documentary *Ways of Seeing*. Supercut and aggregative compilation works by Jonathan Harris and Jason Salavon respectively build on the experimental film legacy of the found footage film pioneered by Bruce Conner and the art historical legacies of pop art. Many more examples might be cited. The new genres promoted and sustained by the web may appear vacuum-sealed in a kind of born-digital hermetic bubble potentially destructive of any sense of history, but the artists engaging these new forms remain dedicated to probing their limits in terms of older aesthetic forms and technologies, and these uses have multiple effects. Yet, if they have one overriding implication, it is perhaps that artists play a crucial role in sorting through the changing conditions of historical experience in the digital age, or what it means to think, see, and feel alongside digital media.

To zoom in a bit more with this last point, I want to return to the GIF-like animation of affect in Bennett's *We Edit Life*. While *We Edit Life* belongs to the archival sensibility of pre–Web 2.0 aesthetics, its subtle animation of movement to expand ambiguous affects gestures forward

to the terrain of ordinary media populated by GIFs. Moving toward the present—inevitably always receding, of course—I want to take a brief but close look at another more recent work of new media art: Eric Fleischauer's and Jason Lazarus's 2013 feature-length GIF compilation video *twohundredfiftysixcolors*. Composed of more than three thousand animated GIFs, *twohundredfiftysixcolors* represents an especially focused treatment of one of the most ubiquitous of the new networked genres populating the contemporary web. In contrast to Bennett's *We Edit Life*, which employs archival footage from nondigital, institutional sources, *twohundredfiftysixcolors* consists of GIFs collected by the filmmakers or sent to them by their friends through the casual practice of "hive mind" crowdsourcing, a means of collecting information and content common to the social media age. Like Steyerl, Stark, and Mills, *twohundredfiftysixcolros* embraces animation aesthetics for its expression of historical experience.

Twohundredfiftysixcolors has no one clear narrative. It proceeds silently through collections of popular web content and iconography: pizza, cats, porn, optical illusions, celebrities, politics, and much else. As splintered as its content seems, the contours of cinematic experience provide the viewer with basic experiential parameters and implicit suggestions for how to understand its silent procession of very short animated images. Its ninety-seven-minute runtime announces a temporal affinity with feature-length narrative cinema. While the video may be seen online, *twohundredfiftysixcolors* is meant, at least ideally, to be seen in a movie theater. At the very least, the video is meant to be viewed in a group setting. As Fleischauer and Lazarus explain, the video's lack of soundtrack opens up a potential space for viewers to talk during the projection, identifying or at least recognizing different GIFs, falling into collective silence, or talking or being quiet and fidgety about something else.

In fact, *twohundredfiftysixcolors* is mostly about *something else*. In my experience, viewers tend to remain audibly engaged (laughing, exclaiming, or talking) for the first several minutes. And then slowly, unevenly, they begin to zone out in waves of disengagement punctuated by sporadic moments of attentive viewing. In short, the primary affective response to *twohundredfiftysixcolors* is boredom. This is not an aesthetic shortcoming; indeed, far from it. As Scott C. Richmond observes, much of our contemporary digital landscape is quite boring. In Richmond's estimation, boredom represents "an affective correlate to media theory's

figure of the withdrawal of digital technics from the grasp of human perception and attention."[4] Some versions of aesthetic boredom are "profoundly boring," for example the boredom felt in the company of Andy Warhol's massively uneventful films *Empire* and *Sleep*. Modernist "profound boredom" begs for intellective recuperation as an experience of the artwork's reflexive character. More contemporary aesthetics, Richmond argues, represent another kind of boredom: "vulgar boredom." Felt paradigmatically while playing *Candy Crush Saga* or watching *Top Chef*, Richmond argues that vulgar boredom "takes place in the failure of the object to involve an interpretive, depressive I" and that its appeal lies in the way it allows "us to be with ourselves for a while, in a way that is neither overorganized, subjected to productivity or uplift or pedagogy, nor intensive, taking the exacerbated or heightened state of modernist or Romantic aesthetic response as its model."[5] Vulgarly boring works don't aim to move us too much. The slackened, diffuse pleasure they catalyze happens in a fashion sort of lateral to our own desultory noncommittal to whatever. In short, vulgar boredom is arguably the affect par excellence of always-on computing. *Twohundredfiftysixcolors* lies somewhere in the middle, between profound and vulgar boredom. Watching the video, one feels the urge to identify different GIFs, to think about the form or genre of the GIF itself. It sometimes solicits an interpretive *I*. But also, one wants to check one's phone, check social media, or otherwise zone out.

The video evokes historical experience in several ways. It begins by announcing a reflexive sense of historical form. After a series of loading, throbber, and progress bar GIFs, a longer series of thaumatrope, phenakistoscope, praxinoscope, and Muybridge-inspired GIFs emphasize the GIF's historical affinity with precinematic animation aesthetics in the long history of the moving image preceding and exceeding film history proper. A single GIF depicts the word ".GIF" inscribed on a stone with cuneiform writing, a compactly signifying image foregrounding the format's existence as digital inscription connected to the longer history of written inscription as the conditions of possibility for history. Yet, after the first twenty minutes of the film, this attention to history largely fades.

In another sense, when watching *twohundredfiftysixcolors* in 2017, the GIFs seem slightly out of date. For the ordinarily avid web aesthete,

this is almost a revelation. Those GIFs culled from the Obama–Romney debates feel almost quaint in the political moment after November 2016. Appearances by faded celebrities seem oddly disenchanted as Lindsay Lohan and Paris Hilton no longer occupy a space front-and-center in the mass cultural psyche. The web appears here as a sort of time capsule. Even as the video rolls along in silence, GIF after GIF after GIF, one persistently encounters the web's equivalent of the snakeskin of history in the experiential pivot away from the past.

Yet this experience is ultimately more dependent on form than on content. The cinematic arrangement of the piece and its feature length demand that the viewer watch it from beginning to end—pointedly, it does not run on a loop—providing an experiential scaffolding that enables the viewer to hold on to two distinct technohistorical modalities at once: the cinema and the web. This is not to say that the cinema isn't contemporary, but it is to say that the cinematic conditions of viewing *twohundredfiftysixcolors* reframe the web in a historical manner. The video's cinematic character anchors its viewer in a proximate, stable relation to the web and its constantly changing stream of images.

The web is the *already there* of contemporary culture. Like much of the web, the primary appeal of the animated GIF is that it doesn't "show up" too much. Viewed in isolation (even a few at a time), the GIF doesn't demand more than a brief response. You like it or not, and scroll or swipe onward. *Twohundredfiftysixcolors* asks what happens when the image whose primary appeal is that it doesn't make too many demands on the viewer, that it doesn't "show up" too much, shows up much too much. One result is a sense of historical experience. I have argued throughout this book that digital media often manifest to human experience in ways that make them seem as if they're *not for us*. *Twohundredfiftysixcolors* crystallizes this idea. History persists, but in a profoundly slackened, lateral sense. Like the aggregative unfurling of GIF after GIF, historical experience persists in relation to human experience. But perhaps more than ever, the opacity of digital media requires the aesthetic mediation of new media art to join our experience to the larger forces and infrastructures shaping historical experience today.

ACKNOWLEDGMENTS

I RELISH THE OPPORTUNITY to write this part of the book! As anyone who has written a scholarly book must know, the process of drafting and redrafting and redrafting some more—and then more redrafting!—can be difficult. To reach the end requires the help of many family members, friends, and colleagues. In my case, I need to thank people who helped me as I wrote this book across three states and four cities and towns: Chicago, Durham, Acton, and Evanston. I owe so much to so many. All errors are my own.

Four friends deserve special mention for their roles in fostering this book's development. It began as a dissertation directed by Mark B. N. Hansen. I have learned so much from Mark, and I am profoundly grateful for his contagious commitment to "driving an argument." Since our becoming friends during graduate school, Scott Richmond has remained my closest intellectual interlocutor. I hope this book lives up to the faith he's shown in my ideas. Patrick Jagoda has provided amazingly generous, incisive, and comprehensive feedback at multiple stages of writing and revision. Finally, I need to give extra special thanks to Nick Davis. Since I arrived at Northwestern, Nick has gone above and beyond as my mentor in the Department of English. He's read more drafts than I had any right to ask him to read. His investment in thinking that takes familiar topics and makes them unfamiliar in new and exciting ways buoys my own aspirations. Plus, he gave me a Muybridge-themed ruler, and I just love it. Thank you.

Many other friends across and beyond academia have supported me. This project began largely through conversations with Andrew Johnston after screenings of experimental animation at various Chicago venues.

Ivan Ross commented patiently and with humor on several early efforts. Kris Cohen introduced me to lateral ways of thinking and opened up media theory for me as a kind of multiverse. Even before I started writing this book, David Kamitsuka, Bob Longsworth, John Olmsted, and Jeff Pence at Oberlin College helped me to get started. My professors at the University of California, Santa Barbara, and the University of Chicago inspired me to be the best version of my scholarly self that I am still becoming. Thank you to Alan Liu, Peter Bloom, and Carl Gutiérrez-Jones at UCSB. At the University of Chicago, thanks to Miriam Bratu Hansen, Tom Gunning, W. J. T. Mitchell, Jim Chandler, and Elaine Hadley. During my postdoctoral year at Duke University, I benefited from a vibrant scene for digital media studies and critical theory. Thanks to Rob Mitchell, Amanda Starling-Gould, Abe Geil, Markos Hadjiannou, and Inga Pollman.

Since joining the Alice Kaplan Institute for the Humanities and the Department of English at Northwestern University, I have counted myself far luckier than I feel any right to be. Special thanks to Humanities directors Holly Clayson, Wendy Wall, and Jessica Winegar and to my English department chairs Laurie Shannon and Susan Manning. My colleagues in the English department and beyond have shown me the true meaning of collegiality, and I am grateful for all the ways they have supported this project. Big thanks to John Alba Cutler and Helen Thompson for feedback on the entire manuscript. Cheers to Danny Snelson, my fellow adventurer of the ordinary and High West. Special thanks to Harris Feinsod, too, for his advice on a thousand tiny questions. And thanks, too, to Juan Martinez for camaraderie and delicious lunches. Thanks, too, to John Bresland for intellectual honesty on the craftsmanship of ideas. Thanks also to Kathleen Bickford Berzock, Eula Biss, Brian Bouldrey, Katharine Breen, Lisa Corrin, Chad Davis, Brian Edwards, Chaz Evans, Kasey Evans, Mary Finn, Christine Froula, Jay Grossman, Josh Honn, Michelle Huang, Rebecca Johnson, Chris Lane, Jules Law, Andrew Leong, Jeffrey Masten, Michael Metzger, Shaun Myers, Susie Phillips, Ariel Rogers, Emily Rohrbach, Viv Soni, Julia Stern, Neil Verma, Rachel Webster, Will West, Ivy Wilson, Kelly Wisecup, Tristram Wolff, and Michelle Wright. Thanks also for the support of William Weaver, Kathy Daniels, Nathan Mead, Jennifer Britton, Dave Kuzel, Myriah Harris, Tom Burke, Megan Skord, Jill Mannor, and Justin Lintelman.

At a conference a few years ago, Kris Cohen said something I'll never forget. Remarking on the commonplace refrains of pessimism and despair over academic publishing, he spoke about how he writes so he can be in the same room at conferences year in and year out with the same group of people (always changing a little every year). It is vital to recognize the soulful, sustaining inspiration of writing for these small networks. Special thanks to my own growing network of peers and friends whose intellectual friendship I renew at SLSA, SCMS, ASAP, and elsewhere: Aubrey Anable, Brooke Belisle, Paul Benzon, Grant Bollmer, Stephanie Boluk, Shane Denson, Scott Ferguson, Mashinka Firunts, Jacob Gaboury, Tung-Hui Hu, Patrick Keilty, Kevin B. Lee, Patrick LeMieux, Kyle Stine, Tess Takahashi, and Damon Young. Thanks to Dan Pecchinino, Jeff Scheible, Nicole Starosielski, and Joshua Neves at UCSB and beyond. Thanks to David Alworth, Adam Hart, Matt Hauske, and Julie Turnock at Chicago and elsewhere. Thanks also to Jon Cates, Alex Galloway, Matt Kirschenbaum, Philip Levanthal, and Tim Murray. Gratitude to all the artists, too, who have so graciously allowed me to reproduce their work. Special thanks to Barbara Lattanzi.

Thanks to John Durham Peters and Thomas Lamarre for amazingly thorough and conscientious manuscript reviews. Thanks, too, to Danielle Kasprzak and Rita Raley at the University of Minnesota Press and the Electronic Mediations series.

A fellowship from the Alice Kaplan Institute for the Humanities at Northwestern University gave me valuable time and space to complete revisions.

Infinite love and thanks to the Hodge family, especially my mother and father, Judy and John Hodge. I owe a special debt of gratitude to Sarah and the Pikcilingis family. In love and friendship, heart-bursting and ongoing thanks to Andres and to Laura.

This book is dedicated to Orion. Maybe one day you'll find Dad's book and discover your name here. I love you, no matter what.

NOTES

Introduction

1. Bernard Stiegler, *Technics and Time*, vol. 1, *The Fault of Epimetheus*, trans. Richard Beardsworth and George Collins (Stanford, Calif.: Stanford University Press, 1998), 21.

2. George Baker, "Paul Chan: The Image from Outside," in *Paul Chan: The 7 Lights*, ed. Melissa Larner and Ben Fergusson (New York: New Museum of Contemporary Art, 2007), 4–18.

3. On Modotti, see Rubén Gallo, *Mexican Modernity: The Avant-Garde and the Technological Revolution* (Cambridge, Mass.: MIT Press, 2005).

4. I am thinking here of Lauren Berlant's discussion of the "eventilization" of history, the too-quick packaging and sedimentation of the past that forecloses difficult and alternative thoughts and feelings about the historical present (*Cruel Optimism* [Durham, N.C.: Duke University Press, 2011]).

5. Paul Chan, "On Light as Midnight and Noon" in *Paul Chan: Selected Writings 2000–2014*, ed. George Baker and Eric Banks, with Isabel Friedli and Martina Venanzoni (New York: ARTBOOK/D.A.P., 2014), 146–55, at 147. See also Anne Friedberg, *The Virtual Window: From Alberti to Microsoft* (Cambridge, Mass.: MIT Press, 2006).

6. Whitney Museum of American Art, "Audio Guide Stop for Paul Chan, 1st Light, 2005," embedded audio, 1:30, Whitney.org/WatchAndListen/1084.

7. Stanley Cavell's film theory has played a major role in the response in cinema studies to the emergence of digital media, especially concerning its changing "ontology." See: Cavell, *The World Viewed: Reflections on the Ontology of Film* (Cambridge, Mass.: Harvard University Press, 1979); D. N. Rodowick, *The Virtual Life of Film* (Cambridge, Mass.: Harvard University Press, 2007); Mark B. N. Hansen, "Technical Repetition and Digital Art, or Why the 'Digital' in Digital Cinema Is Not the 'Digital' in Digital Technics," in *Technology and Desire: The Transgressive Art of Moving Images*, ed. Rania Gaafar and Martin Schulz (Chicago:

Intellect, 2014); and Scott C. Richmond, *Cinema's Bodily Illusions: Flying, Floating, and Hallucinating* (Minneapolis: University of Minnesota Press, 2016).

8. See: N. Katherine Hayles, "Traumas of Code," *Critical Inquiry* 33, no. 1 (Autumn 2006): 136–57; Matthew G. Kirschenbaum, *Mechanisms: New Media and the Forensic Imagination* (Cambridge, Mass.: MIT Press, 2008); Alexander R. Galloway, *The Interface Effect* (Malden, Mass.: Polity, 2012); and Mark B. N. Hansen, *Feed Forward: On the Future of Twenty-First-Century Media* (Chicago: University of Chicago Press, 2015).

9. Dennis Tenen, *Plain Text: The Poetics of Computation* (Stanford, Calif.: Stanford University Press, 2017), 3.

10. I am thinking here of French Caribbean author Éduoard Glissant and his anticolonial, anti-Enlightenment notion of the "right to opacity" in *Poetics of Relation*, trans. Betsy Wing (Ann Arbor: University of Michigan Press, 1997). Glissant has influenced work in queer digital media studies by Zach Blas in "Informatic Opacity," in *Posthuman Glossary*, ed. Rosi Braidotti and Maria Hlavajova (New York: Bloomsbury, 2018). A political commitment to technical opacity also drives the work of Finn Brunton and Helen Nissenbaum in *Obfuscation: A User's Guide for Privacy and Protest* (Cambridge, Mass.: MIT Press, 2015).

11. I am thinking here of Alan Liu's discussion of the ideology of creative destruction in information culture in *The Laws of Cool: Knowledge Work and the Culture of Information* (Chicago: University of Chicago Press, 2004).

12. Fredric Jameson, *The Political Unconscious: Narrative as a Socially Symbolic Act* (Ithaca, N.Y.: Cornell University Press, 1981), 102.

13. Michael Foucault, *The Archaeology of Knowledge and the Discourse on Language*, trans. A. M. Sheridan Smith (New York: Pantheon, 1972), 127.

14. Friedrich A. Kittler, *Gramophone, Film, Typewriter*, trans. Geoffrey Winthrop-Young and Michael Wutz (Stanford, Calif.: Stanford University Press, 1999).

15. See Galloway, *Interface Effect*, 71.

16. See Kirschenbaum, *Mechanisms*.

17. Jonathan Crary, *24/7: Late Capitalism and the Ends of Sleep* (New York: Verso, 2013), 9.

18. Friedrich A. Kittler, "There is No Software," in *The Truth of the Technological Word: Essays on the Genealogy of Presence*, trans. Erik Butler (Stanford, Calif.: Stanford University Press, 2013), 219–29, at 221.

19. See Jacques Derrida, *Of Grammatology*, trans. Gayatri Chakravorty Spivak (Baltimore: Johns Hopkins University Press, 1976); Friedrich Kittler, "The History of Communication Media," *ctheory*, July 30, 1996, ctheory.net/articles .aspx?id=45.

20. See: Donna Haraway, "A Cyborg Manifesto: Science, Technology, and Socialist-Feminism in the Late Twentieth Century," in *Manifestly Haraway* (Minneapolis: University of Minnesota Press, 2016); Kirschenbaum, *Mechanisms*; John Cayley, "Screen Writing: A Practice-Based, EuroRelative Introduction to Digital Literature and Poetics," in *Literary Art in Digital Performance*, ed. Francisco J. Ricardo (New York: Continuum, 2009), 178–86; and Federica Frabetti, *Software Theory: A Cultural and Philosophical Study* (New York: Rowman & Littlefield, 2015).

21. Alexander R. Galloway, *Protocol: How Control Exists After Decentralization* (Cambridge, Mass.: MIT Press, 2004), ch. 7.

22. See Galloway, *Interface Effect*.

23. N. Katherine Hayles, *My Mother Was a Computer: Digital Subjects and Literary Texts* (Chicago: University of Chicago Press, 2005), 41.

24. Kevin Slavin, "How Algorithms Shape Our World," *TED*, July 2011, video, 15:16, ted.com /talks/kevin_slavin_how_algorithms_shape_our_world?language=en.

25. I analyze Ćosić's *ASCII PSYCHO* in depth elsewhere: James J. Hodge, "Digital *Psycho*: Dedramatizing the Historical Event," *Critical Inquiry* 43, no. 4 (Summer 2017): 839–60.

26. For more on *Agrippa (a book of the dead)*, see Alan Liu et al., *The Agrippa Files*, agrippa.english.ucsb.edu.

27. Kittler writes, "the storage capacities of our computers will soon coincide with electronic warfare and, gigabyte upon gigabyte, exceed all the processing capacities of historians" (*Gramophone*, 8). Kittler also writes, "by its own account, the NSA has 'accelerated' the 'advent of the computer age,' and hence the end of history, like nothing else. An automated discourse analysis has taken command" (*Gramophone*, 263).

28. See Jameson, *Political Unconscious*, 35, and Paul Ricoeur, *Time and Narrative*, trans. Kathleen McLaughlin and David Pellauer, 3 vols. (Chicago: University of Chicago Press, 1984).

29. Many prominent cultural theorists similarly imagine history via tropes of animation. Jameson imagines Marxism as a historical method akin to "Tiresias drinking the blood" of the past (*Political Unconsciousness*, 19). Jules Michelet describes history as "resurrection" (cited in Alan Liu, "Friending the Past: The Sense of History and Social Computing," *New Literary History* 42, no. 1 [2011]: 1–30, at 9). Walter Benjamin describes historical materialism as an automaton secretly animated by a hunchback dwarf named "theology" ("On the Concept of History," in *Walter Benjamin: Selected Writings*, vol. 4, ed. Howard Eiland and Michael W. Jennings [Cambridge, Mass.: Belknap, 2006], 389–400, at 389). Siegfried Kracauer imagines the historian as Orpheus descending "into the nether

world to bring the dead back to life" (*History: The Last Things Before the Last* [New York: Oxford University Press, 1969], 79). In the same vein are Stephen Greenblatt's famous declaration of his New Historicist desire to "speak with the dead" (*Shakespearean Negotiations: The Circulation of Social Energy in Renaissance England* [Berkeley: University of California Press, 1988], 1); Harry Harootunian's notion of history as a haunted house ("Remembering the Historical Present," *Critical Inquiry* 33, no. 3 [Spring 2007]: 471–94, at 478); and Alan Liu's evocation of history in the age of information as a matter of making "contact with the ghost" ("Escaping History: The New Historicism, Databases, and Contingency," in *Local Transcendence: Essays on Postmodern Historicism and the Database* [Chicago: University of Chicago Press, 2008], 239–62, at 240).

30. Francis Fukuyama, "The End of History?" *The National Interest* 16 (Summer 1989): 3–18. Relatedly, see the historical field of *posthistoire* as discussed in Perry Anderson, "The Ends of History," in *A Zone of Engagement* (New York: Verso, 1992), 279–375; Lutz Niethammer, in collaboration with Dirk Van Laak, *Posthistoire: Has History Come to an End?* trans. Patrick Camiller (New York: Verso, 1992).

31. Sarah Griffiths, "Print out your photos or risk losing them, warns Google boss," *Daily Mail*, February 13, 2015, dailymail.co.uk/sciencetech/arti cle-2952020/Will-21st-century-lost-history-Father-internet-warns-digital -world-lead-black-hole-knowledge.html.

32. The literature on digital media and archives is extensive. Among many possible citations, see: Paolo Cherchi Usai, *The Death of Cinema: History, Cultural Memory, and the Digital Dark Age* (London: BFI, 2001); Matthew G. Kirschenbaum, Richard Ovenden, and Gabriela Redwine, *Digital Forensics and Born-Digital Content in Cultural Heritage Collections* (Washington, D.C.: Council on Library and Information Resources, 2010); Wolfgang Ernst, *Digital Memory and the Archive*, ed. Jussi Parikka (Minneapolis: University of Minnesota Press, 2013); and Richard Rinehart and Jon Ippolito, *Re-Collection: Art, New Media, and Social Memory* (Cambridge, Mass.: MIT Press, 2014).

33. See Martin Heidegger, *Identity and Difference*, trans. Joan Stambaugh (Chicago: University of Chicago Press, 1969), 41; Maurice Merleau-Ponty, "Eye and Mind," in *Basic Writings*, ed. Thomas Baldwin (New York: Routledge, 2004), 292.

34. Hans Magnus Enzensberger, "Constituents of a Theory of the Media," in *The New Media Reader*, ed. Noah Wardrip-Fruin and Nick Montfort (Cambridge, Mass.: MIT Press, 2003), 259–75, at 265.

35. See Jean-François Lyotard, *The Postmodern Condition: A Report on Knowledge*, trans. Geoff Bennington and Brian Massumi (Minneapolis: University of

Minnesota Press, 1984), xxiv; and Fredric Jameson, *Postmodernism, or the Cultural Logic of Late Capitalism* (Durham, N.C.: Duke University Press, 1991), ix.

36. See: Paul Virilio, *The Information Bomb*, trans. Chris Turner (New York: Verso, 2000), 123–24; Jean Baudrillard, *The Illusion of the End*, trans. Chris Turner (Stanford, Calif.: Stanford University Press, 1994), 2; and Bernard Stiegler, "Memory," in *Critical Terms for Media Studies*, ed. W. J. T. Mitchell and Mark B. N. Hansen (Chicago: University of Chicago Press, 2010), 64–87, at 79.

37. Here is a sample. Philosopher Gianni Vattimo links the postmodern experience of the end of history to the new primacy of computer technology (*The End of Modernity: Nihilism and Hermeneutics in Postmodern Culture*, trans. Jon R. Snyder [Baltimore: Johns Hopkins University Press, 1991], 14). Literary theorist Homi K. Bhabha worries that "the 'presentism' and simultaneity celebrated on the 'Net' . . . may drain everyday life of its historical memory" ("Preface: Arrivals and Departures," in *Home, Exile, Homeland: Film, Media, and the Politics of Place*, ed. Hamid Naficy [New York: Routledge, 1999], vii–xii, at viii). Philosopher Jacques Rancière discusses information generally as opposed to memory and to the past (*Film Fables*, trans. Emiliano Battista [New York: Berg, 2006], 157). Documentary film theorist Bill Nichols describes the computer chip itself as "without history" ("The Work of Culture in the Age of Cybernetic Systems," in *Electronic Media and Technoculture*, ed. John Thornton Caldwell [New Brunswick, N.J.: Rutgers University Press, 2000), 90–116, at 102]. And cultural theorist Andreas Huyssen imagines information technology as a kind of black hole whose pull abolishes any capacity to think beyond the present (*Twilight Memories: Marking Time in a Culture of Amnesia* [New York: Routledge, 1994], 253).

38. For example, see Espen Aarseth, "We All Want to Change the World: The Ideology of Innovation in New Media," in *Digital Media Revisited: Theoretical and Conceptual Innovation in Digital Domains*, ed. Gunnar Liestol, Andrew Morrison, and Terje Rasmussen (Cambridge, Mass.: MIT Press, 2003), 415–41; and Lisa Gitelman, *Always Already New: Media, History, and the Data of Culture* (Cambridge, Mass.: MIT Press, 2006).

39. Liu, *Laws of Cool*, and Carolyn Marvin, "Information and History," in *The Ideology of the Information Age*, ed. Jennifer Daryl Slack and Fred Fejes (Norwood, N.J.: Ablex, 1987), 49–62.

40. See Liu, "Friending the Past."

41. Wendy Hui Kyong Chun, "The Enduring Ephemeral, or the Future Is a Memory," *Critical Inquiry* 35, no. 1 (Autumn 2008): 148–71, at 154, 160. See also Chun, *Programmed Visions: Software and Memory* (Cambridge, Mass.: MIT Press, 2011).

42. Alexander R. Galloway and Eugene Thacker, *The Exploit: A Theory of Networks* (Minneapolis: University of Minnesota Press, 2007), 33.

43. See Gilles Deleuze and Félix Guattari, *A Thousand Plateaus*, trans. Brian Massumi (Minneapolis: University of Minnesota Press, 1987), ch. 1.

44. Alexander R. Galloway, *Gaming: Essays on Algorithmic Culture* (Minneapolis: University of Minnesota Press, 2006), 103.

45. Safiya Umoja Noble, *Algorithms of Oppression: How Search Engines Reinforce Racism* (New York: New York University Press, 2018).

46. Alexander R. Galloway, "The Poverty of Philosophy: Realism and Post-Fordism," *Critical Inquiry* 39, no. 2 (Winter 2013): 347–66.

47. See Patrick Jagoda, "Fabulously Procedural: *Braid*, Historical Processing, and the Videogame Sensorium," *American Literature* 85 (December 2013): 745–79; Stephanie Boluk and Patrick LeMieux, "Dwarven Epitaphs: Procedural Histories in *Dwarven Epitaphs*," in *Comparative Textual Media: Transforming the Humanities in the Postprint Era*, ed. N. Katherine Hayles and Jessica Pressman (Minneapolis: University of Minnesota Press, 2013), 125–54.

48. Vilém Flusser, *Does Writing Have a Future?* Trans. Nancy Ann Roth (Minneapolis: University of Minnesota Press, 2011); Flusser, *Post-History*, trans. Rodrigo Maltez Novaes (Minneapolis: Univocal, 2013).

1. Out of Hand

1. On the manicule in digital culture, see Stephanie Boluk and Patrick LeMieux, *Metagaming: Playing, Competing, Spectating, Cheating, Trading, Making, and Breaking Video Games* (Minneapolis: University of Minnesota Press, 2017), 57–60.

2. William H. Sherman, *Used Books: Marking Readers in Renaissance England* (Philadelphia: University of Pennsylvania Press, 2008), 41.

3. I am thinking here of Charles Sanders Peirce's semiotic notion of the index as a *pointer*, or something like a pointing, indicating hand.

4. See Kyle Stine, "The Coupling of Cinematics and Kinematics," *Grey Room* 56 (Summer 2014): 35–58, at 46.

5. See Stanislas Dehaene, *The Number Sense: How the Mind Creates Mathematics* (New York: Oxford University Press, 2011), 80–83.

6. Wendy Hui Kyong Chun, *Updating to Remain the Same: Habitual New Media* (Cambridge, Mass.: MIT Press, 2016), 3.

7. See Rita Raley, "Dataveillance and Countervailance," in *"Raw Data" Is an Oxymoron*, ed. Lisa Gitelman (Cambridge, Mass.: MIT Press, 2013), 121–45.

8. If the reader prefers a more mainstream symptom of the out-of-hand character of contemporary digital life, recall the social media vogue for hands-only videos of toy unboxing or cooking. See Amanda Hess, "The Hand Has

Its Social Media Moment," *New York Times*, October 11, 2017, nytimes.com/2017/10/11/arts/online-video-hands-buzzfeed-tasty-facebook.html.

9. Martin Heidegger's comments concern his theorization of *Dasein*: "Its own past . . . is not something which *follows along after* Dasein, but something which already goes ahead of it" (*Being and Time*, trans. John Macquarrie and Edward Robinson [New York: Harper Perennial, 2008], 41). While this insight lies at the kernel of this project's approach to history, I follow Stiegler's interpretation more than Heidegger per se, leaving aside much of the latter's vocabulary and many of his concerns in favor of Stiegler's media theoretical perspective.

10. I am thinking here of Wendy Hui Kyong Chun's insight that "computer reading is a writing elsewhere" (*Programmed Visions: Software and Memory* [Cambridge, Mass.: MIT Press, 2011], 5).

11. On the digitalization of the environment, see Nigel Thrift, *Knowing Capitalism* (Los Angeles: SAGE, 2005); Jennifer Gabrys, *Program Earth: Environmental Sensing Technology and the Making of a Computational Planet* (Minneapolis: University of Minnesota Press, 2016); and Benjamin H. Bratton, *The Stack: On Software and Sovereignty* (Cambridge, Mass.: MIT Press, 2016).

12. Maurice Merleau-Ponty, *Phenomenology of Perception*, trans. Donald A. Landes (New York: Routledge, 2012), 107.

13. Heidegger, *Being and Time*, 95–102.

14. See: Walter Benjamin, "The Work of Art in the Age of its Technological Reproducibility (2nd Version)," in *Walter Benjamin: Selected Writings*, vol. 3, ed. Howard Eiland and Michael W. Jennings, trans. Edmund Jephcott, Howard Eiland, et al. (Cambridge, Mass.: Belknap Press of Harvard University Press, 2002), 101–33; and Miriam Bratu Hansen, *Cinema and Experience: Siegfried Kracauer, Walter Benjamin, and Theodor W. Adorno* (Berkeley: University of California Press, 2012).

15. Bernard Stiegler, *Technics and Time*, vol. 1, *The Fault of Epimetheus*, trans. Richard Beardsworth and George Collins (Stanford, Calif.: Stanford University Press, 1998), 140. Subsequent citations will be made parenthetically in text.

16. On animation and labor, see Hannah Frank, "Traces of the World: Animation and Photography," *Animation: An Interdisciplinary Journal* 11, no. 1 (2016): 23–39.

17. Friedrich Kittler compares the experience of programming to magic: "Have you ever had the experience that what you write on paper actually happens? When you program a computer, something is constantly happening. It's almost like magic" (Matthew Griffin and Susanne Herrmann, "Technologies of Writing: An Interview with Friedrich A. Kittler," *New Literary History* 27, no. 4 [1996]: 731–42, at 740).

18. See Sergei Eisenstein, *Eisenstein on Disney* (London: Methuen, 1988); Scott Bukatman, *The Poetics of Slumberland: Animated Spirits and the Animating Spirit* (Berkeley: University of California Press, 2012); and Andrew R. Johnston, "Signatures of Motion: Len Lye's Scratch Films and the Energy of the Line," in *Animating Film Theory*, ed. Karen Beckman (Durham, N.C.: Duke University Press, 2014), 167–80.

19. Critical theory, anthropology, and art history have all contributed to important reassessments of animism. See: Nurit Bird-David, "Animism Revisited: Personhood, Environment, and Relational Epistemology," *Current Anthropology* 40, no. S1 (1999): S67–S91; Bette Marenko, "Neo-Animism and Design: A New Paradigm in Object Theory," *Design and Culture* 6, no. 2 (2004): 219–42; Anselm Franke, *Animism* (Antwerp, Belgium: Sternberg, 2010); Angela Melitopoulos and Maurizio Lazzarato, "Assemblages: Félix Guattari and Machinic Animism," *E-Flux* 36 (July 2012), e-flux.com/journal/36/61259/assemblages -flix-guattari-and-machinic-animism/; Spyros Papapetros, "Movements of the Soul: Traversing Animism, Fetishism, and the Uncanny," *Discourse* 34, no. 2–3 (Spring/Fall 2012): 185–208.

20. The establishment of the journal *Animation: An Interdisciplinary Journal* in 2006 offers clear evidence of growing interest in animation across humanistic disciplines. Animation features in some of the most influential studies of literary affect and queer studies, too. See Sianne Ngai, *Ugly Feelings* (Cambridge, Mass.: Harvard University Press, 2005), ch. 2; Mel Y. Chen, *Animacies: Biopolitics, Racial Mattering, and Queer Affect* (Durham, N.C.: Duke University Press, 2012). More broadly, one finds consonant and at least latent themes of animation within many of the era's new theoretical discourses on the nonhuman, from new materialism to speculative realism. See *The Nonhuman Turn*, ed. Richard Grusin (Minneapolis: University of Minnesota Press, 2015).

21. See Bernard Stiegler, "The Discrete Image," in Steigler and Jacques Derrida, *Echographies of Television*, trans. Jennifer Bajorek (Malden, Mass.: Polity, 2002), 145–63; Beth Coleman, "Everything Is Animated: Pervasive Media and the Networked Subject," *Body & Society* 18, no. 1 (2012): 79–98.

22. *Star Wars Episode I: The Phantom Menace* features prominently in Lev Manovich's important discussion of digital cinema and new media studies in *The Language of New Media* (Cambridge, Mass.: MIT Press, 2001).

23. For a media theoretical account of Japanese anime, see Thomas Lamarre, *The Anime Ecology: A Genealogy of Television, Animation, and Game Media* (Minneapolis: University of Minnesota Press, 2018).

24. See Lev Manovich, "Generation Flash," in *New Media / Old Media: A History and Theory Reader*, ed. Wendy Hui Kyong Chun and Thomas Keenan

(New York: Routledge, 2006), 209–18; Jessica Pressman, *Digital Modernism: Making it New in New Media* (New York: Oxford University Press, 2014).

25. A sample of catalogues devoted to animation in museums includes: *Animated Painting*, ed. Betty-Sue Hertz (San Diego: San Diego Museum of Art, 2008); Paola Antonelli, *Talk to Me: Design and the Communication between People and Objects* (New York: Museum of Modern Art, 2011); Greg Hilty, *Watch Me Move: The Animation Show* (London: Merrill, 2011).

26. Dennis Tenen, *Plain Text: The Poetics of Computation* (Stanford, Calif.: Stanford University Press, 2017), 20–21.

27. Coleman, "Everything Is Animated."

28. As I shall do shortly here, Manovich draws a connection between pre-cinematic devices and digital technology. His argument hinges on a claim with which I strongly disagree, that precinematic animations and digital images are alike because digitization renders any footage whatever to pixels and is thus "no different than images created manually" (*Language of New Media*, 300). Against Manovich, I believe these two regimes of the image are quite different.

29. Tom Gunning and Karen Beckman both note film theory's impoverished treatment of animation. See Tom Gunning, "Moving Away from the Index: Cinema and the Impression of Reality," *differences* 18, no. 1 (2007): 29–52; *Animating Film Theory*, ed. Karen Beckman (Durham, N.C.: Duke University Press, 2014).

30. André Bazin, "The Myth of Total Cinema," in *What Is Cinema?* trans. Hugh Gray (Berkeley: University of California Press, 2005), 17–22, at 19.

31. Tom Gunning, "The Transforming Image: The Roots of Animation in Metamorphosis and Motion," in *Pervasive Animation*, ed. Suzanne Buchan (New York: Routledge, 2013), 52–69, at 63.

32. Jonathan Crary, "Techniques of the Observer," *October* 45 (1988): 3–35, at 20.

33. Alison Cuddy, "The Work of Projectionists in the Age of Digital Movies," *WBEZ Blogs*, February 14, 2013, wbez.org/shows/wbez-blogs/the-work-of-projectionists-in-the-age-of-digital-movies/cfef3edd-6df1-47c8-964c-b69ee574c3e2.

34. Karl Marx, *Capital: A Critique of Political Economy*, vol. 1, trans. Ben Fowkes (New York: Penguin, 1976), 1:164–65.

35. In particular, see Bill Brown, *A Sense of Things: The Object Matter of American Literature* (Chicago: University of Chicago Press, 2004), 25; Maurizio Lazzarato, *Signs and Machines*, trans. Joshua David Jordan (Los Angeles: Semiotext(e), 2014), 64.

36. On animation in Marx's discussion of commodity fetishism, see Sianne Ngai, *Our Aesthetic Categories: Zany, Cute, Interesting* (Cambridge, Mass.: Harvard

University Press, 2012), 61–62; Barbara Johnson, *Persons and Things* (Cambridge, Mass.: Harvard University Press, 2008), 22.

37. Marx, *Capital*, 1:507.

38. Marx, *Capital*, 1:499.

39. Marx, *Capital*, 1:502.

40. Marx, *Capital*, 1:503.

41. Marx, *Capital*, 1:506.

42. Marx, *Capital*, 1:506 (emphasis mine).

43. André Leroi-Gourhan, *Gesture and Speech*, trans. Anna Bostock Berger (Cambridge, Mass.: MIT Press, 1993).

44. See Stanley H. Ambrose, "Paleolithic Technology and Human Evolution," *Science* 291 (2001): 1748–53.

45. Ludwig Feuerbach, *The Essence of Christianity*, trans. George Eliot (Amherst, N.Y.: Prometheus, 1989), 31.

46. Gilbert Simondon, *On the Mode of Existence of Technical Objects*, trans. Cecile Malaspina and John Rogove (Minneapolis: Univocal, 2017).

47. Félix Guattari, "Machinic Heterogenesis," trans. James Creech, in *Reading Digital Culture*, ed. David Trend (Malden, Mass.: Blackwell, 2001), 40.

48. Gunning theorizes the cinema of attractions in a number of essays. For a complete dossier, see *The Cinema of Attractions Reloaded*, ed. Wanda Strauven (Amsterdam: Amsterdam University Press, 2006).

49. Donald Crafton, "Animation Iconography: The 'Hand of the Artist,'" *Quarterly Review of Film Studies* 4, no. 4 (1979): 409–28; Crafton, *Before Mickey: The Animated Cartoon, 1898–1928* (Chicago: University of Chicago Press, 1982).

50. Aristotle cited in Raymond Tallis, *The Hand: A Philosophical Inquiry into Human Being* (Edinburgh: Edinburgh University Press, 2003).

51. See, for example: Sigfried Giedion, *Mechanization Takes Command: A Contribution to Anonymous History* (Minneapolis: University of Minnesota Press, 2013), 5; Martin Heidegger, *Parmenides*, trans. André Schuwer and Richard Rojcewicz (Bloomington: University of Indiana Press, 1992), 85–87; Matthew G. Kirschenbaum, *Track Changes: A Literary History of Word Processing* (Cambridge, Mass.: Belknap, 2016), 139–65.

52. For example, see the covers of Chun, *Programmed Visions*, Brian Massumi, *Parables for the Virtual: Movement, Affect, Sensation* (Durham, N.C.: Duke University Press, 2002); David Golumbia, *The Cultural Logic of Computation* (Cambridge, Mass.: Harvard University Press, 2009). The logo for the Posthumanities book series published by the University of Minnesota Press is a pixelated hand.

53. Henri Focillon, *The Life of Forms in Art*, trans. Charles B. Hogan and George Kubler (New York: Zone, 1992), 157.

54. On murderous severed hands, see adaptations of Maurice Reynard's 1920 novel *The Hands of Orlac*, including Karl Freund's 1935 film *Mad Love* starring Peter Lorre.

55. Peter J. Capuano, *Changing Hands: Industry, Evolution, and the Reconfiguration of the Victorian Body* (Ann Arbor: University of Michigan, 2015).

56. On the "lightning sketch" and related animated forms of performance, see Matthew Solomon, "'Twenty-Five Heads Under One Hat': Quick-Change in the 1890s," in *Meta-Morphing: Visual Transformation and the Culture of Quick Change*, ed. Vivian Sobchack (Minneapolis: University of Minnesota Press, 2000).

57. Rotoscoping is a technique in cel animation whereby an animator employs footage recorded from reality in order to trace it and represent it as the basis for uncannily "natural" motion applied to animated images. Disney's *Snow White and the Seven Dwarfs* (1937) features this technique.

58. See Alan Liu, "Imagining the New Media Encounter," in *A Companion to Digital Literary Studies*, ed. Ray Siemens and Susan Schreibman (Malden, Mass.: Blackwell, 2007), 3–25.

59. See Esther Leslie, *Hollywood Flatlands: Animation, Critical Theory, and the Avant-Garde* (New York: Verso, 2002).

60. See Paul Wells, *Understanding Animation* (New York: Routledge, 1998), 24.

61. Hannah Maitland Frank, "Looking at Cartoons: The Art, Labor, and Technology of Cel Animation" (PhD diss., University of Chicago, 2016), 8.

62. Tom Gunning "The Cinema of Attraction: Early Cinema, Its Spectator and the Avant-Garde," *Wide Angle* 8, no. 3–4 (1986): 63–70.

63. The literature on the index in cinema and digital studies is large. See Braxton Soderman, "The Index and the Algorithm," *differences* 18, no. 1 (2007): 153–86; Kris Paulsen, *Here/There: Telepresence, Touch, and Art at the Interface* (Cambridge, Mass.: MIT Press, 2017).

64. On minstrelsy and animation, see Nicholas Sammond, *Birth of an Industry: Blackface Minstrelsy and the Rise of American Animation* (Durham, N.C.: Duke University Press, 2015).

65. Laura Mulvey, "Visual Pleasure and Narrative Cinema," in *Film Theory and Criticism: Introductory Readings*, ed. Leo Braudy and Marshall Cohen (New York: Oxford University Press, 1999), 833–44, at 841–42.

66. Chris Marker, "A Free Replay (Notes on *Vertigo*)," Chris Marker: Notes from the Era of Imperfect Memory, chrismarker.org/chris-marker/a-free-replay-notes-on-vertigo/ (originally published in French in *Positif* 400 [June 1994]: 79–84).

67. Tom Gunning, "The Desire and Pursuit of the Hole: Cinema's Obscure Object of Desire," in *Erotikon: Essays on Eros, Ancient and Modern*, ed. Shadi

Bartsch and Thomas Bartscherer (Chicago: University of Chicago Press, 2005), 261–77, at 267.

68. Barbara Johnson, "Apostrophe, Animation, and Abortion," *Diacritics* 16, no. 1 (Spring 1986): 28–47, at 30.

69. Proust's novel has been translated into English under the titles *In Search of Lost Time* and *Remembrance of Things Past*. In one episode, the French tea cake known as the *madeleine* precipitates and emblemizes what comes to be known as "involuntary memory." For background and further on Proust and "involuntary memory," including on the *madeleine* episode, see, e.g., Ann Tukey, "Notes on Involuntary Memory in Proust," *French Review* 44, no. 3 (1969): 395–402.

70. The repetition of "No hay banda; there is no band" in the Club Silencio scene in David Lynch's 2001 film *Mulholland Drive* echoes this dynamic.

71. Tenen, *Plain Text*, 42.

72. Grant Taylor, "The Soulless Usurper: Reception and Criticism of Early Computer Art," in *Mainframe Experimentalism: Early Computing and the Foundations of the Digital Arts*, ed. Hannah B. Higgins and Douglas Kahn (Berkeley: University of California Press, 2012), 17–36, at 31.

73. On computer graphics at the University of Utah, see Jacob Gaboury, *Image Objects* (Cambridge, Mass.: MIT Press, forthcoming).

74. Thanks to Julie Turnock for this reference. *Futureworld* is the sequel to Michael Crichton's 1973 film *Westworld*.

75. Bill Brown, "All Thumbs," *Critical Inquiry* 30, no. 2 (Winter 2004): 452–57, at 452. "Emergent," "dominant," and "residual" are, of course, terms drawn from Raymond Williams, *Marxism and Literature* (New York: Oxford University Press, 1977), 121–27.

76. I am thinking of Domietta Torlasco's theorization of many experimental videos as expressing a sense of the future anterior, or "what will have happened" (*The Heretical Archive: Digital Memory at the End of Film* [Minneapolis: University of Minnesota Press, 2013], xiv).

77. As John P. Powers notes, Solomon also employs a number of cheat codes in order to stage specific camera angles and scenes ("Darkness on the Edge of Town: Film Meets Digital in Phil Solomon's *In Memoriam (Mark LaPore)*," *October* 137 [Summer 2011]: 84–106, at 97).

78. On the continuity between Solomon's analog films and digital videos, see Powers, "Darkness."

79. Alexander R. Galloway, *Gaming: Essays on Algorithmic Culture* (Minneapolis: University of Minnesota Press, 2006), 10.

80. Siegfried Kracauer, *Theory of Film: The Redemption of Physical Reality* (Princeton, N.J.: Princeton University Press, 1997), 294.

81. Vilém Flusser, *The Shape of Things: A Philosophy of Design* (London: Reaktion, 1999), 89.

82. Daniel Reynolds, "What Is 'Old' in Video Games?" in *Playing with the Past: Digital Games and the Simulation of History*, ed. Matthew Whilhelm Kapell and Andrew B. R. Elliott (New York: Bloomsbury, 2013), 49–60, at 56.

83. Galloway, *Gaming*, 2.

2. The Noise in History

1. John Durham Peters, "Writing," in *The International Encyclopedia of Media Studies*, ed. Angharad N. Valdivia and Erica Scharrer (Malden, Mass.: Wiley-Blackwell, 2013), 3–22, at 5.

2. Media critic Finn Brunton calls attention to what he calls "robot-readable media": "objects meant primarily for the attention of other objects" (*Spam: A Shadow History of the Internet* [Cambridge, Mass.: MIT Press, 2013], 110–11). His examples are things like QR codes and bar codes, but the bizarre robo-speak of spam also exemplifies the ways digital media are not primarily *for us*.

3. Friedrich Kittler, "There Is No Software," in *The Truth of the Techno-logical Word: Essays on the Genealogy of Presence*, trans. Erik Butler (Stanford, Calif.: Stanford University Press, 2013), 219–29, at 220.

4. Jacques Derrida, *Dissemination*, trans. Barbara Johnson (Chicago: University of Chicago Press, 1981); Bernard Stiegler, *What Makes Life Worth Living? On Pharmacology*, trans. Daniel Ross (New York: Polity, 2013).

5. Plato, *Phaedrus* 275d, in *Phaedrus and the Seventh and Eighth Letters*, trans. Walter Hamilton (New York: Penguin, 1973), 97.

6. I am thinking here of Giorgio Agamben's distinction between *bios* and *zoe* as words for life in ancient Greek designating cultural and bare life, respectively; see Agamben, *Homo Sacer: Sovereign Power and Bare Life*, trans. Daniel Heller-Roazen (Stanford, Calif.: Stanford University Press, 1998).

7. See Derrida, *Dissemination*, 136–37.

8. Originating with Kittler, this phrase has proved highly influential in a series of mid-2000s discussions around the specificity of digital media. Most of these discussions ignore Kittler as the source of this idea, and all of them ignore Kittler's discussion of code as writing in his original essay. See Friedrich Kittler, "On the Implementation of Knowledge: Toward a Theory of Knowledge," in *README! ASCII Culture and the Revenge of Knowledge*, ed. Josephine Bosma et al. (Brooklyn, N.Y.: Autonomedia, 1999), 60–69, at 64. Alexander R. Galloway popularized the idea in *Protocol: How Control Exists After Decentralization* (Cambridge, Mass.: MIT Press, 2004). N. Katherine Hayles omits Kittler and cites

Galloway in discussing this idea in *My Mother Was a Computer: Digital Subjects and Literary Texts* (Chicago: University of Chicago Press, 2005). The idea subsequently appears in Galloway's discussions of code in *The Interface Effect* (Malden, Mass.: Polity, 2012).

9. See, for example, Donna Haraway, "A Cyborg Manifesto: Science, Technology, and Socialist-Feminism in the Late Twentieth Century," in *Manifestly Haraway* (Minneapolis: University of Minnesota Press, 2016); Vilém Flusser, *Does Writing Have a Future?* trans. Nancy Ann Roth (Minneapolis: University of Minnesota Press, 2011); Bernard Stiegler, *Technics and Time*, vol. 2, *Disorientation*, trans. Stephen Barker (Stanford, Calif.: Stanford University Press, 2009); John Cayley, "Screen Writing: A Practice-Based, EuroRelative Introduction to Digital Literature and Poetics," in *Literary Art in Digital Performance: Case Studies in New Media Art and Criticism*, ed. Francisco J. Ricardo (New York: Continuum, 2009), 178–86; Matthew G. Kirschenbaum, *Mechanisms: New Media and the Forensic Imagination* (Cambridge, Mass.: MIT Press, 2008); Federica Frabetti, *Software Theory: A Cultural and Philosophical Study* (New York: Rowman & Littlefield, 2015).

10. Daniel Punday argues that the imagination of computers has historically relied on a *metaphorical* sense of digital media as writing (*Computing as Writing* [Minneapolis: University of Minnesota Press, 2015]).

11. Kirschenbaum, *Mechanisms*, 135.

12. See John Cayley, "The Code Is Not the Text (Unless It Is the Text)," *electronic book review*, September 10, 2002, electronicbookreview.com/essay/the-code-is-not-the-text-unless-it-is-the-text/.

13. Cayley, "Screen Writing," 183.

14. Rita Raley, "Code.surface || Code.depth," *Dichtung-Digital* no. 36 (2006), dichtung-digital.org/2006/1-Raley.htm.

15. On the "end of the book," see Jessica Pressman, "The Aesthetic of Bookishness in Twenty-First Century Literature," *Michigan Quarterly Review* 48, no. 4 (2009): 465–82; Alan Liu, "The End of the End of the Book: Dead Books, Lively Margins, and Social Computing," *Michigan Quarterly* 48, no. 4 (2009): 499–520 (Note: No. 4 of *Michigan Quarterly* 48 [2009] was a special fall issue titled *Bookishness: The New Fate of Reading in the Digital Age*, with other articles worth consulting).

16. William Bradford, *Of Plymouth Plantation*, ed. Harvey Wish (New York: Capricorn Books, 1962), 58.

17. John Cayley, "Overboard: An Example of Time-Based Ambient Poetics in Digital Art," *Dichtung-Digital* no. 32 (2004), dichtung-digital.de/2004/2/Cayley/index.htm.

18. Wendy Hui Kyong Chun argues that digital writing is a "writing elsewhere" (see *Programmed Visions: On Software and Memory* [Cambridge, Mass.: MIT Press, 2011]).

19. See Thomas Y. Levin, "'Tones From Out of Nowhere': Rudolph Pfenninger and the Archaeology of Synthetic Sound," *Grey Room* 12 (Summer 2003): 32–79.

20. Alexander R. Galloway, *Gaming: Essays on Algorithmic Culture* (Minneapolis: University of Minnesota Press, 2006), 6–7.

21. Kirschenbaum, *Mechanisms*, 83.

22. Paul Ricoeur, "Writing as a Problem for Literary Criticism and Philosophical Hermeneutics," in *A Ricoeur Reader: Reflection and Imagination*, ed. Mario J. Valdés (New York: Harvester Wheatsheaf, 1991), 320–37, at 323.

23. See David Wellbery, "The Exteriority of Writing," *Stanford Literature Review* 9 (1992): 11–23.

24. See Mark B. N. Hansen, *Embodying Technesis: Technology Beyond Writing* (Ann Arbor: University of Michigan Press, 2000).

25. See David Wellbery, "Theory of Events: Foucault and Literary Criticism," *Revue Internationale de Philosophie* 41 (1987): 420–32; "Foreword," in Friedrich A. Kittler, *Discourse Networks 1800/1900*, trans. Michael Metteer with Chris Cullens (Stanford, Calif.: Stanford University Press, 1990), vii–xxxiii.

26. On the intersections between French poststructuralism and information theory, see Bernard Dionysius Geoghegan, "From Information Theory to French Theory: Jakobson, Lévi-Strauss, and the Cybernetic Apparatus," *Critical Inquiry* 38, no. 1 (Fall 2011): 96–126; Lydia H. Liu, *The Freudian Robot: Digital Media and the Future of the Unconscious* (Chicago: University of Chicago Press, 2011).

27. William Gibson, *Neuromancer* (New York: Ace, 1984), 3.

28. See Hugh S. Manon and Daniel Tempkin, "Notes on Glitch," *World Picture* 6 (Winter 2011), worldpicturejournal.com/WP_6/Manon.html.

29. Olga Goriunova and Alexei Shulgin, "Glitch," in *Software Studies: A Lexicon*, ed. Matthew Fuller (Cambridge, Mass.: MIT Press, 2008), 110–19, at 111.

30. See Kirschenbaum, *Mechanisms*.

31. See Braxton Soderman, "The Index and the Algorithm," *differences* 18, no. 1 (2007): 153–86.

32. See Paul Ceruzzi, *Computing: A Concise Introduction* (Cambridge, Mass.: MIT Press, 2012). Conceiving of it purely as an engineering problem, Shannon emphasizes the inapplicability of his model to semantic forms of expression. His theorization of information has, of course, proved influential far beyond its original context.

33. Claude Shannon and Warren Weaver, *The Mathematical Theory of Information* (Urbana: University of Illinois Press, 1949).

34. Two noteworthy works that also employ related strategies of repetitive, durational decay are J. J. Murphy's experimental film *Print Generation* (1974) and Eugenio Tisselli's web-based work *Degenerative* (2005). There are also a remarkable number of YouTube-based tributes/updates to Lucier's classic sound work. For example, see the video posted on June 9, 2010, by YouTube subscriber ontologist, entitled "VIDEO ROOM 1000 COMPLETE MIX—ALL 1000 videos seen in sequential order!," YouTube.com/watch?v=icruGcSsPp0.

35. Paul Ricoeur, *Husserl: An Analysis of His Phenomenology*, trans. Edward G. Ballard and Lester E. Embree (Evanston, Ill.: Northwestern University Press, 2007), 146–47.

36. In another sense, Husserl's turn to history is not odd at all. He was writing in 1930s Germany. The world was crumbling around him. What remains surprising—if not downright tragic with historical hindsight—is that *The Crisis of European Sciences*, the larger work from which "The Origin of Geometry" derives, attempts to address the madness of the times by valorizing and articulating a sense of the rational spirit of "European Man" and his destiny in world history via transcendental phenomenology. *Dialectic of Enlightenment* it is not!

37. Edmund Husserl, "The Origin of Geometry," trans. David Carr, in Jacques Derrida, in *Edmund Husserl's* Origin of Geometry: *An Introduction*, trans. John P. Leavey Jr. (Lincoln: University of Nebraska Press, 1989), 157–80, at 164.

38. Mark Paterson, *The Senses of Touch: Haptics, Affects and Technologies* (New York: Berg, 2007), 61.

39. Husserl, "Origin of Geometry," 164. Husserl seems to be silently drawing on the Platonic notion of anamnesis, or memory distinct from its technical support (hypomnesis) and its articulation in Plato's *Meno* and *Phaedrus*.

40. Jacques Derrida, *The Problem of Genesis in Husserl's Philosophy*, trans. Marian Hobson (Chicago: University of Chicago Press, 2003), 168.

41. Derrida, *Genesis in Husserl's Philosophy*, 164 (emphasis mine).

42. Jacques Derrida, *Of Grammatology*, trans. Gayatri Chakravorty Spivak (Baltimore: Johns Hopkins University Press, 1997), 8.

43. Bernard Stiegler, "Derrida and Technology: Fidelity at the Limits of Deconstruction and the Prosthesis of Faith," trans. Richard Beardsworth, in *Jacques Derrida and the Humanities: A Critical Reader*, ed. Tom Cohen (Cambridge: Cambridge University Press, 2001), 238–70, at 252.

44. See Stanley H. Ambrose, "Paleolithic Technology and Human Evolution," *Science* 291, no 5509 (March 2, 2001): 1748–53.

45. Martin Heidegger, *Being and Time*, trans. John Macquerrie and Edward Robinson (New York: Harper, 2008), 41.

46. Husserl, "The Origin of Geometry," 178.

47. Derrida, *Genesis in Husserl's Philosophy*, 164–65.

48. Stanislas Dehaene, *Reading in the Brain: The Science and Evolution of a Human Invention* (New York: Viking, 2009), 4.

49. Dehaene, *Reading in the Brain*, 125.

50. Dehaene, *Reading in the Brain*, 137.

51. Dehaene, *Reading in the Brain*, 138.

52. Contemporary debates over the meaning of writing in contemporary philosophy after Derrida's death in 2004 go beyond what I can examine here. However, it bears noting that, taken with Husserl and Derrida in mind, Dehaene's insights might temper the polemical thrust of Catherine Malabou's argument that "plasticity" surpasses "writing" as a master term of twenty-first-century philosophy (*Plasticity at the Dusk of Writing: Dialectic, Destruction, Deconstruction*, trans. Carolyn Shread [New York: Columbia University Press, 2009]).

53. Derrida, *Grammatology*, 27.

54. Stiegler, *Technics and Time*, 2:12.

55. See Mark B. N. Hansen, "The Time of Affect, or Bearing Witness to Life," *Critical Inquiry* 30 (2004): 584–626.

56. See Tim Griffin, "On Compression," *October* 135 (Winter 2011): 3–20.

57. Pamela Lee, *Chronophobia: On Time in the Art of the 1960s* (Cambridge, Mass.: MIT Press, 2004), 259.

58. Lee, *Chronophobia*, 263.

59. See Grant Taylor, "The Soulless Usurper: Reception and Criticism of Early Computer Art," in *Mainframe Experimentalism: Early Computing and the Foundations of the Digital Arts*, ed. Hannah B. Higgins and Douglas Kahn (Berkeley: University of California Press, 2012), 17–37.

60. See Justin Remes, *Motion(less) Pictures: The Cinema of Stasis* (New York: Columbia University Press, 2015); Paul Roquet, *Ambient Media: Japanese Atmospheres of Self* (Minneapolis: University of Minnesota Press, 2016).

3. Lateral Time

1. Neta Alexander observes how "the length of buffering is always unpredictable." See Alexander, "Rage Against the Machine: Buffering, Noise, and Perpetual Anxiety in the Age of Connected Viewing," *Cinema Journal* 56, no. 2 (Winter 2017): 1–24, at 10.

2. Kris Cohen, *Never Alone, Except for Now: Art, Networks, Populations* (Durham, N.C.: Duke University Press, 2017), 24. "Parallelism," for Cohen, is a

defining structure of networks understood as working "between the public and the population, between subjectivity and forms of life that aren't predicated on the coherence or will or self-consciousness of a subject" (38). See also Tung-Hui Hu, "Real Time/Zero Time," *Discourse* 34, no. 2–3 (Fall 2012): 163–84.

3. Patrick Jagoda, *Network Aesthetics* (Chicago: University of Chicago Press, 2016), 3.

4. Patrick LeMieux, "Histories of the Future," *electronic book review*, March 1, 2014, electronicbookreview.com/essay/futures-of-electronic-literature/.

5. I derive the phrase "always on" from danah boyd's notion of the "always-on lifestyle" ("Participating in the Always-On Lifestyle," in *New Media / Old Media: A History and Theory Reader*, 2nd edition, ed. Wendy Hui Kyong Chun and Anna Watkins Fisher, with Thomas Keenan [New York: Routledge, 2016], 425–28). See also James J. Hodge, "Sociable Media: Phatic Connection in Digital Art," *Postmodern Culture* 26, no. 1 (September 2016), DOI: 10.1353/pmc.2015.0021.

6. Sol LeWitt, "Paragraphs on Conceptual Art," in *Conceptual Art: A Critical Anthology*, ed. Alexander Alberro and Blake Stimson (Cambridge, Mass.: MIT Press, 1999), 12–16, at 12.

7. While in some ways it resembles John Conway's cellular automaton *Game of Life* (1970), *Every Icon* utterly disavows anthropomorphic projection. On Conway, see William Poundstone, *The Recursive Universe: Cosmic Complexity and the Limits of Scientific Knowledge* (Mineola, N.Y.: Dover, 2013). Thanks to John Durham Peters for this reference.

8. Alexander R. Galloway, *The Interface Effect* (Malden, Mass.: Polity, 2012), 73.

9. John Maeda, *Creative Code* (London: Thames & Hudson, 2004), 46.

10. Sarah Sharma, *In the Meantime: Temporality and Cultural Politics* (Durham, N.C.: Duke University Press, 2014).

11. See Stephen Kern, *The Culture of Time and Space, 1880–1918* (Cambridge, Mass.: Harvard University Press, 2003); Rebecca Solnit, *River of Shadows: Eadweard Muybridge and the Technological Wild West* (New York: Viking, 2003), ch. 1.

12. See Peter Kubelka, "The Theory of Metrical Film," in *The Avant-Garde Film: A Reader of Theory and Criticism*, ed. P. Adams Sitney (New York: New York University Press, 1978), 139–59.

13. See N. Katherine Hayles, *Unthought: The Power of the Cognitive Nonconcious* (Chicago: University of Chicago Press, 2017), ch. 6.

14. See Nicole Starosielski, "Fixed Flow: Undersea Cables as Media Infrastructure," in *Signal Traffic: Critical Studies of Media Infrastructures*, ed. Lisa Parks and Nicole Starosielski (Urbana: University of Illinois Press, 2015), 53–70.

15. Edmund Husserl, *On the Phenomenology of the Consciousness of Internal Time (1893–1917)*, trans. John Barnett Brough (Boston: Kluwer, 1991).

16. Bernard Stiegler, *Technics and Time*, vol. 3, *Cinematic Time and the Question of Malaise*, trans. Stephen Barker (Stanford, Calif.: Stanford University Press, 2011).

17. Mark B. N. Hansen, "Technics Beyond the Temporal Object," *New Formations* 1, no. 1 (2012): 44–62; Hansen, *Feed-Forward: On the Future of Twenty-First-Century Media* (Chicago: University of Chicago Press, 2015).

18. Mark B. N. Hansen, "The Primacy of Sensation: Psychophysics, Phenomenology, Whitehead," in *Theory Aside*, ed. Jason Potts and Daniel Stout (Durham, N.C.: Duke University Press, 2014), 218–36.

19. Mark B. N. Hansen, "Technical Repetition and Digital Art, or Why the 'Digital' in Digital Cinema Is Not the 'Digital' in Digital Technics," in *Technology and Desire: The Transgressive Art of Moving Images*, ed. Rainia Gaafar and Martin Schultz (Chicago: Intellect, 2014), 77–102, at 87.

20. See Mark B. N. Hansen, "Feelings without Feelers, or Affectivity as Environmental Force," in *Timing of Affect: Epistemologies, Aesthetics, Politics*, ed. Marie-Luise Angerer, Bernd Bösel, and Michaela Ott (Zurich: Diaphenes, 2014), 65–86.

21. Eugenie Brinkema, *The Forms of the Affects* (Durham, N.C.: Duke University Press, 2014).

22. Aristotle, *Physics* 4.220a24–26. See Aristotle, *The Basic Works of Aristotle*, ed. Richard McKeon (New York: Modern Library, 2001).

23. Quoted in Wolfgang Ernst, "Generating Time by Technical Measuring," in *Chronopoetics: The Temporal Being and Operativity of Technological Media*, trans. Anthony Enns (New York: Rowan & Littlefield, 2016), 37–61, at 39.

24. St. Augustine, *Confessions* 11.14, trans. R. S. Pine-Coffin (New York: Penguin, 1961).

25. Sianne Ngai, *Ugly Feelings* (Cambridge, Mass.: Harvard University Press, 2005), 266.

26. See Scott C. Richmond, "Vulgar Boredom, or What Andy Warhol Can Teach Us about *Candy Crush*," *Journal of Visual Culture* 14, no. 1 (2015): 21–39.

27. Martin Heidegger employs the term "self-affection" in describing Kant's philosophy of time (*Kant and the Problem of Metaphysics*, trans. Richard Taft [Indianapolis: Indiana University Press, 1990], 129–33).

28. Aristotle, *Physics* 4.219a4–9. To be sure, this example is absurd in its abstract confidence that we might be unaffected in the dark. While it is possible to hold your breath or even for yogis to slow their heartbeats, it is impossible not to feel your own body in some kind of motion.

29. Scott C. Richmond, *Cinema's Bodily Illusions: Floating, Flying, and Hallucinating* (Minneapolis: University of Minnesota Press, 2016).

30. Tilman Baumgärtel, *[net.art 2.0]: New Materials Towards Net Art* (Nurnberg: Verlag fur Moderne Kunst, 2001), 99.

31. Rosalind Krauss, "Grids," *October* 9 (1979): 50–64, at 64.

32. Vilém Flusser, *Does Writing Have a Future?* Trans. Nancy Ann Roth (Minneapolis: University of Minnesota Press, 2011), 21.

33. Paul Ricoeur, *Time and Narrative*, 3 vols., trans. Kathleen McLaughlin and David Pellauer (Chicago: University of Chicago Press, 1984–85), 3:104.

34. Jonathan Culler, *The Pursuit of Signs: Semiotics, Literature, Deconstruction* (Ithaca: Cornell University Press, 1981), 152.

35. Barbara Lattanzi, Email to author, June 2011.

36. Lattanzi, Email to author, June 2011 (emphasis mine).

37. Ricoeur, *Time and Narrative*, 3:118.

38. Ricoeur, *Time and Narrative*, 3:104.

39. Matthew G. Kirschenbaum, *Mechanisms: New Media and the Forensic Imagination* (Cambridge, Mass.: MIT Press, 2008).

40. Ricoeur, *Time and Narrative*, 3:120.

41. Marc Bloch, *The Historian's Craft*, trans. Peter Putnam (New York: Alfred A. Knopf, 1953), 54–55.

42. Ricoeur, *Time and Narrative*, 3:304.

43. Ricoeur, *Time and Narrative*, 1:3.

44. Ricoeur, *Time and Narrative*, 3:104.

45. John Durham Peters, "Proliferation and Obsolescence of the Historical Record in the Digital Era," in *Cultures of Obsolescence: History, Materiality, and the Digital Age*, ed. Babette B. Tischleder and Sarah Wasserman (New York: Palgrave Macmillan, 2015), 79–96.

46. Wendy Hui Kyong Chun, *Programmed Visions: Software and Memory* (Cambridge, Mass.: MIT Press, 2011), 137.

47. Chun, *Programmed Visions*, 169.

48. Galloway, *Interface Effect*.

4. The Sensation of History

1. See: Mark Weiser, "The Computer for the 21st Century," *Scientific American* 265, no. 3 (1991): 94–104; Mark B. N. Hansen, "Ubiquitous Sensation: Toward an Atmospheric, Collective, and Microtemporal Model of Media," in *Throughout: Art and Culture Emerging with Ubiquitous Computing*, ed. Ulrik Ekman et al. (Cambridge, Mass.: MIT Press, 2013), 63–88; James J. Hodge, "Gifts of Ubiquity," *Film Criticism* 39, no. 2 (Winter 2014–2015): 53–78.

2. N. Katherine Hayles, "RFID: Human Agency and Meaning in Information-Intensive Environments," *Theory, Culture & Society* 26, no. 2–3 (2009): 47–72, at 48.

3. Nigel Thrift, "Remembering the Technological Unconscious by Foregrounding Knowledges of Position," *Environment and Planning D: Society and Space* 22 (2004): 175–90, at 182.

4. Mark B. N. Hansen, "Ubiquitous Sensibility," in *Communication Matters: Materialist Approaches to Media, Mobility and Networks*, ed. Jeremy Packer and Stephen B. Crofts Wiley (New York: Routledge, 2012), 53–65, at 53.

5. See Belinda Barnet, "Infomobility and Technics: Some Travel Notes," *ctheory*, October 27, 2005, ctheory.net/ctheory_wp/infomobility-and-technics -some-travel-notes/.

6. Muybridge has long been a favorite of animators and media artists. For instance, Muybridge imagery populates Nam June Paik's massive and "environmental" 215-monitor 1995 video installation *Megatron/Matrix*. For a discussion of Muybridge in experimental film animation, see Amy Lawrence, "Counterfeit Motion: The Animated Films of Eadweard Muybridge," *Film Quarterly* 57, no. 2 (Winter 2003–2004): 15–25.

7. Roslyn Sulcas, "3 Modern Collaborators Add a Victorian Shadow," *New York Times*, December 5, 2011, nytimes.com/2011/12/06/arts/dance/un dance-by-wayne-mcgregor-and-friends-in-london-review.html. Sulcas refers to exhibitions at the Royal Academy in London, the Pompidou Center in Paris, and *Undance* by Wayne McGregor.

8. Muybridge's images appear in a 2012 advertisement for Jaguar entitled "Machines."

9. See Seth L. Shipman et al., "CRISPR–Cas Encoding of a Digital Movie into the Genomes of a Population of Living Bacteria," *Nature* 547 (July 2017): 345–49.

10. Neda Ulaby, "Muybridge: The Man Who Made Pictures Move," *All Things Considered*, embedded audio (6:05) and text, *npr*, April 13, 2010, npr.org/ 2010/04/13/125899013/muybridge-the-man-who-made-pictures-move.

11. This is a dominant theme in the early twenty-first-century revival of interest in chronophotography within the field of cinema and media studies. For example, see Mary Ann Doane, *The Emergence of Cinematic Time: Modernity, Contingency, the Archive* (Cambridge, Mass.: Harvard University Press, 2002); Tom Gunning, "'Never Seen This Picture Before': Muybridge in Multiplicity," in *Time Stands Still: Muybridge and the Instantaneous Photography Movement*, ed. Phillip Prodger (New York: Oxford University Press, 2003), 222–72.

12. On Muybridge and pornography, see Linda Williams, *Hard Core: Power, Pleasure, and the "Frenzy of the Visible"* (Berkeley: University of California Press,

1989). On pornification, see Susanna Paasonen, "Diagnoses of Transformation: 'Pornification,' Digital Media, and the Diversification of the Pornographic," in *The Philosophy of Pornography: Contemporary Perspectives*, ed. Lindsay Coleman and Jacob M. Held (New York: Rowman and Littlefield, 2014), 3–16.

13. Alan Liu, *The Laws of Cool: Knowledge Work and the Culture of Information* (Chicago: University of Chicago Press, 2004), 42.

14. Fredric Jameson's phrase was "history is what hurts" (*The Political Unconscious: Narrative as a Socially Symbolic Act* [Ithaca, N.Y.: Cornell University Press, 1981], 102).

15. The choreography for *Beat It* is, of course, based on sequences from the 1961 film *West Side Story*, directed by Robert Wise and Jerome Robbins.

16. For a popular example of this parallelistic group form, see Mark Romanek's 2016 video for Justin Timberlake's song "Can't Stop the Feeling." On "group form," see Kris Cohen, *Never Alone, Except for Now: Art, Networks, Populations* (Durham, N.C.: Duke University Press, 2017). For an example of how video-network aesthetics facilitate global senses of togetherness, see Kevin Macdonald's crowd-sourced feature-length film *Life in a Day* (2011).

17. Writing on the meaning of term "ambient" in the context of ubiquitous computing, Ulrik Schmidt notes, "the word *ambience* stems from the Latin word *ambire*, meaning to 'go around,'" adding, "ambience is the production of a distinctive *effect* characterized by an *intensification of the experience of being surrounded*" ("Ambience and Ubiquity," in Ekman et al., *Throughout*, 175–87, at 176).

18. Mark B. N. Hansen, *New Philosophy for New Media* (Cambridge, Mass.: MIT Press, 2004).

19. Hansen, "Ubiquitous Sensation," 65.

20. Brooke Belisle, "Depth Readings: Ken Jacobs's Digital, Stereographic Films," *Cinema Journal* 53, no. 2 (Winter 2014): 1–26, at 23.

21. Tom Gunning, "'Films That Tell Time': The Paradoxes of the Cinema of Ken Jacobs," in *Films That Tell Time: A Ken Jacobs Retrospective*, ed. David Schwartz (New York: American Museum of the Moving Image, 1989).

22. Malcolm Turvey, "Ken Jacobs: Digital Revelationist," *October* 137 (Summer 2011): 107–24, at 107.

23. Mitchell builds on and departs from Louis Althusser's famous description of ideological interpellation through the example of a policeman hailing someone on the street: "hey, you!" For the relation of ideology to the structure of software, see Wendy Hui Kyong Chun, "On Software, or the Persistence of Visual Knowledge," *Grey Room* 18 (2004): 26–51.

24. W. J. T. Mitchell, *What Do Pictures Want? Essays on the Lives and Loves of Images* (Chicago: University of Chicago Press, 2005), 49.

25. Mitchell, *What Do Pictures Want?* 203.

26. Andrew R. Johnston, "Models of Code and the Digital Architecture of Time," *Discourse* 37, no. 3 (Fall 2015): 221–46, at 226.

27. Beth Coleman, "Everything Is Animated: Pervasive Media and the Networked Subject," *Body & Society* 18, no. 1 (2012): 79–98.

28. Ken Jacobs, "Interview with Ken Jacobs," in Schwartz, *Films That Tell Time*, 32.

29. See Ken Jacobs, "Painted Air: The Joys and Sorrows of Evanescent Cinema," *Millennium Film Journal* 43/44 (Summer 2005): 37–62, at 37. On political modernism, see D. N. Rodowick, *The Crisis of Political Modernism: Criticism and Ideology in Contemporary Film Criticism* (Berkeley: University of California Press, 1988).

30. Ken Jacobs, U.S. Patent #7,030,902, filed April 18, 2006, and U.S. Patent #7,218,339, filed May 15, 2007.

31. See: Jeffrey Skoller, "ReAnimator: Embodied History, and the Post-Cinema Trace in Ken Jacobs' 'Temporal Composites,'" in *Pervasive Animation*, ed. Suzanne Buchan (New York: Routledge, 2013), 224–47; Turvey, "Ken Jacobs: Digital Revelationist"; Eivind Røssaak, "Algorithmic Culture: Beyond the Photo/Film Divide," in *Between Stillness and Motion: Film, Photography, Algorithms*, ed. Eivind Røssaak (Amsterdam: Amsterdam University Press, 2011), 187–205; *Optic Antics: The Cinema of Ken Jacobs*, ed. Michele Pierson, David E. James, and Paul Arthur (New York: Oxford University Press, 2011); J. Hoberman, *Film after Film, or What Became of 21st Century Cinema?* (New York: Verso, 2013), 201–6.

32. Belisle, "Depth Readings," 17.

33. Belisle, "Depth Readings," 24. P. Adams Sitney coins the term "structural film" to describe the shared vocation of a group of 1960s experimental filmmakers, including Jacobs (*Visionary Film: The American Avant-Garde, 1943–2000*, 3rd ed. [New York: Oxford University Press, 2002]).

34. See Skoller, "ReAnimator."

35. Maurice Merleau-Ponty, *The Visible and the Invisible*, ed. Claude Lefort, trans. Alphonso Lingis (Evanston, Ill.: Northwestern University Press, 1968), 40–41.

36. Scott C. Richmond, *Cinema's Bodily Illusions: Floating, Flying, and Hallucinating* (Minneapolis: University of Minnesota Press, 2016).

37. See Maurice Merleau-Ponty, *Husserl at the Limits of Phenomenology*, trans. and ed. Leonard Lawlor with Bettina Bergo (Evanston, Ill.: Northwestern University Press, 2002).

38. Merleau-Ponty writes: "The whole Husserlian analysis is blocked by the framework of *acts* which imposes upon it the philosophy of *consciousness*" (*Visible and the Invisible*, 244). Elsewhere he writes of the necessity of ontologizing the

results of his *Phenomenology of Perception*: "The problems that remain after this first description: they are due to the fact that in part I retained the philosophy of 'consciousness'" (*Visible and the Invisible*, 183).

39. Merleau-Ponty, *Visible and the Invisible*, 196.

40. See Alia Al-Saji, "'A Past Which Has Never Been Present': Bergsonian Dimensions in Merleau-Ponty's Theory of the Prepersonal," *Research in Phenomenology* 38 (2008): 41–71.

41. Maurice Merleau-Ponty, *Phenomenology of Perception*, trans. Donald A. Landes (New York: Routledge, 2012), 252. Subsequent citations will be made parenthetically.

42. Jacobs, "Painted Air," 39–40.

43. See Edmund Husserl, *On the Phenomenology of the Consciousness of Internal Time (1893–1917)*, trans. John Barnett Brough (Dordrecht, The Netherlands: Kluwer, 1991), 22.

44. On the relation of sensation and microtemporality, see Hansen, "Ubiquitous Sensation."

Conclusion

1. Thanks to Danny Snelson for introducing me to this video. For more on *We Edit Life*, see Danny Snelson, "Incredible Machines," Avant.org, June 4, 2014, avant.org/project/incredible-machines/. It can also be seen at youtube.com/watch?v=y_hJmmi_mnI.

2. This idea comes from Baudrillard's 1981 essay "The Precession of Simulacra," republished in Jean Baudrillard, *Simulacra and Simulation*, trans. Sheila Faria Glaser (Ann Arbor: University of Michigan, 1994), 1–42.

3. Mashinka Firunts, "Staging Mobile Pedagogy: Video Tutorials, Lecture-Peformances, and Hito Steyerl's Didactic Educational .MOV Files," lecture presented at Northwestern University, October 5, 2016.

4. Scott C. Richmond, "Vulgar Boredom, or What Andy Warhol Can Teach Us About *Candy Crush*," *Journal of Visual Culture* 14, no. 1 (April 2015): 21–39, at 21.

5. Richmond, "Vulgar Boredom," 31.

INDEX

Page numbers in italics refer to figures.

JAMES J. HODGE is assistant professor in the Department of English and the Alice Kaplan Institute for the Humanities at Northwestern University.